HARMLESS
NATURALISM

HARMLESS NATURALISM

The Limits of Science and the Nature of Philosophy

ROBERT ALMEDER

Open Court
Chicago and La Salle, Illinois

To order books from Open Court, call 1-800-815-2280.

Cover illustration: *Newton* by William Blake
Open Court Publishing Company is a division of Carus Publishing
Company.

Copyright © 1998 by Carus Publishing Company

First printing 1998

Printed and bound in the United States of America.

Library of Congress Cataloging-in-Publication Data

Almeder, Robert F.
 Harmless naturalism : the limits of science and the nature of
philosophy / Robert F. Almeder
 p. cm.
 Includes bibliographical references (p.) and index.
 ISBN 0-8126-9379-5 (cloth : alk. paper). — ISBN 0-8126-9380-9
(paper. : alk. paper)
 1. Knowledge, Theory of. 2. Naturalism. 3. Scientism.
4. Science—Philosophy. I. Title.
BD161.A47 1998
146—dc21 97-53307
 CIP

For Nick Rescher . . .
As a memento of the many enjoyable
hours we have spent in philosophical
discussion

Contents

Preface

The first part of this book is a much-expanded and substantially revised version of my "On Naturalizing Epistemology" which appeared in *The American Philosophical Quarterly* (October 1990). This same paper (with the last section substantially revised) appears in James Fetzer's collection *Foundations of the Philosophy of Science: Contemporary Developments* (New York: Paragon Press, 1992); and an extended discussion emerging from the last section of this paper appears as "Defining Justification and Naturalizing Epistemology" in *Philosophy and Phenomenological Research* (October 1994). The second part of this book is also a much expanded and revised version of a section of the third chapter of my *Blind Realism* (Lanham, Md.: Rowman and Littlefield, 1992) In *Blind Realism*, the discussion in question sought to show that reliabilist and causal theories of justification could not rehabilitate the classical definition of knowledge in the face of recent counter-examples. Here the point of the discussion, apart from a much fuller treatment and discussion of the forms of reliabilism, is to show that because of the same inadequacies in reliabilism and causalism as either a theory of epistemic justification or as a theory of knowledge, the second form of naturalized epistemology, which rests upon reliabilism, is philosophically unacceptable. Also, part

of the current revision includes the addition of "Dretske's Dreadful Question," *Philosophia* (Spring 1996), and parts of my reply "Externalism and Justification" to Dretske's response in the same volume.

Finally, I would like to thank the Center for the Philosophy of Science at the University of Pittsburgh for providing the Senior Fellowships (in 1984 and 1988) and the proper environment that made this writing possible. For the same reason, I am grateful to the Fulbright Foundation and the United States-Israeli Educational Foundation for the Senior Lectureship at Tel Aviv University where I worked on this manuscript and taught a graduate seminar on naturalized epistemology during the Fall Term of 1992. The members of the philosophy department at Tel Aviv, along with the graduate students, and especially Asa Kasher, made my stay there enjoyable and productive. Thankfully, the philosophy departments at the University of Witwatersrand, the University of Capetown and the University of South Africa, along with the philosophers at CREA (in the National Research Center) in Paris, provided lively discussions on the last section of Chapter 1 and on the last section of Chapter 3. Also, along the way, Nicholas Rescher, Alvin Goldman, William Alston, David Blumenfeld, Milton Snoeyenbos, Douglas Winblad, Steve Rieber, and Richard Ketchum all provided valuable comments and criticisms. Ruth Weintraub convinced me, without really trying, to abandon an argument in the final part of this book; and Harvey Siegel gracefully made me aware of my embarrassing failure in earlier publications to notice his early argument for the incoherence of the replacement thesis. Lastly, but by no means the least, the wonderful people at the Hambidge Center in Rabun Gap, Georgia, provided a pleasant and quiet setting for some of the reflections expressed in this book.

Introduction

This book seeks to answer an enduring general question, a question whose proper answer provides a reasonably adequate understanding of the nature and limits of human knowledge. The question itself is about the legitimacy of *scientism*, and what scientism and its denial imply. Advocates of scientism assert, directly or indirectly, that the *only* legitimately answerable questions are those that scientists can answer by appeal to the methods of the natural sciences and they also say that the only correct answers we have (or ever will have) are those that emerge from the application of the methods of testing and confirmation in the natural sciences. By implication, scientism asserts that the only legitimate claims are those that can be confirmed or falsified by the methods of the natural sciences. If scientism were stated more indirectly, rather than directly, it would assert that even if there appear to be questions whose answers are not clearly scientific answers, nevertheless, whether those answers are acceptable answers is in some basic way a scientific question. In other words, even if people claim to know or have answers to questions that are not ostensibly scientific, whether they know what they claim to know is a question

1

for scientists to answer by appeal to the methods of the natural sciences. Even casual observers of the history of philosophy will agree that the debate about the legitimacy of scientism, or scientific naturalism, has a rich and gnarled history with no plausible assessment or resolution of the conflicting answers to the question of whether scientism as so described is rationally acceptable.

In the history of Western Philosophy, for example, scientism roots in doctrines and attitudes that go back at least as far as the Ancient Atomists; and of course in modern times, British Empiricism, culminating in the works of David Hume, was in some measure at least implicitly a source of scientism. Hume's views were seriously challenged by those who correctly suspected that Hume's incipient sensism was a clear problem for those who think there are plausible claims and answers falling outside a methodology committed to nothing but physical objects and sensory representations of them. Thereafter, scientism received its most sustained and popular defense in some of the writings of the Vienna Circle in the 1920s and later in A.J. Ayer's clarion call, *Language, Truth, and Logic*. Ayer captured the imagination and crystallized the core intuition of scientism adopted widely in the Vienna Circle when he argued for the empiricist criterion of meaning and the view that the only meaningful sentences are those that are either analytic (and hence about language only) or empirically verifiable. However, because Ayer and his followers failed to offer a precise definition of empirical verifiability, they fell upon their own swords and were often accused of eating their young. Even so, the core intuition of scientism managed to survive basically untarnished in the works of such philosophers as John Dewey, C.I. Lewis, Nelson Goodman, and, most recently, W.V. Quine, whose "Epistemology Naturalized" is invariably seen as offering the best definition and defense of scientism available. As mentioned above, other advocates of scientism, wishing to distinguish their position from the one Quine urges, offer an allegedly distinct position, a position asserting that there are some non-scientific questions and answers but whether anybody knows what they claim to know is a scientific question. Incidentally, although there is very strong reason to think

that this new variation reduces logically to the same form offered by Quine (and is therefore subject to the same critique as that of Quine's position), we will, for the sake of discussion and refutation of the arguments offered for it, view this new variation as logically distinct from the position described above, advanced by Quine, and variously defended by others.

This whole discussion on scientism, or scientific naturalism, flourishes in contemporary philosophy under the rubric of *naturalized epistemology*; and, even though the basic question reaches back as far as the ancient atomists, any serious effort to examine the strength of the core intuition behind scientism in its various forms will require examining contemporary arguments because, beginning with Quine, the arguments are all present in their strongest form in contemporary philosophical literature.

Let me first briefly state this book's argument in a very general way. Scientism, as described in either of the two forms just noted, is rationally indefensible, and yet there is a defensible form of naturalism that does not directly or indirectly reduce philosophical explanations to scientific explanations—although philosophical explanations are implicitly empirically testable and hence confirmable or falsifiable. In short, I will defend a reasonably comprehensive naturalism while avoiding both scientism and the reduction of philosophical claims and explanations to strictly scientific claims and explanations. In so doing, I also hope to define philosophy by showing how a good philosophical explanation, while empirically testable, differs from a good scientific explanation. But this is all a bit *too* general; so let me now characterize in more detail the forms of naturalism in terms of the forms of naturalized epistemology, and then state more clearly what this book hopes to establish.

There are three allegedly distinct forms of naturalized epistemology. The first form asserts, as we saw above, that the only legitimately answerable questions about the nature of human knowledge and the world are those we can answer in natural science, and the only correct answers or explanations we have in these areas are those furnished by natural science. So described, naturalized epistemology is a branch of natural science wherein the

questions asked about the nature of human knowledge make sense
only because they admit of resolution under the method (or
methods) of such natural sciences as biology, neuropsychology, or
cognitive science and psychology, broadly conceived. Characterized
in this way, naturalized epistemology consists in empirically
describing and scientifically explaining how our various beliefs
originate, endure, deteriorate, or grow. Unlike traditional episte-
mology, this form of naturalized epistemology does not seek to
determine whether the robustly confirmed beliefs of natural science
are more or less justified, as though the very canons of justification
used in natural science need validation by appeal to a more primi-
tive concept of justification not derivable from the canons of
scientific justification operative in the practice of natural science.
For that reason, this first form of naturalized epistemology is not
"normative" in the way traditional epistemology is normative, al-
though it would certainly be normative insofar as correct conclu-
sions drawn by such a naturalized epistemologist would need to
follow the methodological canons of natural science. These metho-
dological canons would derive their normative validity simply from
their instrumental success, or effectiveness, in promoting the ulti-
mate goal or goals of natural science. Not surprisingly, this first
form of naturalized epistemology regards traditional "philosophi-
cal" questions about human knowledge, questions whose formula-
tion and solution do not emerge solely from scientific practice, as
pointless or meaningless.

Accordingly, this first form of naturalized epistemology seeks to
replace traditional epistemology with the thesis that while we cer-
tainly have scientific knowledge, and whatever norms are appropri-
ate for the successful conduct of natural science, we have no
philosophical theory of knowledge sitting in judgment over the
claims of natural science in order to determine whether they live up
to a philosophically congenial analysis of justification or knowl-
edge. We have scientific knowledge, but we do not have what Quine
calls "first philosophy," or some vantage point outside natural
science to assess the epistemological merits of justificatory
practices in natural science. As we shall see shortly, the classical

defense of this first form of naturalized epistemology appears in Quine's essay "Epistemology Naturalized."

The second form of naturalized epistemology, also noted above, seeks less to *replace* traditional epistemology than it does to *transform* and supplement it by connecting it with the methods and insights of psychology, biology, and cognitive science. In *Epistemology and Cognition*, for example, Alvin Goldman has argued for this second form which allows for traditionally normative elements but is "naturalized" for the reason that the practitioners of natural science, especially biology and psychology, will have the last word on whether anybody knows what they claim to know. For Goldman, although defining human knowledge and other epistemic concepts is legitimately philosophical and traditionally normative, whether anybody knows what they claim to know, and what cognitive processes are involved, is ultimately a matter we must consign to psychologists or cognitive scientists. Unlike the first form of naturalized epistemology, this form allows traditional epistemology to sit in judgment on the deliverances of natural science, but, as we shall see, the judgment must be made by the practitioners of natural science using the methods of natural science.

The third distinct form of naturalized epistemology simply insists that the method of the natural sciences is the only reliable method for acquiring a public understanding of the nature of the observed regularities and properties of the physical world. On this view, natural science, and all that it implies, is the most epistemically privileged activity for *publicly* understanding the nature of the physical world. Adopting this last form of naturalized epistemology is, however, quite consistent with rejecting both of the above forms of naturalized epistemology. This third form is quite compatible with traditional epistemology because it does not seek to *replace* traditional epistemology; nor does it seek to *transform* traditional epistemology by turning all questions of who knows what over to psychologists and cognitive scientists.

At any rate, the most currently pervasive and challenging form of naturalized epistemology is the radically anti-traditional, anti-philosophical, thesis arguably offered originally by Quine and

recently defended by others. So, in the first part of this book we shall focus *solely* on the Quinean thesis and the distinct arguments philosophers have recently offered in defense of it. Along the way, we will discuss various objections to such a naturalized epistemology, objections proponents of the thesis have recently confronted. A number of well-defined positions and arguments emerge in this discussion and, given the general importance of this form of naturalism, I offer no apology for what may appear to be an unnecessary preoccupation with other philosopher's stated views, or for my willingness to probe some of them at length when their views seem either praiseworthy or questionable. The modest conclusion of this first part is that there is currently available no sound argument sustaining this first form of naturalized epistemology, which Hilary Kornblith has dubbed "the Replacement Thesis."

More interestingly, however, the essential argument in this first part concludes separately, in bold relief, that *any* argument that could be proposed for the replacement thesis will be unsound and that therefore there can be no rational justification for anybody ever accepting the replacement thesis as construed above. I offer this latter argument as a decisive refutation of the replacement thesis and hence of scientism in general. By implication, it will also follow that there must in fact be correct answers and explanations about the world that are not the product of the methods of the natural sciences.

The second part of this book examines the Transformational Thesis, a second and allegedly distinct form of naturalized epistemology offered by Alvin Goldman and others. This examination involves a pointed discussion of the merits of reliabilism, both as a theory of epistemic justification and as a theory of knowledge, because the transformational thesis requires the viability of reliabilism either as a theory of justification or as theory of knowledge. Goldman's construal of the transformational thesis, for example, rests squarely upon what is essential to any reliabilist theory of justification, whereas Dretske's endorsement of the same thesis roots in a reliabilist theory of knowledge, as opposed to a reliabilist theory of justification. The point of this second part is to

show that reliabilist and causal theories of epistemic justification and knowledge, as they are usually understood, are unsound, and that therefore this second form of naturalized epistemology, the transformational thesis, as construed above, is unworthy of rational acceptance. If both the replacement thesis and the transformational thesis are false, as I argue, then contemporary philosophical naturalism is bankrupt. It is only from a profound appreciation of the bankruptcy of such forms of naturalism that we may proceed to offer and examine a form of philosophical naturalism that seems promising.

The third and final part of this book focuses on and adopts the third form of naturalized epistemology, characterized above. Because this form avoids the pitfalls of both the replacement thesis and the transformational thesis, I call it "Harmless Naturalism" and construe it, along with philosophers such as Peirce, James, Nagel, and others as a liberal empiricism unlike the classical empiricism of a David Hume. This part also argues that while the methods of the natural sciences are indeed privileged as the only way of coming to a *public* knowledge and understanding of physical objects and the laws governing them, there is *private* knowledge of the physical world, that is, knowledge based on evidence that is transitory or accessible only to the subject. In short, this last part ends up proposing the third form of naturalized epistemology to the extent that it makes a claim about the proper method for acquiring any *public* knowledge. But it also asserts, in passing, that there certainly is a type of knowledge which is private and cannot be vindicated or validated by the method or methods of the natural sciences. In the end, the interesting point to make about private knowledge is that it is private, and what that means is that some people know something that others do not know and cannot know simply by any appeal to the methods of the natural sciences. Or so I will argue.

Most importantly, however, the concluding section of this book also examines the implications of the failure of naturalism as expressed in both the replacement thesis and the transformational thesis. One basic implication is that there are indeed some answerable (and answered) questions about the world that are not

answerable (nor answered) by appeal to the methods of the natural sciences. Answering, or having answered, any one of those questions is a matter of providing an explanation which is not a scientific explanation. And the question here is what such explanations look like logically, and where we have any clear instances of such explanations. I call the latter class of explanations "philosophical" and point to clear instances of noncontroversially sound philosophical answers which are explanations that are empirically refutable without being scientific explanations. In short, something needs to be said, in fear and trembling, of course, about the distinction between science and philosophy; and if philosophy is to provide any knowledge of the world it must in some sense be constrained by the empirically ascertainable nature of the world without thereby being assimilated to the methods of the natural sciences. This constraint suggests a firm distinction between two kinds of empirically testable claims, those distinctive of natural science and those distinctive of philosophy. When properly characterized, the distinction permits a clear delineation between scientific and philosophical explanations, within a general commitment to a liberal empiricism.

In sum, after examining and rejecting the two dominant forms of philosophical naturalism, I shall offer and defend the essentials of a third form of philosophical naturalism, a form that is distinctive because it clearly distinguishes between explanatory success in philosophy and explanatory success in science without making the former an instance of the latter. In such a naturalism, moreover, while philosophical explanations are not scientific explanations, they are nonetheless empirically falsifiable in a way that scientific explanations are not. Philosophy is not science, but philosophical claims are empirically testable and hence confirmable or falsifiable in a way that demarcates them from scientific claims. Harmless Naturalism not only makes a claim about the ways we achieve a public and reliable knowledge of the physical world, but it also rejects an *apriorism* in philosophy while simultaneously advancing a global empiricism that subsumes both philosophy and science.

1

The Replacement Thesis

1.1 Quine's Argument

In "Epistemology Naturalized," Quine begins his defense of naturalized epistemology by asserting that traditional epistemology is concerned with the foundations of science, broadly conceived. As such, it is supposed to show how the foundations of knowledge, whether it be the foundations of mathematics or natural science, reduce to certainty. In short, showing how certainty obtains is the core of traditional epistemology, and this implies that the primary purpose of traditional epistemology is to refute the Cartesian skeptic whose philosophical doubts over whether we can attain certainty has set the program for traditional epistemology.[1]

But, for Quine, traditional epistemology has failed to refute the skeptic, and will never succeed in refuting the skeptic. Mathematics reduces only to set theory and not to logic; and even though this reduction enhances clarity it does nothing by way of establishing certainty because the axioms of set theory have less to recommend them by way of certainty than do most of the mathematical theorems we would derive from them. As he says:

> Reduction in the foundations of mathematics remains mathematically and philosophically fascinating, but it does not do what the epistemologist would like of it: it does not reveal the ground of mathematical knowledge, it does not show how mathematical certainty is possible.[2]

11

Moreover, mathematics aside, the attempt to reduce natural knowledge to a foundation in the certainty of statements of sense experience has also failed miserably. Common sense about sensory impressions provides no certainty. And, when it comes to justifying our knowledge about truths of nature, Hume taught us that general statements and singular statements about the future do not admit of justification by way of allowing us to ascribe certainty to our beliefs associated with such statements. For Quine, the problem of induction is still with us; "The Humean predicament is the human predicament" (72). As Quine sees it, Hume showed us quite clearly that any attempt to refute the skeptic by uncovering some foundation of certainty associated with sense statements, whether about sense impressions or physical objects, is doomed equally to failure (72).

This last consideration is crucial. Indeed, as soon as we accept Quine's rejection of the analytic-synthetic distinction and assert the existence of only synthetic propositions, Hume's argument casts a long despairing shadow over our ever being able to answer the skeptic because synthetic propositions could never be certain anyway. The conclusion Quine draws from all this is that traditional epistemology is dead. There is no "first philosophy." There are no strictly philosophical, or extra-scientific truths validating the methods of the natural sciences. Nor can we validate in any non-circular way the methods of the natural sciences by appeal to psychology or the methods of the natural sciences. As he says, "If the epistemologist's goal is validation of the grounds of empirical science, he defeats his purpose by using psychology or other empirical science in the validation" (75–76). We may well have justified beliefs based upon induction, but we cannot have any non-circular justified belief that we can have justified beliefs based upon induction. Accordingly, if epistemology is to have any content whatever, it will seek to explain, via the methods of natural science, the origin and growth of beliefs we take to be human knowledge and natural science. Construed in this way, epistemology continues as a branch of natural science wherein the only epistemically legitimate questions are questions answerable in science by

scientists using the methods of natural science. This reconstrual of the nature of epistemology consigns the enterprise to a psychology whose main function is basically to *describe* the origin of our beliefs and the conditions under which we take them to be justified. For this reason, Quine has sometimes been criticized (incorrectly I believe) for failing to preserve the "normative" nature of epistemology when advancing the cause of naturalized epistemology.[3] At any rate, on Quine's view, all questions and all doubts are scientific and can only be answered or resolved in science by the methods of natural science. Philosophical discussions on the nature and limits of scientific knowledge, questions that do not lend themselves to resolution via the methods of natural science are simply a part of traditional philosophy that cannot succeed. What can we say about all this?

1.2 The Charge of Internal Inconsistency

In "The Significance of Naturalized Epistemology," Barry Stroud criticizes Quine's defense of naturalized epistemology.[4] After a brief description of Quine's position, Stroud argues that Quine is inconsistent for arguing *both* that there is no appeal to scientific knowledge that could non-circularly establish the legitimacy of scientific knowledge in the presence of the traditional epistemological skeptic, and in *Roots of Reference* that we should take seriously the project of validating our knowledge of the external world.[5] For Stroud, it was in *Roots of Reference* that Quine came to believe in the coherent use of the resources of natural science to validate the deliverances of natural science. But that would be to countenance the basic question of traditional epistemology when in fact the thrust of Quine's thesis on naturalized epistemology is that such a question forms part of "first philosophy" which is impossible. Apart from such an inconsistency, Stroud also argues that Quine's attempt to validate scientific inference fails (81). Stroud's thesis here is that Quine attempts to offer a naturalized defense of

science in "The Nature of Natural Knowledge,"[6] but the effort fails because, on Quine's reasoning, we can see how others acquire their beliefs but we are denied thereby any evidence of whether such beliefs are correct beliefs about the world. By implication, we have no reason for thinking our own beliefs are any better off (81). In commenting on Quine's defense, Stroud says:

> Therefore, if we follow Quine's instructions and try to see our own position as "just like" the position we can find another "positing" or "projecting" subject to be in, we will have to view ourselves as we view another subject when we can know nothing more than what is happening at his sensory surfaces and what he believes or is disposed to assert. (81)

His point here is that when we examine how another's beliefs originate, we have no way to look beyond his positing to determine whether his beliefs are true or correct. In that position we never can understand how the subject's knowledge or even true belief is possible. Therefore, we never can understand how our own true beliefs are possible either. Stroud says:

> The possibility that our own view of the world is a *mere* projection is what had to be shown not to obtain in order to explain how our knowledge is possible. Unless that challenge has been met, or rejected, we will never understand how our knowledge is possible at all. (83)
>
> . . . if Quine's naturalized epistemology is taken as an answer to the philosophical question of our knowledge of the external world, then I think that for the reasons I have given, no satisfactory explanation is either forthcoming or possible. (83)

He goes on to conclude that if naturalized epistemology is *not* taken as an answer to the philosophical question of our knowledge of the external world, and if the question is a legitimate question (and Quine has not shown that it is not), then naturalized epistemology cannot answer the question. He says:

> I conclude that even if Quine is right in saying that skeptical doubts are scientific doubts, the scientific source of these doubts has no anti-skeptical force in itself. Nor does it establish the relevance and legitimacy of a scientific epistemology as an answer to the traditional epistemological question. If Quine is confident that a naturalized

> epistemology can answer the traditional question about knowledge, he must have some other reason for that confidence. He believes that skeptical doubts are scientific doubts and he believes that in resolving those doubts we may make free use of all the scientific knowledge we possess. But if, as he allows, it is possible for the skeptic to argue by *reductio* that science is not known, then it cannot be that the second of those beliefs (that a naturalized epistemology is all we need) follows from the first.
>
> Until the traditional philosophical question has been exposed as in some way illegitimate or incoherent, there will always appear to be an intelligible question about human knowledge in general which, as I have argued, a naturalized epistemology cannot answer. And Quine himself seems committed at least to the coherence of that traditional question by his very conception of knowledge. (85–86)

Stroud's closing remark is that the traditional question has not been demonstrated as illegitimate, and Quine's attempt to resolve skeptical doubts as scientific doubts within science has failed. Moreover, for Stroud, apart from the question of whether Quine has succeeded, his effort is predicated on the legitimacy of the traditional question of whether science provides us with knowledge of the external world.

In defense of Quine's position, however, some naturalized epistemologists will probably disagree with Stroud's analysis. They will urge that Quine's attempt to validate scientific knowledge is misunderstood and thus illegitimately undermined when construed as part of an attempt to establish first philosophy as a way of validating non-scientifically the claims of natural science. Better by far, they will say, that we read Quine as asserting that there is simply no way outside of science to validate the deliverances of science as more or less warranted. In short, even if Stroud's critique is sound, it only shows that Quine cannot hold to both positions. Quine is at liberty to concede the inconsistency and then simply argue that there is no way, given his main argument, to validate outside of science the validity of science as a source of knowledge of the external world. It is not that Quine begs the question on traditional epistemology; rather, he has shown by his main argument that the traditional enterprise cannot work. Or so it can be said. Besides, in

his reply to Stroud, Quine explicitly gives up the project of seeking to validate extra-scientifically scientific knowledge because such a project would entail a commitment to either first philosophy or vicious circularity. He says:

> What then does our overall scientific theory really claim regarding the world? Only that it is somehow structured as to assure the sequences of stimulation that our theory gives us to expect. . . . In what way then do I see the Humean predicament as persisting? Only in the fallibility of prediction: the fallibility of induction and the hypothetico-deductive method in predicting experience.
>
> I have depicted a barren scene. The furniture of our world, the people and sticks and stones along with the electrons and molecules, have dwindled to manners of speaking. And other purported objects would serve as well, and may as well be said already to be doing so. So it would seem. Yet people, sticks, stones, electrons and molecules are real indeed, on my view, and it is these and no dim proxies that science is all about. Now, how is such robust realism to be reconciled with what we have just been through? *The answer is naturalism: the recognition that it is within science itself, and not in some prior philosophy, that reality is properly to be identified and described.*[7]

1.3 The Sosa Reply

In reflecting on Quine's reply to Stroud, Ernest Sosa has been quick to note the incoherence involved in accepting science as the "reality-claims court coupled with denial that it is anything but a free and arbitrary creation."[8] By this, presumably, Sosa means that Quine has asserted without benefit of scientific proof, that traditional questions about the validity of science, questions whose answers lay outside science itself, are illegitimate. Continuing his criticism of Quine, Sosa goes on to say:

> The incoherence is not removed, moreover, if one now adds:
> (Q1) What then does our overall scientific theory really claim regarding the world? Only that it is somehow so structured as to assure the sequence of stimulation that our theory gives us to expect.
> (Q2) Yet people, sticks, stones, electrons and molecules are real indeed.

(Q3) [It] . . . is within science itself and not in some prior philosophy,
 that reality is properly to be identified and described.

If it is within science that we settle, to the extent possible for us, the
contours of reality; and if science really claims regarding the world only
that it is so structured as to assure certain sequences of stimulation;
then how can we possibly think reality to assume the contours of
people, sticks, stones and so on?

We cannot have it all three ways: (Q1), (Q2), and (Q3) form an
incoherent triad. If we trust science as the measure of reality, and if we
think there really are sticks and stones, then we can't have science
accept only a world "somehow so structured as to assure" certain
sequences of stimulations or the like. Our science must also claim that
there really are sticks and stones.

What is more, if science really is the measure of reality it cannot
undercut itself by saying that it really isn't, that it is only convenient
"manners of speaking" to guide us reliably from stimulation to
stimulation. (69)

As an internal critique of Quine's views and of their mutual con-
sistency with each other, Sosa's criticism seems quite pointed. But
here again, it is not difficult to imagine somebody arguing in
response to Sosa that Quine may be wrong in thinking and assert-
ing that realism is true, but his main argument for the claim that
there is no first philosophy is not undermined by the fact that he
may have contradicted himself in subsequently asserting a proposi-
tion inconsistent with that view. It would be easy enough for Quine
to say, after all, that there is no way to validate the established
claims of science in the interest of bolstering realism. It would not
follow thereby that either realism or some form of idealism is true.
What would follow is that we have no traditional way to answer the
question for which realism or idealism are proposed answers. So,
the kind of internal inconsistency noted by Stroud and Sosa can be
resolved in favor of the replacement thesis by simply holding on to
the implications of the main argument and letting go of anything
that would be inconsistent with the main argument.

However, even if the critiques offered by both Stroud and Sosa
should turn out to be either a misconstrual of Quine's position, or
criticisms that do not undermine the main argument taken in

isolation, there are other strong objections we shall raise not only to Quine's main argument for the replacement thesis, but also to any argument for the replacement thesis in general. Before offering those objections in the penultimate section of this first part, however, we should first discuss the other available arguments favoring the replacement thesis. When finished examining these other arguments, we will conclude with a general critique of the replacement thesis.

1.4 The Argument from "The Scandal of Philosophy"

A general and pervasive argument urges the death of philosophy (or the replacement thesis) on the basis of the scandal of philosophy. Indeed, so the argument goes, as a community, philosophers have not agreed upon anything, and for that reason there is good reason to suppose that they will in the future continue to disagree as strenuously on everything as they have in the past. In every respect traditional epistemology has failed to provide any firm and generally agreed upon answers to even the most basic of questions. In such a universe, where no answers are agreed upon, it is only natural to conclude that there is no real point to continuing such a tradition. Why take seriously any questions that do not admit of even minimal resolution under a method that fails to produce anything but sad illusions and contentious bickering? At least natural science provides some measure of agreement and thereby a sense of cognitive achievement under a methodology whose results are generally accepted as informing rational belief about the world.

In the light of the same sort of general argument, philosophers such as Descartes, Husserl, Wittgenstein, Heidegger, and Austin have all sought to overcome the scandal by offering methodological repairs of the activity of philosophizing, and each has failed to achieve anything by way of dissolving or overcoming the scandal of philosophy. Indeed, some have even argued that there is no way of

overcoming this scandal, and that this in itself is sufficient for abandoning traditional philosophy as in any way worthy of rational pursuit.[9] Is there any validity to this common argument? As plausible as it may seem, this argument fails for two reasons.

First, it overlooks the facts that philosophers continue to agree on certain basic philosophical issues and that, however uninspiring the results after all the toil, there has been some progress. For example, it is fair to say that most philosophers have examined closely the question of other-mind solipsism and have found the arguments favoring it incoherent. No non-skeptical philosopher I know honestly admits that Hume's argument favoring other-mind solipsism is worthy of rational acceptance. The same can be said of an argument often ascribed to Aristotle to the effect that because non-human animals do not understand the means-end relationship necessary for making tools and instruments, they do not think, and hence do not have the distinctively higher rational souls that humans have because humans make tools, and therefore think.[10] After Jane Goodall's films showing gorillas and chimps fashioning and using tools, who could honestly defend the Aristotelian argument about the basic difference between humans and non-human animals for the reasons he offered? Aristotle's argument certainly seems to imply that the use of tools would be sufficient to establish the kind of thinking proper to rational intelligence, and because he could not find such tool use in the non-human animal kingdom, he concluded that humans were superior in kind to non-human animals. Similarly, has any recent philosopher ever thought that Descartes's formulation of the Ontological Argument is a sound argument? Does anybody think it obviously true that it is better to exist than not to exist? Does anybody think that Christine Ladd Franklin's response to Bertrand Russell's argument (namely that she was so convinced by it that she too was a solipsist) was not a conclusive refutation of any argument to the effect that "I am the only person in the world?"[11] Does anybody think that in the interest of defending a claim it is perfectly legitimate to simultaneously assert and deny a premise in the interest of making the claim? Why are not these items, and others one might care to list, instances of

real progress in philosophy? So, there is good reason to think that while philosophers earn a living disagreeing with each other, they often agree as a community on certain philosophical views. It is difficult to see how this can be denied.

Secondly, in the nature of the case, to reject philosophical questions for the reason that they do not promote the same kind of agreement we find in natural science is problematic for two reasons. First, the rejection is simply question-begging in favor of a concept of success appropriate to the methods of natural science. Accordingly, the rejection is gratuitous when motivated by the reason that philosophy does not achieve standards of agreement so obvious in science. Secondly, what's so special about scientific agreement? Does the kind of agreement achieved in science indicate irreversibly established belief? Have not our most cherished of scientific beliefs sometimes gone the way of phlogiston, the caloric theory of heat, the geocentric theory, and absolute space and time? Is there not a good argument that, inductively speaking, any well agreed-upon theory may go the way of phlogiston? So what is the special advantage of setting aside philosophy for failing to achieve the special consensus so often present in natural science?

1.5 The "Philosophy Is Science" Argument

Among recent arguments for the Quine thesis, the argument offered by William Lycan in *Judgement and Justification* is quite different from Quine's.[12] Unlike the Quinean argument, it does not rest on the alleged failure of the analytic-synthetic distinction and upon the subsequent classification of all propositions as synthetic. Nor does it feed upon Quine's Humean argument that synthetic propositions cannot be justified from the viewpoint of a first philosophy and so, if epistemology is to continue, it can only be in terms of the deliverances of a descriptive psychology. The argument is novel and warrants close scrutiny.

Before actually offering the argument, Lycan characterizes

classical philosophy in terms of the deductivist model which captures what he means by "deductivism"; and under this model philosophy gets characterized in a certain way:

> Philosophers arrive at conclusions that are guaranteed to be as indisputably true as the original premises once the ingenious deductive arguments have been hit upon. This attitude has pervaded the rationalist tradition and survives among those who are commonly called "analytic philosophers" in a correctly narrow sense of that expression. Of course the quality of self-evidence that the deductivist premises are supposed to have and to transmit to his conclusion has been variously described (as for example, analyticity, a prioricity, clarity and distinctness, mere obviousness, or just the property of having been agreed upon by all concerned). . . .
>
> In any case, the deductivist holds that philosophy and science differ in that deductive argument from self-evident premises pervades the former but not the latter. (Some deductivists have held a particularly strong version of this view, identifying the philosophy/science distinction with the *a priori*/empirical distinction.) Now Quine (1960, 1963, 1970) has a rather special reason for rejecting the dichotomy between philosophy and science, or, to put the point more accurately, between philosophical method and scientific method. He rejects the analytic-synthetic distinction, and thus the proposal that there are two kinds of truths ("conceptual" or "*a priori*," and "empirical" or scientific), one of which is the province of philosophy and the other the province of science. . . . (116–17)

In fact, Lycan sides with Smart and Quine against the deductivist, but for what he believes is a more fundamental and persuasive reason, one that does not depend on the rejection of the analytic-synthetic distinction. Naturally, if Lycan's argument is sound, then one can countenance that distinction and still be forced to adopt the Smart-Quine methodological view. More specifically, his argument is the following.

> Suppose we try to take a strict deductivist stance. Now, as is common knowledge, one cannot be committed (by an argument) to the conclusion of that argument unless one accepts the premises. Upon being presented with a valid argument, I always have the option of denying its conclusion, so long as I am prepared to accept the denial of at least one of the premises.

Thus, every deductive argument can be set up as an inconsistent set. (Let us, for simplicity, consider only arguments whose premises are internally consistent.) Given an argument

P1. P
P2. __Q__
 / ∴ R

the cognitive cash value of which is that R follows deductively from the set of P and Q, we can exhaustively convey its content simply by asserting that the set (P, Q, not-R) is inconsistent, and all the original argument has told us, in fact, is that for purely logical reasons we must deny either P, Q, or not-R. The proponent of the original argument, of course, holds that P and Q are true; therefore, she says, we are committed to the denial of not-R, that is, to R. But—how does she know that P and Q are true? Perhaps she has constructed deductive arguments with P and Q as conclusions. But, if we are to avoid regress, we must admit that she relies ultimately on putative knowledge gained nondeductively; so let us suppose that she has provided nondeductive arguments for P and Q. On what grounds then does she accept them? The only answer that can be given is that she finds each of P and Q more plausible than not-R, just as Moore found the statement "I had breakfast before I had lunch" more plausible than any of the metaphysical premises on which rested the fashionable arguments against the reality of time.

But these are just the sorts of considerations to which the theoretical scientist appeals. If what I have said here is (more or less) right, then we appear to have vindicated some version of the view that (1) philosophy, except for that relatively trivial part of it that consists in making sure that controversial arguments are formally valid, is just very high level science and that consequently (2) the proper philosophical method for acquiring interesting new knowledge cannot differ from proper scientific method. (117–18)

In defending this general argument, Lycan then responds to two basic objections which he offers against his own thesis. The first objection is that even if all philosophical arguments rest on plausibility arguments, the above argument has not established what is necessary, namely, that considerations that make for plausibility in science are the same considerations that make for plausibility in philosophy. The second objection is that even if we were to establish as much, it would not thereby obviously follow

that philosophy is just very high-level science. Philosophy and science might have the same method but differ by way of subject matter (116–18). The core of Lycan's defense of his general argument consists in responding to the first objection. So, let us see whether the response overcomes the objection.

In response to the first objection, Lycan constructs the following argument:

P1. The interesting principles of rational acceptance are not the deductive ones (even in philosophy).

P2. There are, roughly speaking, three kinds of ampliative, non-deductive principles of inference: principles of self-evidence (gnostic access, incorrigibility, a priority, clarity and distinctness, etc.), principles of what might be called "textbook induction" (enumerative induction, eliminative induction, statistical syllogism, Mill's Methods, etc.), and principles of sophisticated ampliative inference (such as PS principles and the other considerations of theoretical elegance and power mentioned earlier, which are usually construed as filling out the "best" in "inference to the best explanation").

P3. Principles of textbook induction are not the interesting principles of rational acceptance in philosophy.

P4. Principles of "self-evidence," though popular throughout the history of philosophy and hence considered interesting principles of rational acceptance, cannot be used to settle philosophical disputes.

Therefore: If there are any interesting and decisive principles of rational acceptance in philosophy, they are the elegance principles. (119)

Lycan adds that the elegance principles are to be extracted mainly from the history of science, and that we can obtain precise and useful statements of such principles only by looking to the history of science, philosophy, and logic in order to see exactly what considerations motivate the replacement of an old theory by a new theory (119–20). Generally they are understood in terms of such principles as Parsimony, Simplicity, Explanatory Fit, Coherence, and Deductive Fertility (or fecundity). So, the answer to the question "Why does it follow that the considerations that make for plausibility in philosophy are the same as those that make for plausibility in science?" is simply "There is nowhere else to turn"

(120). For a number of reasons, however, this response to the first objection above seems problematic.

1.6 Analysis of the Lycan Argument

To begin with, what exactly does P1 assert? It is common knowledge that one cannot be *rationally justified* in *accepting* the conclusion of a deductive argument unless the argument is valid and consistent in addition to the premises being true. So, we cannot construe P1 to assert that validity and consistency are redundant or eliminable as conditions necessary for the rational acceptability of an argument. Lycan certainly does not mean to argue that point. Rather P1 asserts that even though validity and consistency are necessary conditions for the soundness of a deductive argument, validity and consistency provide no grounds for thinking that the conclusion deduced is plausible, plausibility being a feature of an argument deriving solely from the relative truth content of the premises, which content is not established deductively or *a priori*. In short, P1 asserts that it is not even a necessary condition for the *plausibility* of a proposed argument that it be both sound and consistent. If this is not what P1 asserts, it is difficult to see just what it asserts. The reasons offered for P1, however, seem particularly questionable and the reasons for thinking P1 false seem straightforwardly compelling. Let me explain.

Lycan claims that P1 is true because deductive rules are not controversial in their application (119). But how exactly would that establish that such rules of inference are not interesting, meaning thereby not plausibility-conferring on the conclusion? Why not say instead that *because* such rules are noncontroversially applied they are interesting, that is, plausibility conferring? In other words, what does the fact that such rules are non-controversial in their application have to do with their not being plausibility-conferring on the conclusions that follow from them? Is it meant to be obvious that a deductive rule of inference is plausibility-conferring only when its

application is controversial? Why should anyone accept such a definition of plausibility, especially because it seems to endorse saying such things as "Your argument is perfectly plausible even though it is both invalid and inconsistent." Why aren't deductive rules interesting (or plausibility-conferring) because they are more likely to guarantee truth from premises that are true? If "interest" is relative to purpose and, if one's purpose is to provide a system of inferential rules that is strongly truth-preserving, then such rules are quite interesting, even if their application is non-controversial. This in itself is sufficient to show P1 is involved in a questionable bit of semantic legislation.

Moreover, Lycan's second reason for P1 is that any deductive argument can be made valid in a perfectly trivial way by the addition of some inference-licensing premise (119). But how exactly does it follow from the fact (if it be a fact) that any deductive argument can be made trivially valid that *no* deductive principle (including consistency) is interesting in the sense of conferring plausibility in any degree on what follows from the deductive principle? Here again, is it meant to be obvious that deductive principles are plausibility-conferring only if they function in arguments incapable of being rendered valid and consistent in non-trivial ways? Does not such a claim presuppose a definition of plausibility which, by *stipulation*, asserts that the plausibility of a deductive conclusion has nothing to do with the fact that the argument is valid and consistent? And is that not precisely what needs to be shown? Indeed, if any deductive argument could be rendered valid and consistent in wholly trivial ways and the conclusion still be plausible, why insist, as we do, on validity and consistency for soundness as a necessary condition for rational acceptance? Why insist on rules that are truth-preserving for soundness if one can get it in trivial ways and it has nothing to do with the plausibility of the conclusion?

Lycan's third reason for P1 is that deductive rules are not plausibility conferring because such rules are uninteresting. For Lycan, they are uninteresting precisely because deductive inferences obviously do not accomplish the expansion of our total store of explicit and implicit knowledge, since they succeed only in

drawing out information already implicit in the premises (119). Here again, however, even if deductive inference only renders explicit what is implicitly contained in the premises that would only show that deductive inference is not inductive inference, and, unless one *assumes* that the only plausibility considerations that will count are those relevant to expanding our factual knowledge base, rather than showing that one's inferences are the product of truth-preserving rules, why would the fact that deductive inference is not inductive inference be a sufficient reason for thinking that deductive inference is uninteresting as a way of enhancing the plausibility of one's conclusions deductively inferred? The reason Lycan offers here (like the two offered above) strongly implies that the plausibility of a person's beliefs has nothing to do with whether it is internally consistent, or follows logically from well-confirmed beliefs, or is consistent with a large body of well-confirmed beliefs, or is the product of truth-preserving rules of inference; and this just flies in the face of our epistemic practices.

Lycan's last reason for P1 is that any deductive argument can be turned upon its head (120). Once again, what needs proving is assumed. Even if we can turn a valid deductive argument on its head, so to speak, does that mean that there are no valid arguments? If the answer is yes, why say that valid deductive inference is uninteresting rather than impossible? But if we are not arguing that valid deductive inference is impossible, why exactly would such inference be uninteresting if it is truth-preserving, and would guarantee consistency, coherence with well-confirmed beliefs, and the explicit addition of true verifiable sentences not formerly in the corpus of our beliefs? If such considerations do not count as plausibility-conferring, it could only be because "plausibility" is stipulatively defined to rule out such considerations as plausibility-conferring. Such a definition needs defending rather than pleading.

By way of general observation with regard to P1, it seems clear that plausibility considerations often rest quite squarely on questions of consistency and derivability. One of the traditional tests for theory confirmation (and hence by implication for plausibility) is derivability from above. For example, the fact that

Balmer's formula for the emission spectra for gases derives logically from Bohr's theory on the hydrogen atom, counts strongly in favor of Balmer's formula above and beyond the evidence Balmer gave for his formula.[13] What is that to say except that considerations purely deductive in nature function to render theories more or less plausible? What about the rest of Lycan's argument against the first objection to his general argument?

Well, suppose, for the sake of discussion that P2 and P3 are true. Will P4 be true? In other words, will it be true that principles of self-evidence do not count for plausibility unless they can be used to settle some philosophical disputes. Here the argument seems to be suggesting that a commonsense principle will be plausibility-conferring only if it can be used to "settle" (in the sense of everybody agreeing henceforth to the answer) some philosophical dispute. But such a requirement seems arbitrarily too strong. Obviously, a conclusion can be plausible and worthy of rational acceptance even when others will disagree to some degree. Two mutually exclusive conclusions may both be rationally plausible without the principle that renders them plausible "settling" the dispute once and for all. Moreover, are we sure that appeals to commonsense principles have failed to resolve or settle philosophical disputes? In a very strong sense of "settle," of course, nothing is settled in philosophy. But that would be to impose an arbitrarily strong sense of "settle" on philosophy, a sense we certainly would not impose on science. In a suitably weak sense, "appeals to obviousness or self-evidence" often, but not always, settle disputes. Indeed, isn't the basic reason that the question of other-mind solipsism consistently fails to capture anybody's sustained attention that it is so implausible by way of appeal to common sense? Who these days really takes the possibility of other-mind solipsism seriously? Isn't that a philosophical problem pretty much settled by appeal to common sense or self-evidence? Of course, not all appeals to common sense are so successful, and some are more successful than others as clean "conversation stoppers."

These reasons show that Lycan's reply to the first objection fails. Further, it would have been surprising if the reply had succeeded

because it seems clear that in science, but not in philosophy, a necessary condition for any explanation being even remotely plausible is that it be in principle explicitly empirically testable. As we shall see later in Chapter 3, there are certainly different views about what empirical testability consists in and, admittedly, some views are more naive than others. But, as an empirical matter, if we consult practicing scientists (and not philosophers), then we will find the truism that unless one's scientific explanations are ultimately explicitly empirically testable in some way—that is, unless we know what specific observational evidence, under what general and specific conditions, would need to occur in order to falsify or confirm the hypothesis or explanation—we say, for good reason, that the explanation is not scientific. Most practicing scientists have no trouble in saying that such a proffered explanation is scientifically meaningless because it is not empirically testable in any explicitly specifiable way. Minimally, then, in science a hypothesis or a theory will be plausible only if it is in some way explicitly empirically testable, and it will be testable only if what the hypothesis virtually predicts, by itself or in conjunction with other background theories, is in principle observable under clearly specifiable conditions and provisos, and would occur as expected depending on whether the hypothesis or explanation in question is true. On the other hand, if we are not to beg the question against philosophy as distinct from science, and look at philosophical theses, we will find that some philosophical theses can be more or less plausible quite independently of whether they are *explicitly* empirically testable under clearly specifiable conditions. Even in the absence of explicit testability, as we shall see in greater detail in Chapter 3 below, a philosophical view can be quite coercive and hence plausible.

As a matter of fact, consider, for example, the dispute between classical scientific realists and classical anti-realists of an instrumental sort. What empirical test might one perform to establish or refute the view that the long-term predictive success of some scientific hypotheses is a function of the truth of claims stated, implied, or assumed by the hypotheses? Surely one of these theses must be correct, and yet neither the realist nor the anti-realist

position here is explicitly testable by appeal to any known experimental or non-experimental test.[14] Does that mean that while one position must be correct *neither* is demonstrably plausible? Paradox aside, if we say yes, how is that anything more than assuming what needs to be proven, namely that considerations that count for plausibility in science are the same as those that count for plausibility in philosophy?

Surely, however, there are also other philosophical arguments that in fact do depend for their plausibility on the verification and falsification of certain factual claims. Recall an example that we will return to later in Chapter 3, namely, Aristotle's argument that humans are substantially different from (and superior to) other animals because humans use tools, and thereby show a capacity to think, whereas other animals do not use tools and therefore do not think. Aristotle's argument here is implausible because readily empirically falsified by careful observations of the sort Jane Goodall and others continually make. So, in philosophy, plausibility may sometimes root in considerations bearing on testability, even if the testability is not quite explicit at the time of the claim made, just because one of the premises in the argument asserts that some factual claim about the world is true or false. But, as we just showed in the case of the dispute between the scientific realist and the scientific anti-realist, plausibility may have very little or nothing to do with the explicit empirical testability of the hypothesis. It may simply be a matter of showing the internal inconsistency of a particular argument, or the dire epistemic consequences of adopting one position over the other, or the informal (or formal) fallacies attending the argumentation of one position over the other. In short, as practiced, philosophical reasoning often requires both deductive and inductive principles of rational acceptance for plausibility.[15] However, it certainly is not a necessary condition for philosophical plausibility that one's philosophical explanations or answers be *explicitly* testable or explainable in a way that accommodates *explicit* empirical testability as a necessary condition for significance. Moreover, it should be apparent by now that to insist that plausibility in philosophy must accommodate the above-

referenced canons of empirical testability or the canons of explana-
tion in the natural sciences is simply a blatant question-begging
move against the objection offered by Lycan against his own
(Lycan's) main argument. As such, this move would be a rationally
unmotivated stipulation against philosophy as distinct from natural
science. Later in Chapter 3 we will take up again the distinction
between scientific explanations and philosophical explanations in
a more sustained effort to distinguish and clarify philosophy and
natural science; but for now we should draw a conclusion and
promise to offer more clarification later.

In sum, Lycan's reply to the first objection to his general
argument fails unless one wants to suppose that there is nothing at
all plausible about any philosophical argument primarily because
philosophical arguments are not *straightforwardly* explicitly
empirically testable, and hence verifiable or falsifiable in the way
that scientific claims are. Besides, it seems that Quine's "Epistemol-
ogy Naturalized" is having an unrealized effect on the main
argument Lycan offers. This is because if one excludes philosophi-
cal arguments from the realm of the analytic or *a priori* (as Quine
does), it would appear that if there is anything to them at all, they
must fall into the realm of the synthetic; and hence it seems only
too natural to suppose that synthetic claims are meaningful only if
explicitly testable and confirmable (or falsifiable) in some basic
way by the method of the natural sciences. But the very argument
offered from this view supposes, once again, what needs defending,
namely, that philosophical plausibility depends on plausibility
considerations that are appropriate only to the methods of the
natural sciences. When we look to the actual practice of philosophy,
that assumption seems quite false, or the argument Lycan offers
begs the question against the distinctness of philosophy. We will
return to this difficult topic in an attempt to be explicit on what the
differences are between explanations in natural science and
explanations in philosophy when both fall into the domain of the
synthetic *a posteriori*. There I will urge that both must be empiri-
cally testable but in ways that are sufficiently different to warrant

a real distinction between philosophy and science. In the mean-time, let's turn to another recent argument for the Quine thesis.

1.7 The Disappearance Argument on Traditional Epistemology

In his recent book *Explaining Science: A Cognitive Approach*, Ron Giere argues that the justification for the naturalizing of philosophy will not come from explicitly refuting the old paradigm of tradi-tional epistemology, by explicitly refuting on a philosophical basis the philosophical arguments favoring the traditional posture. Rather the argument for naturalizing epistemology will simply be a function of the empirical success of those practitioners in showing how to answer certain questions and, at the same time, showing the irrelevance of the questions asked under the old paradigm.[16] Comparing the naturalized epistemologist with the proponents of seventeenth century physics, he says:

> Proponents of the new physics of the seventeenth century won out not because they explicitly refuted the arguments of the scholastics but because the empirical success of their science rendered the scholastic's arguments irrelevant. (9)

This same sort of argument has been offered by philosophers such as Patricia Churchland and Paul Churchland, who have claimed that traditional epistemology or "first philosophy" will disappear as a consequence of the inevitable elimination of folk psychology in favor of some future successful neuroscientific account of cognitive functioning.[17]

1.8 Critique of the Disappearance Argument

While there are various reasons for thinking that the eliminative materialism implied by the above argument cannot occur,[18] what

seems most obvious is that the assertion made by Giere and the Churchlands is simply not an *argument* for naturalized epistemology. Rather, it is a buoyantly optimistic prediction that, purely and simply because of the expected empirical success of the new model, we will naturally come to regard traditional epistemology (normative epistemology) as having led us nowhere. In short, we will come to view the questions of traditional epistemology as sterile and no longer worth asking. In spite of the optimism of this prediction, it is difficult to see what successes to date justify such a prediction. What central traditional epistemological problems or questions have been rendered trivial or meaningless by the advances in natural science or neuroscience? Unless one proves that a basic question in traditional epistemology is "How does the Brain Work?" the noncontroversial advances made in neuroscience will be quite irrelevant to answering the questions of traditional epistemology. While some people seem to have *assumed* as much,[19] it is by no means clear that knowing how one's beliefs originate is in any way relevant to a determination of their being justified or otherwise worthy of acceptance.[20] Without being able to point to such successes, the eliminative thesis amounts to an unjustified assertion that traditional philosophy is something of an unwholesome disease for which the doing of natural science or neuroscience is the sure cure. In the absence of such demonstrated success, however, no traditional epistemologist need feel compelled by the prediction to adopt the posture of naturalized epistemology. It is, as Susan Haack has noted, no more than a bit of ambitious bandwagonism.[21]

As a program committed to understanding the mechanisms of belief-acquisition, naturalized epistemology may very well come to show that our traditional ways of understanding the origin of human knowledge is in important respects flawed and, as a result, we may indeed need to recast dramatically our understanding of the nature of human knowledge. It would be silly to think that this could not happen. Aristotle's conception of human rationality, for example, and the way in which it was allegedly distinct from animal rationality, was shown to be quite wrong when we all saw Jane

Goodall's films depicting chimps and gorillas making and using tools. Thereafter, Aristotle's *philosophical* argument that humans think, whereas animals do not, because the former but not the latter use tools, disappeared from the philosophical landscape. So, it is quite possible that there are certain empirical assumptions about the nature of human knowledge that may well be strongly and empirically falsified in much the same way that Aristotle's position was falsified. But even that sort of progress is still quite consistent with construing epistemology in non-naturalized ways. Traditional epistemology should have no difficulty with accepting the view that some philosophical theses can be conclusively refuted by the occurrence of certain facts. That would be simply to acknowledge that philosophy, and philosophical arguments, are not purely *a priori* and hence immune from rejection by appeal to the way the world is. So, the traditional epistemologist will need to wait and see just what naturalized epistemology comes up with. Whether it lives up to the expectations of Giere and others who, like the Churchlands, offer the same basic argument is still an open question, at best. As things presently stand, there are good reasons, as we shall see, for thinking that no amount of naturalized epistemology will ever be able in principle to answer the crucial questions about the nature of epistemic justification.

Otherwise Giere's defense of naturalized epistemology consists in responding to others who argue against naturalized epistemology. In responding to these objections, Giere seeks to show that there is certainly no compelling reason why one should not proceed on the new model. He cites and considers the following three arguments.

A. Putnam's Objection

According to Giere, in "Why Reasons Can't be Naturalized," Putnam argues that:

> A cognitive theory of science would require a definition of rationality of the form: A belief is rational if and only if it is acquired by employing some specified cognitive capacities. But any such formula is either obviously mistaken or vacuous, depending on how one restricts the

range of beliefs to which the definition applies. If the definition is meant to cover *all* beliefs, then it is obviously mistaken because people do sometimes acquire irrational beliefs using the same cognitive capacities as everyone else. But restricting the definition to rational beliefs renders the definition vacuous. And so the program of constructing a naturalistic philosophy of science goes nowhere. (Putnam 1982, 5)[22]

In response to this particular argument, Giere says:

The obvious reply is that a naturalistic theory of science need not require any such definition. It is clear that Putnam is assuming a categorical conception of rationality. A naturalist in epistemology, however, is free to deny that such a conception can be given any coherent content. For such a naturalist, there is only hypothetical rationality which many naturalists, including me, would prefer to describe simply as "effective goal-directed action," thereby dropping the word "rationality" altogether. (9)

In short, for Giere, Putnam is just begging the question by insisting that there must be a coherent concept of categorical rationality. In defense of Putnam's intuition, however, one can argue that Giere missed Putnam's point. Putnam's point is just as easily construed as asserting that if the naturalized epistemologist is not to abandon altogether the concept of rationality (and thereby abandon any way of sorting justifiable or warranted beliefs from those that are not) the rationality of a belief will be purely and simply a function of the reliability of the mechanisms that cause the beliefs. But because a belief can be produced by a reliable belief-making mechanism and be rationally unjustified, such a definition will not work. Putnam's objection, when construed in this way, is compelling.

Unfortunately, Giere's response seems to miss the point Putnam makes. Presumably, Putnam would respond that even if we were to stop talking about rationality, we would still need some way of determining which beliefs are more or less justified; and the naturalized epistemologist would need to define such concepts in terms of the mechanisms that produce certain beliefs. And Putnam's point is that that clearly will not work because unjustified beliefs can emerge just as easily from reliable mechanisms.

B. Siegel's Objection

Giere also responds to an alleged objection to the replacement thesis offered by Harvey Siegel in his "What Is the Question Concerning the Rationality of Science?"[23] According to Giere, the objection in question asserts that instrumental rationality is not enough for a naturalized epistemologist; there must be a rationality of goals as well because there is no such thing as rational action in pursuit of an irrational goal. In response to this alleged objection to naturalizing epistemology, Giere notes:

> This sort of argument gains its plausibility mainly from the way philosophers use the vocabulary of "rationality." If one simply drops this vocabulary, the point vanishes. Obviously, there can be effective action in pursuit of any goal whatsoever—as illustrated by the proverbial case of the efficient Nazi. . . . Nor does the restriction to instrumental rationality prevent the study of science from yielding normative claims about how science should be pursued. Indeed, it may be argued that the naturalistic study of science provides the only legitimate basis for sound science policy. (Campbell 1985, 10)

The argument Giere ascribes to Siegel does not appear explicitly in the essay cited by Giere. At any rate, in later papers Siegel has responded to Giere's claim that instrumental rationality, or rationality construed simply in terms of effectiveness of inductive rules or means for achieving the putative goals of natural science is sufficient for the normativity of naturalized epistemology. Among his arguments, Siegel claims that Giere's basic reply just cited trades on equivocating between rationality as effectiveness and rationality as involving the support of reasons.[24] Siegel also argues that one cannot even judge that certain methods are effective for achieving certain goals without supposing that one is offering evidence and that offering evidence in this way presupposes some concept of rationality, or epistemic justification, which is not instrumental in Giere's sense rather than intrinsic or categorical, and not the product of applying the methods of the natural sciences.[25] In short, the methods of science cannot justify the

methods of science in any non-circular way and, hence, the justification of the methods of science even as efficient devices for achieving stated scientific goals must appeal to some concept of justification or rationality which precedes, rather than is generated from, scientific practice. "Rationality of means only" as specified by Giere and virtually all other advocates of the replacement thesis, presupposes standards of rationality and justification that are extra-scientific. Without them there could be no way to determine in principle whether any scientific methodology is more or less effective for achieving the ends of science. Finally, in fairness to Siegel, we may note that Giere's response to those who criticize the disappearance thesis overlooks the force of Siegel's argument to the effect that any argument for the replacement thesis will be self-defeating.[26] As we shall see in the conclusion of this chapter, it is this more persuasive argument that casts a pall over the replacement thesis, and nobody who adopts the replacement thesis has yet confronted the argument seriously.

C. The Objection from Vicious Circularity

There is another common objection to eliminating traditional epistemological questions in favor of questions about effective means to desired goals. Giere characterizes it in the following way:

> To show that some methods are effective, one must be able to show that they can result in reaching the goal. And this requires being able to say what it is like to reach the goal. But the goal in science is usually taken to be "true" or "correct" theories. And the traditional epistemological problem has always been to justify the claim that one has in fact found a correct theory. Any naturalistic theory of science that appeals only to effective means to the goal of discovering correct theories must beg this question. Thus a naturalistic philosophy of science can be supported only by a circular argument that assumes some means to the goal are in fact effective. (10)

Giere then proceeds to show that this sort of objection (which he does not cite anybody in fact offering) is based on some dubious items of Cartesian epistemology. A more direct response, however,

is that this objection is unacceptable because it assumes rather than proves that the goal of scientific theories is to achieve truth rather than empirical adequacy. In other words, a proper response would consist in straightforwardly denying that the goal of science is to discover "true" or "correct" theories rather than ones that are instrumentally reliable as predictive devices. So, for other reasons, we need not take this objection very seriously.

For these stated reasons, it is difficult to see that Giere has successfully confronted the above stated criticisms offered by Putnam, Siegel and others who have issued pointed criticisms of the replacement thesis. Moreover, we need only remember that the general claim for the disappearance thesis is not an argument at all.

Finally, in an effort to further defend the replacement thesis by appealing only to evolutionary theory and the advantages of the latter, Giere asserts that evolutionary theory provides an alternative foundation for the study of science. Of evolutionary theory, he says:

> It explains why the traditional projects of epistemology, whether in their Cartesian, Humean, or Kantian form, were misguided. And it shows why we should not fear the charge of circularity. (53)

But what exactly is it about traditional epistemology that made it misguided? That it sought to refute universal skepticism? Whoever said that was *the goal* of traditional epistemology? Was Plato seeking to refute universal skepticism or rather was he trying to show how human knowledge is possible? Was Kant trying to refute universal skepticism or rather was he trying to show how true and certain knowledge is possible? As we noted earlier when we examined Quine's argument, to define the concept of knowledge and then to determine whether, and to what extent, human knowledge exists in the various ways we define it seems equally the major goal of traditional epistemology. And why, exactly, is that a misguided activity? Such an activity seems justified by the plausible goal that if we get very clear on just what we mean by basic epistemological concepts, we might just be in a better position to determine the snake-oil artist from those whose views are worthy of adoption. This goal is based on the noncontroversial point that knowledge

just isn't a matter of accepting everything a passerby might say. At the root of most arguments for naturalized epistemology, as we shall see, is this peculiar claim to the effect that traditional epistemology somehow has failed or been misguided in its search for some cosmic skyhook. Certainly we saw as much when we examined Quine's argument. But when the arguments are laid on the table, some philosophers may come to think that what gets characterized as traditional epistemology is quite different from the real thing. Socrates, after all, began his discussion in *Theatetus* with the question "What is knowledge?" and not "Is human knowledge possible?" or "How does the mind represent reality?" or (as Patricia Churchland recently claimed) "How does the brain work?"[27] That anybody could seriously think that Socrates was really asking for an account of how the brain works is difficult to comprehend. And to say that is what he *should* have been asking (because nobody has or can answer whatever other question he might have asked) presupposes that one can show that the questions he did ask are misguided or bad questions, and that is yet to be shown in any way that does not beg the question against philosophy and traditional epistemology. We may now turn to the fifth argument in favor of the replacement thesis.

1.9 The Argument from Evolutionary Theory

Evolutionary epistemology is a form of naturalized epistemology which insists that the only valid questions about the nature of human knowledge are those that can be answered in biological science by appeal to evolutionary theory. For the evolutionary epistemologist, the Darwinian revolution underscored the point that human beings, as products of evolutionary development, are natural beings whose capacities for knowledge and belief can be understood by appeal to the basic laws of biology under evolutionary theory. As Michael Bradie has noted, evolutionary epistemologists often seem to be claiming that Darwinian or, more generally,

biological considerations are relevant in deciding in favor of a purely naturalized approach to the theory of knowledge.[28] When we examine the arguments proposed by specific evolutionary epistemologists, there seem to emerge two distinct arguments. The first argument, allegedly offered by philosophers such as Karl Popper, and reconstructed by Peter Munz is as follows:

P1. We do in fact have human knowledge.
P2. No justification is possible.
Therefore:
P3. Human knowledge does not involve justification.
Therefore:
P4. Every item of knowledge is a provisional proposal or hypothesis subject to revision.[29]

For this reason Popper held that the only problem in epistemology was the problem of the growth of human knowledge, or the biological question of how human knowledge originates and grows. Therefore, epistemology is not normative in the way that traditional epistemology is normative, although the methodology of testing conjectures and falsifying them in science is instrumentally normative for the attainment of the ends of science. As Bradie has noted, Popper's argument for P2 is based on his acceptance of Hume's critique of induction and the corollary that no empirical universal statements are provable beyond doubt (10). The second argument, inspired by Quine's reference to Darwin, is offered by Hilary Kornblith and reconstructed by Bradie as follows:

P1. Believing truths has survival value.
Therefore:
P2. Natural selection guarantees that our innate intellectual endowment gives us a predisposition for believing truths.
Therefore:
P3. Knowledge is a necessary by-product of natural selection.

In order to get the desired conclusion of a purely naturalized epistemology, Kornblith supplies the following premise:

Therefore:
P4. If nature has so constructed us that our belief-generating processes are inevitably biased in favor of true beliefs, then it must be that the

processes by which we arrive at beliefs just are those by which we
ought to arrive at them.

warranting the final conclusion:

Therefore:
P5. The processes by which we arrive at our beliefs are just those by
which we ought to arrive at them.[30]

What can we say about these two arguments?

1.10 Response to the Argument from Evolutionary Theory

With regard to the first argument, the one Peter Munz ascribes to
Popper, the first thing to note is that there is nothing particularly
biological or evolutionary about it at all. It is simply a philosophical
argument based on a philosophical acceptance of Hume's philo-
sophical skepticism to the effect that no factual claim about the
world could be justified sufficiently for knowledge. So, the argu-
ment does not provide a justification deriving from evolutionary
theory for taking the naturalistic turn. Secondly, as we suggested
when we discussed Quine's argument above, arguing for the
replacement thesis on premises that are philosophical produces an
argument that is radically incoherent and self-defeating. A philo-
sophical argument to the effect that there is no first philosophy
because Hume was correct in his defense of the problem of
induction, seems radically incoherent and self-defeating in a way
apparently not yet appreciated by proponents of the replacement
thesis. More on this later.

The second argument has already been well-criticized by
Michael Bradie who has noted (along with many others, including
Stich, Leowontin, and Wilson) that P2 is quite questionable. The
fact that certain beliefs endure and have survival value by no means
implies that they are the product of natural selection. There are
many traits that evolve culturally which have no survival value
(Bradie 16). Moreover, even if it were true that our cognitive

capacities have evolved by natural selection, the important point is that, by itself, that is no reason for thinking that we are naturally disposed to believe truths rather than falsity. On the contrary, the evidence seems pretty strong that, given the history of scientific theorizing, the species is more disposed to accept empirically adequate rather than true hypotheses.

One interesting response to this last line of reasoning comes from Nicholas Rescher who, in *Methodological Pragmatism*, has argued that, say what we will, the methods of the natural sciences have indeed been selected out by nature, otherwise they would not have endured as such reliable instruments for prediction and control. Rescher's basic point is that on any given occasion, contrary to what *thesis pragmatism* asserts, an instrumentally reliable belief or thesis may well fail to be true. But that is no reason for thinking that nature has not selected out the *methods* of the natural sciences because in the long run the methods of the natural sciences provide truth, even if they occasionally generate useful but false theses.[31] Rescher's point is well taken, but it is not an argument for the thesis that epistemology is purely descriptive. Rescher certainly is not a naturalized epistemologist in that sense. Rather it is an argument for regarding the deliverances of the methods of natural science as epistemically privileged. In offering the argument he does here, Rescher is merely showing how the usual arguments against pragmatism hold for *thesis* pragmatism and not for *methodological* pragmatism. Nor does his argument provide the evidence necessary for making sound Kornblith's reconstructed argument from evolution. This is because Kornblith's proposed argument still falters on P2. Rescher's argument by no means shows or supports the view that people by nature are innately disposed to believe only true propositions. If that were so, it would be difficult to see why we would ever need the methods of the natural sciences anyway. Nature selected out the methods of the natural sciences just *because* we are not natively disposed to believe only true propositions.

But, if the above two arguments are the best evolutionary biologists can offer in defense of the replacement thesis, it would

seem that biology itself, and especially evolutionary biology, is yet to offer a persuasive argument for the replacement thesis. Along with Bradie, we can only conclude that there does not seem to be any sound argument from evolutionary theory in favor of the first form of naturalized epistemology.[32]

1.11 The Argument from Cognitive Science

Another argument for the replacement thesis is the general argument from Cognitive Science to the effect that there are no beliefs. Obviously, if there are no beliefs then there could be no knowledge as traditionally conceived, because in traditional epistemology knowledge is a special kind of belief. If there is no subject matter for traditional epistemology, then any interesting questions about the nature of human knowledge, assuming such questions are not incoherent or vacuous, would need to be answered in natural science by the methods of natural science. Or so the general argument asserts. This general argument has been advanced by a number of people in the process of what has become a concerted attack on folk psychology involving no less than three separate arguments for the falsity of folk psychology. Folk psychology has traditionally held that we can explain human behavior only in terms of a person's beliefs, desires and intentions. Presumably, if there are no beliefs, then not only will folk psychology disappear in the presence of a completed scientific psychology, but with it will go traditional epistemology and any Archimedean vantage point from which to assess the overall validity of scientific claims as beliefs more or less justified. What, then, are these three arguments for the claim that there are no beliefs?

A. The Argument for the Falsity of Folk Psychology

Some cognitive scientists admit that there are beliefs, but they construe beliefs as the neuro-physiological analogues of "belief-

that" sentences in the way traditional contingent identity theorists assert. This, of course, is simply an indirect way of denying the existence of "belief" as traditionally construed in folk psychology. Other cognitive scientists simply assert that there are no beliefs; there are only brain states that admit of content-free neurobiological description. On this latter view, there are no such things as beliefs, desires or intentions that could serve as causes for human behavior if by "cause" we mean something other than a brain state admitting of description in the language of neuro-physiology. And naturally, it is part of commonsense or folk psychology to think that explanations of human behavior will require the existence of beliefs, desires and intentions that are not, either directly or indirectly, reducible to brain states in any fundamental way. Let us look at the strongest arguments for the denial of belief.

The first general argument, offered by Stephen Stich, consists in his asserting that "However wonderful and imaginative folk theorizing and speculation has been, it has turned out to be screamingly false in every domain where we now have a reasonably sophisticated science."[33] In apparent agreement with this basic assertion, Paul Churchland has also argued that folk psychology is a degenerating research program, more like mythical parts of a bad theory than incomplete explanations.[34] In another place, Paul Churchland says:

> Could it turn out that nobody has ever believed anything? Could a completed scientific psychology impugn the common sense conception of the mental, the framework in which concepts such as "belief," "desire," and "intention" are embedded? Could the common sense framework be exposed as a "false and radically misleading conception" of the causes of human behavior and the nature of cognitive activity? If so, belief is as empty as phlogiston.[35]

Elsewhere he asserts that the commonsense concept of the mental

> appears (so far) to be incommensurable with or orthogonal to the categories of the background physical sciences whose long-term claim to explain human behavior seems undeniable. Any theory that meets this description must be allowed as a serious candidate for outright elimination.[36]

As some have noted, both Stephen Stich and Paul Churchland agree that folk psychology will have either a very weak vindication or will be eliminated for failure of explanatory adequacy. In neither case would a physicalist psychology recognize a "property of believing that p" or invoke beliefs or other propositional attitudes to explain anything.[37] For Churchland, the commonsense conception of the mental will be vindicated only when it is reducible to neuroscience, that is, only when commonsense claims are relatively isomorphic (or materially equivalent) to claims made in neuroscience. This of course does not differ in kind from the position of "eliminative materialism" which is by no means a vindication of common sense rather than its elimination as a source of explaining human behavior. According to the eliminative materialist, commonsense theory is an empirical theory and is subject to complete elimination via replacement *in toto* by a physicalistic psychology.[38] In the end both Stich and Churchland argue that folk psychology is no more science than Ptolemaic astronomy.

Accordingly, the first general argument for the denial of belief (an argument asserted by both Stich and Churchland) is that folk theorizing in the past has turned out to be screamingly false, therefore, if induction is reliable, folk psychology is false too. This general argument sustains the further conclusion to the effect that, if any effort to explain human behavior will succeed, neuroscience alone will provide adequate explanations of human behavior and thereby allow for either subsumption or elimination of folk psychology.

B. Critique of the First Argument: Haack's Response

This argument has been well-criticized by others. Susan Haack, for example, has noted that even as a weak induction it is very unconvincing. In criticizing Stich's induction based upon his analogy with folk theorizing, she says:

> The main problem though is the shiftiness of his use of the term "folk theory." Stich talks casually, though hardly idiomatically, of "folk

astronomy," "folk physics," etc., giving the impression that any old, but now discredited, theory would get counted as a "folk theory." If the adjective "folk" is applied to a theory or idea in virtue of the fact that it used to be widely accepted by the lay public *but is now discredited*, however, it is unproven that the idea that human action can be explained by the interaction of subject's beliefs and desires is a folk theory, and the induction does not get off the ground. If, on the other hand, the adjective, "folk" is being used in a neutral way, to refer to ideas that have been part of common sense for a long time, the other premise, that folk theories have invariably turned out to be false in the light of sophisticated scientific theorizing, is false and so again the induction does not get off the ground. What is being suggested, though not quite explicitly claimed, is that folk psychology stands to cognitive science as, say, ancient Babylonian to modern astronomy. But the implicit comparison is surely misleading. It is surely less plausible to think of modern psychology than to think of modern astronomy as a mature science; for psychology still seems today, as throughout its relatively short history, notably prone to schools and schisms, fads and fashions. The high-tech character of the techniques of cognitive science might warrant regarding it as *sophisticated*; but its theoretical background is not obviously of the rigor and strength that would warrant regarding it as *mature*.[39]

Simply put, the first argument begs the question against folk psychology by asserting that all commonsense views of the world fall into the class of non-reductive views that have turned out to be false. Comparing and identifying epistemologically folk psychology with ancient Babylonian astronomy is to assert an identity that requires proving folk psychology false rather than simply asserting as much. Just because folk psychology is not an instance of reductive materialism it does not follow that folk psychology is thereby false.

Haack also notes, by way of offering another criticism of Stich's argument, that if we assume for the sake of argument that modern psychology is mature science, then Stich cannot allow the induction "folk theories have usually turned out to be false, the belief-desire theory is a folk theory, so the belief-desire theory will probably turn out to be false," without allowing equal force to the induction "mature scientific theories have usually turned out to be false, modern psychology is mature science, so its theories will probably

turn out to be false" (204).

No less persuasive are her criticisms of Churchland's collateral claim that folk psychology is a degenerating research program. She says:

> Earlier in *Scientific Realism and the Plasticity of Mind* Churchland had argued for the appropriateness of calling the belief-desire model of the explanation of action a "theory" on the grounds that one's beliefs and desires are not incorrigibly open to introspective observation. So the word "theory" is playing a neat rhetorical trick; it is a long way from granting the infallibility of introspection to describing the belief-desire model as a "research program." No sooner is the belief-desire model elevated to the status of "research program," however, than it is demoted by the accusation "degenerating." This seems to me like calling the postulation of physical objects a "degenerating research program" on the grounds, first, that it has been sustained for many centuries without major modification, and, second, that it is simple, coarse-grained and gerrymandered relative to the ontology of modern physics.[40]

C. The Remaining Two Arguments

Stich offers two more arguments for the conclusion that specific developments in cognitive science indicate that there is a serious possibility that there are no such things as beliefs.

The first is an argument appealing to the work of Nisbett and Wilson on "attribution theory." "Attribution theory" asserts that people sometimes explain their own behavior by appeal to rather crude theories, and this attribution of causes has distinct behavioral effects. Usually experiments in "attribution theory" move a subject to make a false inference about the cause of some of her behavior, and then to behave as if the mistaken inference were correct. On this item, Stich discusses two groups of insomniac patients who were given placebo pills. One group was told that the pills would induce the symptoms of insomnia, the other group that the pills would produce psychological conditions associated with relaxation. Attribution theory predicts that the first group would take less time to get to sleep, because they would attribute any arousal symptoms to the pills, while the second group would take more time to get to

sleep, because they would infer that, since their arousal symptoms persist even though they took pills that should relax them, their thoughts must be especially disturbing. Both predictions were borne out. When questioning them as to what they thought caused them to take more/less time to go to sleep, however, Nisbett and Wilson found that nobody offered what attribution theory conjectures on the correct explanation. On the basis of several similar experiments, to explain the discrepancy between subject's verbal accounts of their mental processes and the hypothesized true explanations of their responses, Wilson offered a model which he describes as postulating two relatively independent cognitive systems, one largely unconscious, to mediate non-verbal behavior, and the other largely conscious, to explain and verbalize what happens in the unconscious system.[41] Stich claims that since beliefs are supposed to play a role in the explanation of both verbal and non-verbal behavior, neither of Wilson's two systems could be thought of as a system of beliefs.[42]

By way of criticizing Stich's interpretation of the experiments, one might note that there certainly is a discrepancy between the true explanation and that given by the subjects themselves, if what attribution theory predicts in these experiments is correct. But the obvious explanation of the discrepancy roots in the fact that people's awareness of their own mental states is confused and apt to be influenced by their expectations and preconceptions. This equally plausible explanation is no threat whatsoever to the folk psychological framework. Put differently, having mistaken beliefs about one's own mental states and their causes, however wide spread the phenomenon, does not establish that people do not have beliefs about their mental states.[43] For these and other reasons (including one that would imply that Wilson's paper is self-defeating because he explains the data in terms of what the subjects *believe* are the cause of their insomnia), Stich's interpretation of the results of the experiments as establishing the non-existence of belief is quite unjustified.[44]

The thrust of Stich's second argument is that if what he calls the "modularity assumption" is false, it follows that there are no such

things as beliefs, and that there are recent developments in AI indicating that the modularity assumption is false. As Stich describes it, a system is modular, *"to the extent that there is some more or less isolatable part of the system which plays, or would play, the central role in a typical causal history leading to the utterance of a sentence."*[45]

As others have noted, there are two features of this characterization that raise problems about the claim that if the modularity assumption is false then it shows that people do not have beliefs. The first problem is that Stich's characterization of modularity makes modularity a matter of degrees; whereas, presumably, it is either true or false that people have beliefs. And it explains modularity in terms of only one kind of behavior, namely, sentence utterance—thereby ignoring other kinds of verbal behavior such as assent to sentences, and non-verbal behavior.[46] Anyway, Stich begins here by noting that many cognitive scientists are working with highly modular models of cognitive processing, but he notes that some major figures have begun to favor non-modular approaches. He mentions Winograd and Minsky as people who have moved away from such models, the latter dramatically so. Let's say a few things about Winograd's thesis and leave the question of the critique of Minsky's work to others who have discussed and criticized it trenchantly.[47]

After noting that many phenomena, which for an observer can be described in terms of a representation, can actually be understood as the activity of a structure-determined system with no mechanism corresponding to representation, Winograd gives examples that look like instances of goal-directed behavior, but turn out to be explicable without our needing to postulate anything like a goal or desire. For some critics, Stich seems best interpreted as inviting one to draw the conclusion that everything that looks like goal-directed behavior might be so explicable (Haack, 208).

Winograd's first example is straightforward. There might be some temptation to think that the suckling baby has a representation of the relevant anatomy, but, he suggests, a better explanation is that it has a reflex to turn its head in response to a touch on the

cheek, and a reflex to suck when something touches its mouth—which calls for no ascription of beliefs or desires to the baby.[48]

In reflecting on this particular case, it seems clear that while there is no reason to contest Winograd's description of this case, there is equally no reason to suppose that it shows that adult activities are not sometimes goal-directed. The baby's response is reflexive rather than responsive to circumstances in the way characteristic of goal-directed behavior. As Haack has observed, the suckling baby would react in the same way *whatever* touched its cheek and *whatever* touched its mouth.[49]

Stich cites Winograd's work as indicating that some things look like goal-oriented behavior, but they are not (208). Stich's point is that adult behavior or rational "behavior" may turn out to be more like babies' responses than we realize. Paul Churchland makes explicit this claim when he says that "Babies' activities are recognizably continuous with children's and adults'; so, folk psychology which ascribes beliefs and desires to children and adults but not infants, makes a distinction where there is no real difference."[50]

Certainly, Stich may be right in his claim that much of what looks like goal-oriented behavior may well turn out to be something that is not. Some of it may well turn out to be more like what we call the "behavior" of a computer following certain commands. But the important point is that one cannot generalize in the way he suggests. However intriguing, the thesis is not established that all behavior *is* more plausibly to be construed like the babies' activities (or the activity of a computer following certain commands, or correcting certain mistakes) which ostensibly do not require goal-oriented behaviors, beliefs or desires. Moreover, Stich's assertion that babies' activities are recognizably continuous with children's and adults is simply a gratuitous assertion based on a faulty induction to a general conclusion not supported by the evidence. Certainly, some "activities" children and adults share with babies; but that of itself does not show that all adult activities are lacking goal-oriented motivations or that one need never appeal to beliefs or desires as explanations for some human behavior.

D. The Last Nail

Finally, if Stich and the Churchlands are right in their claim that there are no beliefs, it leaves them with the problem of explaining their utterance "There are no beliefs." The problem here is that if, as they claim, there are no beliefs, then it would seem to follow that they do not believe their own utterance; and if by "believing" we mean something very much like "accepting," then it follows that they do not accept what they assert everybody else ought to accept and that nobody by implication (since believing implies accepting) can accept. But how can one possibly assert "There are no beliefs" without falling into such rank incoherence? Denying that anybody can accept anything, and then *asserting* that we ought to accept that there are no beliefs, seems unavoidably incoherent.[51]

For all the above reasons, and others we have not discussed,[52] it would appear that the argument from cognitive science (or better yet, the various arguments from cognitive science) for the elimination of belief, and by implication for the replacement thesis, are not worthy of rational acceptance.[53]

1.12 The Argument from the "Impossibility of Defining Justification"

The last, and perhaps the most interesting, argument available for the replacement thesis appears more recently in a paper by Richard Ketchum entitled "The Paradox of Epistemology: A Defense of Naturalism." Possibly the best formulation of Ketchum's argument is the following:

An adequate traditional epistemology will require, among other things, an acceptable definition, or explication of the concept of justification. But, so this argument asserts, it is impossible to offer a non-circular or non-question-begging definition, or explication of the concept of justification. After all, whatever definition one would

offer for the concept of justification admits of the question "Are you justified in accepting or believing this definition of justification?" Presumably if one were to answer yes and then defend the answer, the stated defense would need to be an instance of the original definition—thereby rendering the defense circular or question-begging because what is at issue is whether the original definition itself is justified. Appealing to the analysans of the definition to justify the definition is patently circular and hence question-begging; and appealing to anything else would be logically contra-dictory because it would be a matter of ultimately asserting and denying one's stated definition of justification. No matter what one's definition might be, there could be no non-question-begging way of answering the question of whether one is justified in accepting that definition. Thus, traditional epistemology is dead.[54] What about this argument?

It is, of course, quite possible, for traditional epistemology to fail without its failure forcing us to accept the replacement thesis. We might, for example, go skeptical in a grand style and argue by implication that we cannot under any circumstances (whether in or outside of science) non-arbitrarily determine whether anybody is justified in his or her belief that p. But asserting as much as a justified belief has the awful ring of incoherence to it, whereas simply accepting the current canons of justification in natural science because of the general utility of such beliefs seems the only logically viable alternative. Thus the impossibility of defining justi-fication, along with the need to avoid the incoherence of a global skepticism, strongly tips the scales in the direction of the replace-ment thesis. In fact, the failure of traditional epistemology and the impossibility of accepting an incoherent global skepticism of the sort just indicated would force us to the replacement thesis. As we shall see, the only problem left for the replacement theorist would be to show why the inability of traditional epistemology to define justification should not count equally for undermining confidence in the canons of justification in natural science. Is there any way to respond to the original argument and possibly undermine it?

A. *Various Unacceptable Responses*

One possible response is that while one may not be justified in believing one's definition of justification, one might certainly have good reasons for accepting one's definition of justification. But the problem with this response is that it arbitrarily prevents one from defining justification in terms of having good reasons. Besides, if having good reasons for accepting a definition of justification is sufficient for accepting it, then why is that not the definition of justification? Can one have sufficient reasons for accepting something and not be justified in accepting it?

Another possible response asserts that the problem with this argument is not in the assumption that we must be justified in believing our definition of justification. Rather it is in the assumption that "justification" in believing a definition has the same meaning as "justification" when the term applies to non-definitions. On this view, being justified in believing a definition is simply a matter of whether one has correctly generalized from the conditions of correct usage in natural or scientific discourse (or, if our definitions are stipulative, a matter of whether they lead us to conclusions that satisfy the purpose behind defining things the way we do); whereas being justified in believing a non-definition, or a proposition about the world, is a matter of whether one can give (if necessary), or have, good reasons for thinking that the proposition is a reasonably adequate description of one's mental content or of the non-mental world. Given this difference in meaning, one could clearly be justified in believing one's definition of justification without circularity, or without begging the question in favor of the definition. Is there anything wrong with this proposed solution?

Yes, and it is this: The original question returns in the form of the question "Are you justified in believing that the concept of justification differs in meaning, in the way just indicated, for reportive definitions and for non-definitions?" Here again, if one answers affirmatively, one could only defend the answer by making it an instance of the concept of justification appropriate for non-

definitions, and that is what is at issue. In short, the question returns with a sting even when we try to distinguish various senses of justification.

By explicit implication, if one were to say "I am justified in accepting my definition of justification because the definition conforms to the rules we require for generating acceptable definitions," the obvious response would be "Are you justified in accepting the rules for generating acceptable definitions?"; if the answer is yes (as presumably it would be), then the answer is defensible only if it is an instance of one's definition of justification for non-definitions; but one's definition of justification for non-definitions is justifiable only if it is an instance of the definition of justification for non-definitions. In itself, however, the latter definition is what is at issue, and so we come back to the original question and the impossibility of answering it in a non-question-begging way.

A third response to the question consists in asserting that asking the question is contradictory because we know that this question must come to a stop somewhere, if there is to be any knowledge at all. In *Judgement and Justification*, for example, William Lycan makes this claim and, in explicating this answer, he says:

> I have suggested that something like our rules of theory preference comprise the foundation of ampliative inference; for me they are ultimate, not themselves justified by any more fundamental epistemic norms. And this raises the specter of skepticism, in both a general and a more specific way.
>
> The general worry is that if the canons are ultimate and cannot themselves be justified, then it seems they are epistemically *arbitrary;* they are the rules that human beings happen to use, perhaps even the rules human beings are built to use, but that does nothing to justify them in the normative sense appropriate to epistemology. We sport no epistemic halos when we use them; they are, at best, devices of convenience. And if they are arbitrary in this sense, no belief licensed solely by them is justified or, at any rate, an item of knowledge. But as an explanationist I hold that any belief is licensed solely by them: Global skepticism ensues.[55]

A little later, after claiming that it is the utility of beliefs generated by one's basic principles of justification that allows us to set aside

the skeptical posture, Lycan confronts the epistemologist's concern about the unjustified nature of these basic principles:

> It may seem paradoxical that any beliefs (or inferential methods) that are justified in the epistemological sense are justified ultimately on the basis of beliefs and/or methods that are not susceptible of proof, but the alternative *is* paradoxical: on pain of circularity or regress, we know that some epistemic methods or procedures (whether explanatory methods or others) are going to be fundamental; so, if a theorist is claiming to have discovered some such fundamental epistemic method, it is a fortiori inappropriate to respond by demanding a justification of it, in the sense of a deduction of it from some more fundamental principle—indeed, it is contradictory. As Bentham says, "That which is used to prove everything else . . . cannot itself be proved" (1789/1961, 19). Basic epistemic norms, like moral norms (and logical norms), are justified not by being deduced from more fundamental norms (an obvious impossibility), but by their ability to sort more specific, individual normative intuitions and other relevant data into the right barrels in an economical and illuminating way. The present skeptical observation is tautologous, and the attendant demand is contradictory. (135–36)

In reply to this sort of response, we can certainly agree that basic epistemic principles of justification will not be susceptible of proof by appeal to more primitive canons of justification. Doubtless, *if there is any knowledge or justification at all*, then there will be principles of justification that are primitive and thus incapable of being justified by appeal to more primitive principles. But, according to the skeptic, it by no means follows from this alone that one's cherished definition of justification will be acceptable just in case the proponent of it claims that it is basic, and not to be coherently questioned for that reason. In other words, while it is certainly contradictory for the proponent of a particular definition of justification to both claim that her preferred definition is basic and at the same time to entertain seriously the question of justifying it, asking the question is certainly not contradictory from the viewpoint of a disinterested inquirer seeking to determine which definition of justification to accept among mutually exclusive offerings. Oddly enough, the fact that the proponents of the various mutually exclusive definitions cannot without contradiction answer the

question plays directly into the hands of the skeptic who simply concludes that because there is no way for any proponent of a particular definition to rationally, or coherently, justify her definition of justification over any proposed competitor, and because that would be a necessary condition for any adequate theory of knowledge, there is no way of establishing a non-arbitrary definition of justification. In such a world, global skepticism would reign supreme because there would be no non-arbitrary way to determine whether anybody is justified in his or her belief that p. So, according to the skeptic, accepting the demand to justify one's basic definition of justification may well be contradictory for the proponent of any particular definition of justification (who cannot accept the demand and at the same time argue that the definition is basic), but it is by no means contradictory for somebody not advancing any particular view about the nature of justification to demand that those who offer a basic definition of justification show that their definition is more rationally acceptable than mutually exclusive proposals each of which equally claims to be basic and not subject to the demand for justification.

In spite of his argument, however, in the section quoted above, Lycan offers a response to the demand. This response consists in admitting that while one cannot justify deductively by appeal to a more primitive principle one's definition of justification (that, he says, would be contradictory), nevertheless, one's definition could be *vindicated* to the extent that following it produces beliefs that are maximally useful as tools for guiding decisions for goals (134). But is this a good response?

To this last question, rather than take the reply that Lycan ascribes to "the snooty epistemologist" (namely, that this *vindication*, rather than *justification*, is thin and sweaty), the skeptic might well note that whether one is distinguishing between vindication and justification, the logical problem is still the same, although the terminology has been changed to protect the guilty. Indeed, the skeptic can say that Lycan's response takes the form of assuming, as worthy of rational acceptance, his chosen definition of justification, as distinguished from vindication. This move will count as a

plausible response to the original concern of the skeptic, however, only if the implied definition of justification, which distinguishes it from vindication, is rationally worthy of acceptance. But that is just what is at issue. And so, the skeptic will again naturally ask "Is your definition of justification, insofar as it distinguishes justification from vindication, worthy of rational acceptance?" Why isn't vindication just another form of justification? Here again, one cannot distinguish between justification and vindication without assuming a definition of justification about which the skeptic may justifiably ask "But are you justified in accepting that definition of justification?" If the only answer to this last question is that one is vindicated in adopting such a definition, but it makes no sense to ask for the justification of the implied definition of justification which distinguishes between vindication and justification, then the answer is no answer at all. It is rather a refusal to answer the question, while at the same time granting, at least implicitly, legitimacy to the question. So, if there is something inappropriate about asking the question, it is not that it is contradictory to ask it for the reason that there is no non-contradictory way of answering it.

A fourth reply to the argument consists in ruling against the meaningfulness of the question "Are you justified in accepting your definition of justification?" on the grounds that if we take this question seriously, then it would lead to an infinite regress demanding global skepticism, and that result in itself is compelling grounds for not taking the question seriously. On this reasoning, specifically, whatever answer one might give to the question, the respondent could still ask "But are you justified in believing that?" and so on *ad infinitum* for each response. Differently stated, to countenance the question in the first instance is to countenance more properly the assumption that one must be justified in all one's beliefs and, as we know from Aristotle's argument in the first book of *Prior Analytics*, that requirement guarantees skepticism, because the need for an infinite amount of justification prevents there ever being any demonstrative knowledge. Is this response to the argument acceptable?

Not really. To reject the argument because it implies global skepticism is not unlike rejecting an atheist's proposed argument for the non-existence of God because it implies atheism. For some people, of course, it would be an epistemic *reductio* to show that the argument entails global non-methodological skepticism. For them, the price one pays for accepting such an argument, namely, that nobody could ever know anything, is too dear because so profoundly counter-intuitive. For the proponent of the replacement thesis, however, the skepticism implied by the argument is less an unfortunate consequence of the argument than precisely what the argument seeks to establish via demonstrating the impossibility of defining justification. Of course, advocates of the replacement thesis do not see themselves as global skeptics, rather than as advocates of the methods of justification in natural science because the latter canons are not in need of justification, whereas every other conception of justification is. For them, faulting the above argument for implying global skepticism outside natural science begs the question against the argument. Indeed, if the replacement thesis is true, then from the viewpoint of traditional epistemology, nobody is ever demonstrably or certifiably justified in believing anything outside of science; and this conclusion establishes the impossibility of traditional epistemology. Rejecting the argument for implying as much not only begs the question against the argument, but it also independently begs the question against the kind of global skepticism which the adherent to the replacement thesis will be quick to adopt as a way of specifying the content of the replacement thesis.

Incidentally, advocates of the above argument for the replacement thesis will surely note that if we take seriously the traditional epistemologist's claim that the question "Are you justified in accepting your definition of justification?" is meaningless, or not to be taken seriously, then the traditional epistemologist has no apparent way of adjudicating between mutually exclusive proposals seeking to define the nature of epistemic justification. Would not adjudicating between such proposals be no more and no less than justifying one proposed definition of justification over another? As

we shall see shortly, the traditional epistemologist has an answer to this question. So, this reply will not hold up as well as the reply in the last paragraph.

The fifth response to the argument is that the original question cuts both ways, and is therefore as damaging to the replacement thesis as it is to traditional epistemology. Why cannot the traditional epistemologist ask of the proponent of the replacement thesis "Are you justified in accepting your definition of justification as it applies in natural science?" Presumably, the replacement theorist will reject the question on the grounds that one just does not ask such questions in science, but why should that response not be allowed equally to the traditional epistemologist? Ostensibly, it is as legitimate to ask the question of the traditional epistemologist as it is of the replacement theorist. The question applies with equal justification and force in natural science. Accordingly, the replacement theorist is hardly in a superior epistemic position; the concept of justification will be no more or less definable in natural science than in traditional epistemology. Thus, accordingly, if traditional epistemology is shown dead by the legitimacy of the question "Are you justified in accepting your definition of justification?" then, by parity of reasoning, natural science is equally dead. Is this response to the original argument any more persuasive than the four responses noted above?

Once again, the answer is no. The replacement theorist can reply that the question does *not* cut both ways at all, because in natural science we do not need to answer the question, whereas in traditional epistemology we must. His reason for this last claim is simply that in natural science, but not in traditional epistemology or philosophy, there is fairly solid agreement on what counts for justification in science. So, the question does not have the same urgency among the practitioners of natural science. The confusion and disagreement in traditional epistemology requires that a proposed definition of justification be justified as more or less persuasive relative to other proposals on the table. But the fact that practicing scientists have no real or substantial doubt about what they accept as a community in the name of justified belief under-

mines the philosopher's attempt to show that scientists too must answer the question "Are you justified in accepting your definition of justification?" This response, of course, typifies the prevailing attitude on the part of practicing scientists to Hume's agony over justifying induction; and indeed there is much to be said for the view that the need for giving a justification is context-sensitive and that when the question "How do you know?" or "Are you justified in accepting your definition of justification?" is not appropriate for the splendid reason that nobody but the philosopher really doubts what has been said or asserted, the question does not need to be answered. So, David Hume notwithstanding, it is by no means clear that the question cuts both ways rather than strongly against the traditional epistemologist.

It would appear then that none of the above five responses, however initially plausible, are satisfactory responses to the argument for the impossibility of defining justification.

B. Two Acceptable Responses

In the end, there are at least two reasons rendering the replacement theorist's above stated argument for the death of traditional epistemology unacceptable. In the first place, it is not (as we saw above in the discussion on the fourth response) that the argument entails a non-methodological global skepticism outside of science, but rather that the general skeptic on the question of defining justification (whether in or outside of natural science) is in the logically contradictory position of asserting as logically privileged or justified the claim that no beliefs are demonstrably and non-arbitrarily justified. Curiously enough, the claim itself certainly seems to follow logically from our demonstrated failure to define successfully the concept of justification in the presence of competing and mutually exclusive proposals. Presumably, however, the general position of the skeptic, asserting as demonstrably and non-arbitrarily justified that no belief is demonstrably and non-arbitrarily justified, cannot be established by any argument, much less the methods of the natural sciences.[56] For some peculiar reason, as yet unfathomed by the history of philosophy, general non-methodologi-

cal skeptics on the question of justification are not moved by the observation that their position when honestly asserted is logically contradictory. Nevertheless, the traditional epistemologist will argue that any thesis leading to the acceptability of general skepticism on the question of justification is for that reason reduced to absurdity. Accordingly, because the alleged impossibility of offering a non-question-begging definition of justification leads to such an incoherent skepticism, the position stands refuted and, by implication, the need to take seriously the question "Are you justified in accepting your definition of justification?" dissolves. Indeed, if one's view is that what is wrong with generalized skepticism on the question of justification is that it is logically self-defeating because self-contradictory and incoherent, then that in itself would serve as a fine *reductio ad absurdum* of the need to justify one's definition of justification assuming that there is no non-question-begging definition to be offered.

If this last response to the original argument is not enough, perhaps the more compelling response is that the question "Are you justified in accepting your definition of justification? " is actually self-defeating in a way not at all obvious. Let me explain.

Whoever asks the question "Are you justified in accepting your definition of justification?" can be met with the response "What do you mean when you ask whether I am 'justified' in accepting this definition?" When anyone asks the question "Are you justified in accepting or believing your definition of justification?" he must have in mind just what it means to be justified, otherwise it is not a meaningful question because if he did not have in mind just what it meant, he would not know what would count for a good answer if an answer were possible. Thus, if the question makes any sense at all, the questioner must be prepared to say just what *he* means by justification when he asks the question "Are you justified in believing your definition of justification?" Moreover, the person asked the question will not know what is being asked if the questioner cannot say what he means by "justified" because there are such different meanings the person asked may attribute to the concept of justification. In fact, then, it is a necessary condition for

this question being meaningful (that is, understood by both the one asked and the one asking) that the questioner be able to say what it would mean for someone to be justified in believing that a particular definition of justification is correct. If the questioner cannot answer the question "What do you mean?" then the question need not be taken seriously, and in that sense it becomes pointless or meaningless. If he can, then his question is easily answered. For example, if the questioner is asking for a good reason for accepting the definition, the response might well be that we have a good reason because the definition is a sound generalization of the facts of ordinary usage (and that's a good reason because evolution selects out this way of determining the meaning of expressions). In short, if the question is an honest one, then the questioner is asking for a justification, and if he cannot say what would count as an answer to his question (thereby saying what he means by "justification"), then we need not and will not, take his question seriously. On the other hand, as soon as he tells us just what he means by "justification" his question seems meaningful and answerable.

However, now comes the rub. We can still refuse to take his question seriously because *we* can now raise the question of whether his understanding of "justification" is justified, because if it is not, we do not need to answer his question; and if he says our question is meaningless, then so too was his initial question. But now the shoe is on the other foot, as it were. The person who questions the original definition of justification can make sense of his question only if he is willing to say just what justification consists in; but if the original question makes sense then it will make equal sense when the question is asked of him—meaning that *he* has no non-question-begging way of answering a question necessary for his meaningfully asking "Are you justified in believing your definition of justification?" Thus it appears that we are justified in ignoring the question because the questioner cannot, *ex hypothesi*, satisfy a condition necessary for the meaningfulness of the proposed question. He cannot, *ex hypothesi*, answer in any non-question-begging way the question we can ask of him, namely, "Are you justified in accepting your definition of justification?"

More importantly, not only is the question meaningless because the questioner cannot answer in a non-question-begging way what he means by "justification," it is also semantically incoherent and self-defeating because a necessary condition for its being meaningfully asked (namely, that one be able to defend one's definition of justification in a non-question-begging way), is what the questioner denies that one can do.

The major discernible objection to this last argument comes in the assertion that one does not need to justify one's definition of justification in order to ask whether somebody else is justified in accepting his proposed definition of justification. But why exactly? After all, if it makes perfectly good sense to ask "Are you justified in accepting your definition of justification?" then if the questioner must, in the interest of asking an unambiguous and answerable question, say just what *he* means by "justified," then the same question should apply with equal legitimacy to the questioner's question. Only now the impossibility of answering the question in a non-circular and question-begging way undermines and shows incoherent in the first instance the very question "Are you justified in accepting your proposed definition of justification?" Thus we do not reject the question *because* it cannot be answered in a non-viciously circular and question-begging way; that reason for rejecting the question is consistent with global skepticism. Rather we reject the question as meaningless because, if we accept that there is no non-circular way of answering the question, the question becomes, for the reasons just mentioned, incoherent and self-defeating.

Another objection to our second response to the original argument is as follows. Suppose that when, in order to disambiguate his question "Are you justified in accepting your definition of justification?" we ask our questioner "What do *you* mean by justification?" he says "Oh well, by 'justified' I mean just what you mean by 'justified.'"[57] Given the appropriateness of this response, our questioner would not need to justify his definition of justification, because he does not offer one; and if we say he is offering a definition (namely, the same one I offer), we cannot consistently take issue with it

while offering the same definition. Or so it would seem.

On reflection, however, this objection does not work either. After all, if his definition of justification is the same as mine, then his question amounts to an oblique way of asking "Are *we* justified in accepting *our* definition of justification?" To that question I can legitimately respond "What do *we* mean by 'justified' when we ask whether *we* are justified in accepting our definition of justification?" Presumably, answering this last question is simply a matter of repeating our original definition of justification. Otherwise our answer would be contradictory. But now does it make any sense to ask "Are we justified in accepting this latter definition of justification?" if, as the original questioner asserts, it cannot be answered in a non-circular way? Thus the question "Are we justified in accepting our definition of justification?" makes sense only if we have *already* justified our definition of justification, thereby rendering the question unnecessary. Either that or the question makes no sense whatever because the question demands for its meaningfulness an answer to another question which the questioner also claims cannot be given in a non-circular way. At the moment, I cannot see any other interesting objections to the second acceptable response.

What is the difference between the above two arguments offered here as acceptable responses to the argument that there is no way to define successfully the concept of justification in traditional epistemology? In the first argument, both the *position* and *assertion* of the sort of global skepticism implied by accepting the impossibility of defining justification in a non-circular way, is contradictory and self-defeating. In the second argument the *question itself* in the first instance is meaningless because it is incoherent and self-defeating.

Incidentally, it seems inescapable that this same general conclusion applies with equal validity to all questions such as "Do you know that your definition of knowledge is correct?" or "Do you believe that your definition of correct belief is correct?"

Accordingly, we have two persuasive reasons, or arguments, why the above argument for the replacement thesis and the death of traditional epistemology is not sound. This conclusion carries with it

a strong reason why we should never accept as meaningful the question "Are you justified in accepting your definition of justification?" Of course, none of this implies that we have no way of assessing the relative merits of mutually exclusive definitions of justification. What it does mean, however, is that when we are involved in the practice of making such assessments we remind ourselves that we are not involved in the activity of justifying our definition of justification. Rather we are doing something else. We are determining which definition, if any, to accept as a more or less adequate generalization of our collective usage and practice in the relevant contexts. We do this because we believe that when it is done well it will produce a measure of understanding and enlightenment not otherwise available. Whether we are justified in this latter belief is an interesting question, but it is certainly not the question of justifying our definition of justification. For all the reasons mentioned above, we must not succumb to the temptation to characterize this activity as the activity of justifying our definition of justification.

1.13 The Incoherence Argument Against the Replacement Thesis[58]

By way of a general assessment of the replacement thesis, it now seems clear that Quine's argument for the replacement thesis is a *philosophical* argument whose general conclusion, whatever the premises, is not properly testable under the methods of the natural sciences. Indeed, as an hypothesis, Quine's conclusion that there are no correct answers or statements that either have emerged, or can emerge, from extra-scientific methods (that is, that there is no "first philosophy") has no statable sensory test implications that would allow us to confirm it positively. What sensory data, predicted by the hypothesis, could we accept as positive instances confirming the hypothesis? Apart from the non-occurrence of falsifying data (which every hypothesis, if true, trivially predicts) what exactly

does the truth of the replacement thesis predict or imply at the sensory level? The thesis of naturalized epistemology, as Quine and others construe it, is an answer to the question of whether there is any knowledge outside of science; but it is not an answer that we have established, or can establish, by appeal to its positive instances under the methods of testing and confirmation proper to the natural sciences. Such a demonstrable lack of confirmatory content results from the fact that the thesis itself does not seek to describe or explain some observable regularity or property in the world, or answer a cause-seeking why-question about observed phenomena governed by nomic forces. It does not seek to solve any empirical problem that practicing scientists would recognize. This consideration alone tends to explain why nobody in the scientific community has directly and explicitly tested the replacement thesis. So, apparently, we cannot list the replacement thesis as one of those robustly confirmed, or confirmable, theses in natural science along with, say, the law of gravity, or the existence of neutrinos. Or so it seems.

By way of a response to these last claims, however, someone could conceivably reply that the replacement thesis is indeed testable and falsifiable. Suppose, they might say, we encountered a diverse group of psychic gamblers who non-fraudulently and correctly predict the winner of each consecutive horse race at Scarborough Downs a thousand times, or they similarly predict the nine-digit number winning a daily lottery 100 times in a row. When asked which horse will win the next race, or what will be the nine-digit winning lotto number tomorrow, each psychic gambler never fails to give the correct answer. In such a world, it can be said that we would need to call each a knower whose answers to such questions are legitimately answered and correct. The truth of the replacement thesis certainly predicts that no such events will *ever* occur. Were such events to occur, we would need to agree that our psychic gamblers frequently answer legitimate questions about the world, but their answers would not be the product of the methods of testing and confirmation proper to the natural sciences. Thus, it is tempting to reply to the above argument that the replacement

thesis is indeed testable because falsifiable. In fact, some philoso-
phers may even confidently assert that the replacement thesis *has*
indeed been tested carefully, and survived the test, whenever any-
body examined the claims of alleged famous psychics only to find
them fraudulent.[59] Is this a reasonable response to our earlier claim
that the replacement thesis is not testable because it has no positive
instances at the sensory level?

 Not really. After all, however plausible it may seem to say that
the replacement thesis is at least *testable in principle* (because we
know what sensory data would falsify it), noting further that what
it would take to refute it has never actually occurred seems alto-
gether insufficient as grounds for saying that the thesis has in fact
been tested and confirmed. It does not seem to satisfy the Popper-
ian requirement of "severe" testing, because one is simply waiting
for the appearance of the data (psychic gamblers, for example) that
would refute the hypothesis in question. More importantly, of
course, it seems equally doubtful that non-Popperians would call it
"testing" the replacement thesis when one is not seeking to test it
in terms of degrees of corroboration or support provided by its
positive instances at the sensory level, and when one simply adopts
it on the grounds that there has not yet appeared the requisite falsi-
fying evidence. Barring holistic *ad hoc* adjustments in order to keep
the hypothesis come what may, the fact that the occurrence of a
number of psychic gamblers of the sort just described would refute
the replacement thesis, does not straightforwardly imply that estab-
lishing the absence of such disconfirming evidence, confirms (or
even "corroborates") the replacement thesis. If the history of scien-
tific theorizing and confirmatory practices is any indication at all,
and if various well-known critiques of Popperian falsificationism
are to be believed, it will not be sufficient for the confirmation of
an hypothesis that it not be falsified. As between remaining and
competing alternative hypotheses not yet falsified, we will need a
comparative measure of the degree of support in terms of probabil-
ities based on the frequency of the occurrence of what is implied by
way of positive instances of the hypothesis under fairly severe

testing at the sensory level. As others have noted elsewhere, simple falsificationism is not sufficient for the kind of testing necessary for the confirmation and acceptance of a proposed hypothesis or theory.[60] This seems especially so when one cannot produce any positive inductive evidence deductively implied by the hypothesis and tending to confirm the hypothesis, apart from saying that what it would take to disconfirm the replacement thesis has not yet occurred. What positive evidence would it take to confirm the replacement thesis? Again, what does the replacement thesis predict by way of its positive instances at the sensory level other than that it will not be falsified by the sudden appearance of such items as successful and non-fraudulent psychic gamblers, or successful gypsy fortune-tellers? Does it predict, for example, that some physical object, or property, or process will appear, or is detectable, under certain complex or simple experimental procedures? Supposing it were true, would the replacement thesis ultimately allow us to non-trivially predict or control any physical process, property or state of affairs? The answer to all these questions is no and, again, the basic reason why the replacement thesis is itself not a scientific thesis is that it is not part of any attempt to answer a cause-seeking why question about observable phenomena.

On the face of it, as we noted three paragraphs above, nobody in the scientific community has directly tested the replacement thesis although, to be sure, some may argue that in all cases in the past whenever anybody has claimed to know something about the world by appeal to methods outside the methods of the natural sciences, those claims have never been shown to be correct in any non-accidental way. Whether this last claim is correct is incidental to the issue of whether we should call it "scientifically testing a hypothesis" when we simply wait for attempts at falsification and argue that the thesis is confirmed or corroborated because such efforts at falsification have failed. So, even if we know what it would take to falsify a scientific hypothesis, typically, some positive instances of the hypothesis at the sensory level, instances deductively implied by the hypothesis, must occur for positively confirming

the hypothesis if it is to be tested in a way that allows for robust confirmation of the hypothesis.

Admittedly, failure to refute a particular hypothesis when strenuously seeking to refute it, increases the likelihood of the truth of the hypothesis, and might well be called an empirical test of the hypothesis. A hypothesis that has not been refuted but severely tested in terms of what it would take to refute it, is a working hypothesis not refuted. But calling it a "working hypothesis" usually implies, among practicing scientists, that it has some predictive power distinct from merely predicting that attempts to refute it will not work. This latter feature is not an apparent feature of the replacement thesis. The latter has no positive empirical content that any practicing scientist could recognize.[61]

So the validity of naturalized epistemology, understood as the replacement thesis, has not emerged as a confirmed hypothesis in natural science, and cannot be positively established or confirmed as a scientific thesis because it is not testable in the general way required for the successful confirmation of a hypothesis in natural science. At the very least, even if it were testable in a way that allows for robust confirmation, the fact of the matter is that, on its own terms, until it is explicitly tested and confirmed in natural science, we cannot say that, as an answer to an important question about the limits of human knowledge, the replacement thesis is a correct answer that has emerged from the methods of testing and confirmation proper to the natural sciences.

By general implication, the replacement thesis, as both an assertion and a proposed answer about the limits of human knowledge, is inconsistent with the very statement of the thesis. If, as the replacement thesis asserts, the only legitimate answers (claims) are those that are scientifically testable and capable thereby of being strongly confirmed in natural science, then the replacement thesis, as an answer to the question about the limits of human knowledge, specifies, as a condition for the truth of any thesis, a condition which the replacement thesis itself cannot satisfy. It is therefore a self-defeating thesis.

Further, even were we to grant that it is a testable thesis, the

replacement thesis would still be a self-defeating thesis because it also asserts that the only legitimate answers we have are those that have been established by the methods of testing and confirmation proper in natural science; and the replacement thesis has not been so established.

The replacement thesis is, moreover, incoherent or inconsistent because it follows that if the replacement thesis is true as an assertion about the world, then the assertion of the thesis itself must be false because a condition it asserts as necessary for its own truth is not, and cannot be, satisfied. In short, it appears that any argument defending the replacement thesis will have a conclusion that is incoherent and self-defeating, because if what the replacement thesis asserts is true, then the very statement asserting it must be false because it not only has not emerged as a confirmed thesis in natural science, it is also not explicitly testable in any way that could possibly positively confirm it.

Consider, further, that if the replacement thesis cannot be established by appeal to the methods of explicit testing and confirmation proper to the natural sciences, then *any* allegedly sound argument for the replacement thesis would need to have at least one essential premise which is not in fact scientifically testable in a way necessary for strong confirmation. This would make the argument "philosophical" because its premises could not all be established by appeal to the methods of explicit testing in the natural sciences alone. The interesting question is, then, whether there is also something fundamentally incoherent about arguing *philosophically* for the replacement thesis.

It certainly seems that offering *any* philosophical argument in favor of denying that philosophical arguments will count in answering questions about the nature of epistemology or the world is equally inconsistent or incoherent. The truth of such premises would be undermined by, and inconsistent with, the very conclusion which they are supposed to establish. If the conclusion were true, not all the essential premises upon which it is based could be true, because they could not all be scientifically testable or established true by the methods of testing in natural science.

Hence *any* argument for the replacement thesis will be unsound. This general conclusion is unavoidable as long as the premises for the replacement thesis are not established by the methods of explicitly testing necessary for confirmation in the natural sciences. In spite of its popularity, then, there is no sound philosophical argument possible for the replacement thesis.[62] Not only is Quine's particular argument for the replacement thesis unsound and self-defeating (because incoherent in the way noted above), our argument showing as much is generalizable to *any* argument favoring the replacement thesis. Indeed, once we grant, as we should, that the replacement thesis is not a scientifically established thesis because it is not explicitly testable in the interest of positively confirming it, then certainly some of the premises necessary for its establishment will not be so explicitly testable in the general way usually required of confirmable hypotheses in natural science. Therefore, the replacement thesis asserts a statement which, if true, shows that some of the essential premises upon which the replacement thesis rests cannot be true; if those premises were true, it is impossible that they should establish the replacement thesis because the replacement thesis denies that such premises can be true. Similarly, if the replacement thesis is true, it rules against such premises being legitimate or true premises in any argument for the replacement thesis. Thus, apart from the fact that the replacement thesis itself is not an answer that we can establish by appeal to the methods of the natural sciences, *any* argument for the replacement thesis will be unsound for the same basic reason that Quine's argument is unsound.

Notice also that the above argument against the replacement thesis works equally strongly against the simple claim that the only correct answers we have about the world are those that have emerged from the methods of testing and confirmation proper to the natural sciences. The falsity of this latter claim, incidentally, shows that to some questions about the world there must be some correct answers that have not emerged from the methods of testing and confirmation proper to the natural sciences.

A. Two Likely Objections

To be sure, one predictable objection to our argument against the replacement thesis is that the argument assumes, rather than proves, that some form of *explicit* testability is a necessary condition for acceptable scientific claims or hypotheses, but not for philosophical claims or hypotheses. The best response to this objection, however, consists in granting that the argument does indeed assume as much, but that there is nothing particularly problematic about such an assumption. Among natural scientists it is a non-controversial requirement for a claim's being a meaningful scientific claim about the world that it in some way, either directly or indirectly, holistically or non-holistically, be explicitly empirically testable and confirmable in terms of its positive instances. Early Kuhnian considerations not withstanding, defining science as it is usually practiced by scientists, rather than as it could be viewed by some philosophers or sociologists, requires that we accept some form of explicit testability as a usual or necessary condition for any proposed hypothesis or explanation in natural science. Hypotheses to the contrary have the maximally implausible effect of turning thinkers such as Hume and Quine into natural scientists whose conclusions, oddly enough, are never established by appeal to the methods natural scientists actually use in the conduct of science. Hypotheses to the contrary also seem to overlook the fact that in the history of science there has never been a robustly confirmed, or accepted, theory that did not have positive inductive support from its positive instances as well as a clear statement of what it would take at the sensory level to falsify the hypothesis. Asserting the necessity of confirmation based on some form of explicit testability is, of course, quite consistent with the sort of *holism* in confirmation theory advocated by philosophers such as Quine. Holism, as Quine construes it, for example, does not *abandon* the need for explicit testability in hypothesis or theory confirmation; it simply reconstrues the unit of significance in terms of the whole theory and not individual sentences in the theory.

Another predictable objection would seek to protect the replacement thesis against the above argument by asserting that while the replacement thesis may certainly not be explicitly testable in the sense specified, nevertheless, in conjunction with our having a substantial list of non-controversial answers emerging from the practices of natural science, the replacement thesis is certainly a *legitimate inductive generalization* from the repeated failures of traditional epistemology to provide us with anything like a non-controversial solution to any basic questions about human knowledge. So, while it may not be legitimately and explicitly testable, the replacement thesis is a legitimate inductive generalization from the facts, and that is enough to warrant it as a thesis established by appeal to a basic method of inference in natural science. In short, explicit testability may be sufficient but it is not necessary as a mark of the scientific.[63] In response to this objection, we can assert the following.

As hypotheses go, the replacement thesis might explain the fact, if it were a fact, that the only correct answers we have ever had are those that have emerged from the practices of the natural sciences. But how does one *show* that that is a fact without begging the question in favor of the view that all proposed answers to questions about the world are legitimately answerable only if they emerge from the practice of natural science? Besides, are there no proposed solutions in philosophy that philosophers have generally accepted as legitimate answers? While there may not be many, there are some non-controversial refutations in philosophy. Is there anybody, for example, who sincerely and unconfusedly believes that he is the only person in the world? Moreover, what about the fact that what is often allegedly accepted as a non-controversially correct answer in science is often subsequently rejected in the light of revolutionary advances in natural science? In offering an allegedly non-controversial list of correct answers in natural science, how does one distinguish between those allegedly correct answers that will go the way of phlogiston and the geocentric hypothesis from those equally robustly confirmed beliefs that will not? If that cannot be done, and arguably it cannot, the basis for the above inductive generalization

in support of the replacement thesis is quite defective, even if philosophers never agreed on anything.

Besides, as many others, including Quine, have been quick to note, offering an inductive generalization to the effect that the replacement thesis is true, is patently circular. Alexander Rosenberg has recently observed, for example, that appealing to some non-trivial methodology in natural science to defend the methods of natural science as the only reliable set of methods to acquire knowledge about the world is *viciously circular* and to do anything else seems fundamentally inconsistent for a naturalist favoring the replacement thesis. Indeed, for Rosenberg and a number of other naturalists, this problem of not being able to offer a non-circular defense of scientism (the replacement thesis) is the most serious challenge facing scientism. Rosenberg seeks to meet that challenge by asserting that the challenge is met when one asserts that the primary goal of science is prediction and control, and for that end natural science, as natural scientists will all admit, "delivers the goods." He insists that even those who would explicitly deny that the basic goal of science is prediction and control in fact implicitly and inescapably assert it, willy-nilly, at every turn when they conduct inquiries.[64] Rosenberg thinks that if his is not the proper solution to the question of vicious circularity for the defense of scientism, then naturalism goes bankrupt leaving us with either the sophistry of "relativism cum constructivism" or some objectionable form of *apriorism* which will not allow for our non-controversially fundamental need for prediction and control.

The skeptic about scientism will probably respond to Rosenberg's gambit by noting that, in addition to what we urged two paragraphs above (namely that some form of explicit testability is indeed a necessary condition for explanatory hypotheses in natural science, and that it is question-begging to assert that we have a non-controversial list of correct answers provided by science), Rosenberg's proposed solution is still viciously circular because in asserting that "science delivers the goods," he is also in effect claiming that we have adequate inductive evidence that natural science has in fact offered us non-controversial list of answers to

basic questions in the past. As we saw two paragraphs above, that claim itself presupposes the validity of that particular inductive inference and so the vicious circle remains at the heart of any empirical defense of the replacement thesis. For the proponent of the replacement thesis the problem remains: Not to offer some inductive defense or some explicitly testable defense of the replacement thesis is inconsistent with the thesis itself, and to offer one is viciously circular, because it would offer a scientific defense of scientific methodology as the only way of answering any legitimate questions about the world. The apparent failure of the kind of solution offered by Rosenberg to the problem of vicious circularity adds further strength to the argument offered above that the replacement thesis cannot be defended successfully.[65]

1.14 Conclusion: The Death of the Replacement Thesis

If much of what we have said above is correct, not only is there no sound argument presently available supporting the replacement thesis, there never will be a sound argument for it.[66] The scientism implied by the replacement thesis is false. Let us turn to the second form of naturalized epistemology to determine whether the naturalism implied by it is any more defensible.

2

The
Transformational
Thesis

2.1 Introduction: Reliabilism and Naturalized Epistemology

Back in the Introduction we saw that the second distinct form of naturalized epistemology does not seek to *replace* traditional epistemology in the radical way suggested by Quine and others who abandon all questions unanswerable by appeal solely to the methods of the natural sciences. Rather it seeks to *transform* traditional epistemology by connecting it more centrally with the methods and insights of such natural sciences as biology, psychology, and cognitive science. On this view, it is the task of philosophy to offer conceptual analyses of basic epistemological concepts, but it is the task of natural scientists to determine whether anybody knows, or is completely justified in believing, what they profess to know or what they profess to be completely justified in believing. In short, while there are legitimate philosophical questions reflecting classical or traditional epistemological concerns, the question of whether or what anybody knows or believes is ultimately an empirical question we must consign to psychologists, neurobiologists, or cognitive scientists, broadly construed. This is the view, for example, Alvin Goldman adopts in *Epistemology and Cognition*, and, as we shall soon see, many have found this particular view of epistemology more congenial, perhaps because less radical, than

the replacement thesis although, to be sure, the fundamental distinction between this view and the replacement thesis is certainly questionable.[1] But what motivates this second form of naturalized epistemology? What is the basic argument for it, and is it a persuasive argument?

The basic argument feeds on a defense of *reliabilism*, and so a few general observations here on reliabilism are necessary. Most generally construed, reliabilism asserts that whether anybody knows that *p*, or whether anybody is completely justified in believing that *p*, depends on whether his or her belief that *p* is the product of a reliable belief-making mechanism, process or method functioning normally in its usual setting. Such mechanisms, processes or methods are reliable if they generally *tend* to produce, or produce more often than not, true beliefs rather than false beliefs. Philosophers who adopt reliabilism fall into two distinct groups.

The first group adopts the reliability condition as a justification condition for knowledge, or as an addendum to the justification condition for knowledge. These philosophers assert that justification is necessary for knowledge, and then define justification in terms of reliably produced belief construed as either a necessary, or a sufficient, or as a condition necessary but not sufficient, or as a condition both necessary and sufficient, for justification. Depending on which reliabilist one consults in this group, the reliabilist may, or may not, require as part of the definition of justification the condition that the subject be consciously aware of, or have a cognitive grasp of, whatever it is that makes the belief reliably produced or justified. Those who insist on the latter condition sometimes describe themselves as holding an *internalist* theory of justification, because they insist that the subject be internally or reflectively aware that her belief is justified and also have some cognitive grasp of what it is that justifies her belief even when the reliability of the belief is a function of a particular causal relationship between some fact external to the agent and which is a cause of the agent's belief when it is reliably produced.[2] Some of these internalists do, while some do not, further require that, under certain circumstances, a subject's being justified in her belief requires that she be able to

give reasons showing that her belief is reliably produced and hence justified. Those reliabilists who do *not* insist that the subject be consciously aware of, or have a cognitive grasp of, what it is that justifies her belief as reliably produced, define justification solely in terms of reliability, and thus often describe themselves as holding an *externalist* theory of justification; they insist that if one's belief is reliably produced, then it is justified even if the subject is not internally or reflectively aware either that it is reliably produced or of what justifies it. For such an externalist, obviously, one need never give reasons (or be able to give reasons) in order to be justified in one's belief. For such an externalist, what makes the belief justified is simply its logical relationship to some fact external to the agent, and which fact in some important way is a cause of the belief's truth when the belief is reliably produced.[3]

The second general group insists that the reliability condition is not a justification condition, and that while knowledge requires reliably produced true belief (of which the subject may or may not be reflectively aware), it does not require justification because the latter is a reason-giving activity which is superfluous and irrelevant to the question of whether one is in a state of having a reliably produced true belief. This position, for example, has been strongly defended by Fred Dretske in *Knowledge and the Flow of Information*. Because people in this group see justification basically as a reason-giving activity which is unnecessary for having reliably produced true belief, they hold to a *reliability theory of knowledge* as opposed to a *reliability theory of justification*.

Whichever of these two basic groups the reliabilist falls into, reliabilism as a general thesis implies that whether anybody knows that *p*, or is completely justified in believing that *p*, depends on whether her belief that *p* is caused by, or is the product of, reliable belief-making mechanisms or processes functioning normally in their usual setting. These mechanisms are basically those of ordinary perception, memory, reflection, introspection, or other neurobiological processes open to the scrutiny of psychologists, neurobiologists, and cognitive scientists. Consequently, determination of the reliability of such mechanisms for producing true beliefs

in any given case falls either into the hands of those who study such mechanisms, namely, psychologists—broadly conceived as embracing neuroscientists and cognitive scientists—or into the hands of the subject reflecting on the nature of the claim and the circumstances of its origination. The first option defines the transformational thesis of naturalized epistemology because it consigns the question of who knows what to the determination of natural scientists using the methods of natural science to certify the reliability of the belief-making mechanisms producing the subject's beliefs. Obviously, this form of reliabilism, in the interest of furthering the transformational thesis must, and does, construe the mechanisms and processes in question (as well as the methods of reasoning based upon them) as fundamentally neuro-biochemical. The second option is not necessarily a naturalism at all rather than an internalist form of reliabilism because the determination of reliability can be left up to the reflective subject, even though the reliability itself may require a causal connection between some external fact and the belief caused in some way, through some mechanism or other, by the external fact. As we shall see, Alvin Goldman and Fred Dretske defend the first option, and William Alston the second.

Whether one adopts the reliability theory of knowledge or the reliability theory of justification, what is definitive of reliabilism is the central claim that unless one's belief is caused by mechanisms, methods or processes that typically tend under normal conditions, and in the usual context, to produce true beliefs, that belief cannot be either an item of knowledge or a justified belief. As indicated in the last paragraph, not all such reliabilists, as so generally construed, are naturalists. Reliabilists of a naturalist bent are typically externalists who require for knowledge or justification only an empirically observable causal connection between one's true belief and some external state of affairs or mechanism which is generally reliable in producing true beliefs.

At any rate, it seems clear that the transformational thesis rests squarely on the claim that reliability is either a necessary condition, or a sufficient condition, or a condition both necessary and sufficient, for human knowledge. So, let us begin by examining the

reliability theory of justification and then pass on to the reliability theory of knowledge. In doing this I hope to show that neither position is viable and that by implication a naturalized epistemology of the transformational type cannot succeed. In the offing we shall also see that, whether it has naturalistic implications or not, reliabilism both as a theory of knowledge and as a theory of justification fails. But first, a few other relevant preliminaries.

2.2 Causal and Reliability Analyses of Justification: A Brief Description

Inspired by the need to accommodate Gettier-type counterexamples to the classical definition of knowledge, a number of philosophers have urged that we can overcome these well-known counterexamples if only we require that the nondefectiveness of a justification be a function of *how* one's beliefs originate.[4] For these philosophers, a person's knowing what he is completely justified in believing is a function of whether his belief is caused in certain ways, or has an appropriate causal history. Such analyses fall into two categories, *causal* analyses and *reliability* analyses.

Briefly, causal analyses typically assert that a person's justification will be nondefective if the chain of causes leading her to have the belief she has is nondefective. Of course the nondefectiveness of this causal chain is a function of whether the true belief is caused by the state of affairs about which the belief is a true belief. Some causal analyses go further and require of a suitable causal analysis that it also prevent the existence of any true proposition such that if it were added to one's justification she would no longer be completely justified in believing what she does believe. These latter causal analyses have sometimes been called defeasibility analyses, because they require non-defeasibility for justification, and hence require that whatever causal chain one insists upon to block Gettier-type counterexamples that it also prevent the existence of any true proposition such that if it were added to one's justification

one would no longer be justified in believing what one does believe. Hence there must be some suitable causal connection between the belief and the state of affairs that makes the belief true *and* at the same time excludes any true proposition such that if it were added to her justification she would no longer be justified in believing what she does believe. When this occurs, it supposedly prevents the subject from being completely justified in believing a false proposition and, by implication, prevents a person from being completely justified in believing a true proposition and not knowing it.[5] The basic task of such analyses is to provide a precise characterization of the features the causal chain must have if it is to produce a belief that is completely justified and nondefective in the way just specified. Marshall Swain, in his careful proposal, gives possibly the best-known example of a causal analysis that also serves as a defeasibility analysis.[6] Like all other causal analysts after Gettier, Swain believes that he has offered an analysis that succeeds in blocking Gettier-type counterexamples without requiring of a justification that it consist of *entailing* evidence in order to be nondefective.

But there are defeasibility analyses which are not causal analyses. Such analyses do not explicitly require for the non-defectiveness of a justification that it be caused in a particular way in order that it assure that there is no true proposition such that if it were added to a person's justification, he would no longer be justified in believing what he does believe. They simply state the non-defeasibility condition without speculating on how, or under what criteria, the condition is to be satisfied.[7]

Equally briefly, reliability analyses of justification, as we saw above, typically assert that a person's justification will be nondefective if (or only if, or if and only if) the person's completely justified true belief is the product of a reliable belief-making mechanism. Sometimes the mechanism is understood in terms of one's basic cognitive equipment, and at other times it is a matter of the non-cognitive processes by which one acquires one's beliefs. Ordinarily, as we also saw above, the reliability of one's belief-making mechanisms is construed as a function of whether those mecha-

nisms generally tend to produce, in their usual setting, true beliefs under normal circumstances. Goldman has urged, for example, that if the process that produces a belief is reliable in the sense just specified, and if there is available to the believer no other reliable process that, if used, would have led him not to have the belief, then with respect to that particular belief the person's cognitive equipment has functioned properly; that person has a nondefective belief. If a person's belief-making mechanisms or processes generate true beliefs on some particular occasion, but not generally or usually so, then even though that belief may be true, it is defective; it is not a mechanism or process that generally *tends* to produce true beliefs under normal circumstances.[8] Like causal analyses, reliability analyses basically attempt to specify the logical features of reliable belief-making mechanisms that, when suitably characterized, prevent there being any true proposition such that if it were added to one's justification one would no longer be completely justified in believing what one believes. As Dretske has noted, if you believe that you see Jimmy coming through the door, and Jimmy is coming through the door, but you cannot distinguish Jimmy from his identical twin Johnny, then you do not know that Jimmy is coming through the doorway; your belief-producing mechanism is unreliable because it is not discriminating enough to exclude relevant alternatives defeating your belief that it is Jimmy and not someone else coming through the doorway.[9]

Incidentally, while both causal and reliability analyses assert that the nondefectiveness of a completely justified belief is a function of *how* that belief is generated, reliability analysts sometimes see themselves as offering a distinct and superior kind of causal analysis. Alvin Goldman, for example, has urged that reliability analyses of the general sort he has proposed are superior to typical causal analyses because reliability analyses can accommodate certain Gettier-type counterexamples that most causal analyses could not (such as Goldman's well-known example involving the barn facsimiles).[10] He also thinks that while defeasibility analyses can accommodate such examples, the problem with defeasibility analyses of the sort we have already discussed is that they are

altogether too strong.[11] Accordingly, any alleged refutation of either causal or defeasibility analyses of the sort already discussed will, according to Goldman, not impugn the adequacy of his analysis because it is logically distinct from the other two.

At any rate, given this background music on both how reliabilism has emerged and how it can be logically distinct from other post-Gettier causal and defeasibility analyses of justification, let us proceed without further ado to the question of whether reliability is either necessary, or sufficient, or both necessary and sufficient, for justification or knowledge.

2.3 Reliabilism and Goldman's Theory of Justification

In the following few pages we will see that it is neither a necessary nor a sufficient condition for the justification of a belief that the belief be the product of a reliable belief-making mechanism, method, or process functioning normally in its usual setting. In seeing as much, we will confront Alvin Goldman's defense of reliabilism, which, as delineated in *Epistemology and Cognition*, asserts that it certainly is a necessary condition for the justification of a belief that the belief be reliable, that is, the product of a reliable belief-making mechanism, method, or process. In arguing for the general thesis, however, I will urge that *all* the so-called counterexamples to the reliabilist theories of justification (including those theories asserting that it is sufficient for the justification of a belief that the belief be reliably produced) beg the question against Goldman's position because they all *presuppose* that justification is the activity of providing, or of being able to provide, suitable reasons for one's beliefs. Goldman has argued strenuously against this latter view but, to date, nobody has systematically confronted those arguments rather than simply *assume* their invalidity by incorporating into counterexamples just what would be false if Goldman's arguments are sound. After rejecting Goldman's arguments, and thereby validating some existing counterexamples

to Goldman's reliabilism and reliabilism in general, we will then see that all other available arguments favoring Goldman's position that justification is never the activity of giving reasons are unacceptable.

The bottom line of this discussion will be that epistemic justification is always and only a matter of being able to provide conclusive reasons for one's belief just in case the question "How do you know?" is appropriate. Doubtless, if a person knows that p, then his belief that p is caused by a reliable belief-making mechanism, process, or method. Even so, a person's knowing that p does not require that his belief that p, *in order to be completely justified*, be caused or produced in any humanly specifiable way. By implication, for the sake of determining whether a person knows that p, the correct analysis of knowledge does not require any specification of the way in which a person's belief that p originates or is caused.

2.4 Aunt Hattie, Various Clairvoyants, and Other Counterexamples to Reliabilism

Along with others, Alvin Goldman has argued that a person's belief that p is epistemically justified only if the belief is the product of a reliable belief-making mechanism, method, or cognitive process.[12] Others have argued that reliability is sufficient for justification, and some have argued that it is both necessary and sufficient for justification. In response to these claims we have had a number of counterexamples which fall into two groups: those seeking to show that a person can be justified in a belief that is not reliably produced or generated; and those seeking to show that a person's belief that p can be reliably produced but not justified. Let us take a typical example of each.

As an example of the first type, Carl Ginet offers the following:

Suppose, for example, that it is a mild day in Ithaca but the weather forecast I hear on the radio says that a mass of cold air will move into the region tomorrow. As soon as I hear that, I have, we may suppose, good reason to believe that it will be colder in Ithaca tomorrow; and if

I were caused to believe it by having that reason then my belief would be produced by a (relevant) reliable process. But let us suppose that I irrationally refuse to believe it until my Aunt Hattie tells me that she feels in her joints that it will be colder tomorrow. She often makes that sort of prediction and I always believe her, even if I have no other supporting evidence. She is right about as often as she is wrong. So, the (relevant) process by which my belief is actually caused is not reliable. Nevertheless, my belief is justified. I do have justification for it, namely, my justified belief as to what the Weather Bureau said. Thus I am protected from reproach for holding the belief, though I may deserve reproach for something else, namely, *being moved* to hold it *by* Aunt Hattie's prediction and not by the Weather Bureau's. I could rebut any reproach for my holding the belief by pointing out that I do have justification for it. My recognizing the evidential value of the Weather Bureau's forecast is quite compatible with my (irrationally) refusing to be moved to belief by that evidence.[13]

Given this counterexample, we are led to conclude that reliability is not a necessary condition for justification. To this same end, John Pollock has offered the following:

The simplest and most intuitive objection to reliabilism is that justification is a normative notion and this precludes reliability from playing any direct role in justification. Reliability cannot be a necessary condition for justification because a person can have every reason to think that his beliefs are reliable when in fact they are not. Consider the venerable brain in a vat: Suppose a person is kidnapped in his sleep and his brain is removed from his body and placed in a vat where it is stimulated artificially. If the artificial stimulation is done skillfully enough so that there is no apparent incoherence in his experience, surely when the victim awakes he is justified in the beliefs he has about the normality of his immediate surroundings, although such beliefs are totally unreliable. The reason he is justified is, roughly, that he could not be expected to know better. He satisfies the normative requirement of justification, and that is good enough.[14]

A little later in the same paper (112), Pollock straightforwardly asserts that "justification is a matter of having good reasons for beliefs," and, by implication, being able to state them when challenged, otherwise there would be no role for rebuttal defeaters. For Pollock, there is no way to make reliability a necessary condition for justification, but, interestingly enough, lack of reliability

will defeat a justification. Later we will explain why this last claim is not the contradiction it may appear to be.

As an example of the second kind of counterexample, that which seeks to show that reliability is not a *sufficient* condition for justification, consider Laurence Bonjour's clairvoyant, Norman:

> Norman, under certain circumstances that usually obtain, is a completely reliable clairvoyant with respect to certain kinds of subject matter. He possesses no evidence or reasons of any kind for or against the general possibility of such a cognitive power, or for or against the thesis that he possesses it. One day Norman comes to believe that the President is in New York City, though he has no evidence either for or against this belief. In fact, the belief is true and results from his clairvoyant power, under circumstances in which it is completely reliable.[15]

In accepting this counterexample Marshall Swain says:

> Thus, we must grant that the reliability of a belief is not alone sufficient for the belief to be epistemically justified. . . . To put the matter another way, one can be justified only if one is in a position to defend the claim that one is justified. This requirement for justification would explain why Norman's belief is unjustified, for he is by hypothesis completely unable to offer any justification whatever either for the belief that the President is in New York City or for the claim that he is justified in the belief that the President is in New York City. On the other hand, if Norman knew something about his powers, he might be able to offer some such justification.[16]

2.5 The Reliabilist's Response

But the reliabilist need not accept any of the above counterexamples. This is so because all the above counterexamples in one way or another *assume* rather than prove that epistemic justification is a matter of one's being able to present suitable reasons when challenged, or, as Swain noted when commenting on Bonjour's example, to defend with reasons the claim that one is justified. Pollock implicitly claims as much when he asserts that we must have reasons that meet rebutting defeaters; and the Aunt Hattie example works only because Ginet can, when challenged, justify his

claim by giving reasons about the weather report. If he couldn't defend himself or rebut others by the citation of suitable reasons he would not be justified. All of the counterexamples in one way or another simply plead for the intuition that justification is something distinct from having beliefs that are reliably produced and this something distinct requires the activity of providing, or being able to provide, suitable reasons in defense of one's belief.[17]

However, Goldman, among others, has argued that epistemic justification is *not* an activity of providing reasons, or of being able to provide reasons, for one's beliefs. If Goldman's arguments are sound, then we are epistemically obliged to abandon the intuition that justification is a reason-giving activity rather than simply assert as much in the process of seeking to *show* that justification of a belief is not a matter of the reliability of the belief. If Goldman's arguments are sound, then we cannot without begging the question against reliabilism structure counterexamples that work only because in them one can assume that justification is a matter of being able to give reasons to defend one's beliefs. In short, unless we straightforwardly confront Goldman's arguments, all the above counterexamples ostensibly beg the question against any form of the reliability theory of justification. So, in the interest of not so begging the question against Goldman's thesis and reliabilism in general, we may now examine his arguments to the effect that justification cannot ever be a matter of reason-giving, or the ability to give reasons under certain contexts.

2.6 Goldman's Arguments Against Interpersonalism

In *Epistemology and Cognition*, after coining the expression "J-rules" to designate the rules to be followed in determining the justification of beliefs, Goldman distinguishes between the *interpersonal* and the *intrapersonal* approaches to justification. Thereafter he says:

A prime example of the interpersonal approach focuses on reason-giving as an interpersonal activity. The idea here is that justifications are things we give to other people which the latter either accept or reject. A person is justified in holding a certain belief only if he actually gives others, or could give them, acceptable reasons for the belief. This interpersonal approach is succinctly characterized by Rorty: "Justification is not a matter of a special relation between ideas (or words) and objects, but of conversation, or social practice. . . . [We] understand knowledge when we understand the social justification of belief.

As this passage indicates, the interpersonal approach may also be called a "social" approach to justification. . . . On an intrapersonal approach, permission conditions of J-rules would make no reference to other people. They would restrict themselves exclusively to the cognizer's own mental contents, such as prior beliefs, perceptual field, ostensible memories, cognitive operations and the like. . . . Most traditional epistemologies have indeed focused on such mental states; but they have not been exclusively mentalistic. . . . However, since they make no reference to other people, I shall classify approaches of this sort as intrapersonal, and I will even speak of them (loosely) as "mentalistic" approaches.

There are a number of solid reasons for rejecting the social, or interpersonal approach to J-rules. . . . But the theory of *justification*—at least the theory of *primary* justification—does not require reference to social dimensions.[18]

Goldman then embarks on giving five basic reasons why he prefers the intrapersonal approach to the social, or the interpersonal, approach. The reasons, as I paraphrase them, are as follows:

1. An adequate theory of justification should pertain to *all* propositions, including propositions about other people. A conception of justification that presupposes the existence of others leaves no room for the question of their existence—which a full theory should be capable of addressing. (75)

2. Interpersonal reason-giving depends on intrapersonal reasons. "Whatever a person can legitimately say in defense of his or her beliefs must report or express mental states: his or her premise beliefs, perceptions and the like. What justifies a person is not the statements that might be uttered, but the mental states those statements would express (or describe). . . . The believer's mental condition, or the mental operations he or she executes are fundamental

for justifiedness. Ability to *report* these things is, at best, only of derivative significance. (76)

3. Justified belief is necessary for knowing. "But if we are interested in the conception of justification most closely associated with knowledge, the interpersonal conception of J-rules is too stringent. One can know without being able to give a justification in the sense indicated by the interpersonal theorist. One may possess good reasons for belief without being able (fully) to state or articulate them in verbal form. Our perceptual beliefs, for example, often depend on cues of which we are not wholly conscious, or which we could not characterize in words. Many theoretical beliefs depend on a host of background assumptions that are hard, if not impossible, to bring to the surface, much less itemize exhaustively." (76)

4. "It begs important questions to assume that current justificational status depends on what the cognizer can say *now* in support of his or her belief. Justifiedness may involve *historical* factors, how prior beliefs originated, that the cognizer no longer recalls, and hence could not deploy in argument with an interlocutor. Then, too, what people can say in a debate or defense depends partly on their psychological constitution: how adept they are at dealing with pressureful situations. Some people who have excellent reasons for their belief might choke or clam up. So, dispositions to say things in an interpersonal situation are not the proper measure of justifications." (76)

5. "The guiding idea behind the interpersonal conception is that cognizers are justified only if they can show to others that their view is plausible. I already gave some arguments against this in Chapter 1, but there is more to say. *Which* other potential reason receivers are relevant? What if those persons are too stupid or stubborn to follow one's arguments or abandon prior prejudices?" (77) If nobody understood Einstein, it would not follow that Einstein did not know or was not justified in believing his own theory of relativity.

2.7 Goldman's Arguments Examined

To these five arguments, in the order of their appearance, the following replies are in order.

The first argument offered above incorporates a Strawman because it asserts that the interpersonal theory *assumes* the existence of some particular person whose existence may be questionable. However, were there any doubt about Smith's stated belief that a certain person fitting a particular description exists in a particular place, there are non-controversial ways of justifying his belief. Admittedly, interpersonal reason-giving primarily presupposes the existence of at least one other person in addition to the reason giver because it requires the ability to justify one's beliefs to another. But is it an inadequacy of a presumptively full theory of justification that it does not take other-person solipsism seriously? Is it fair to say that such a theory *presupposes* or *assumes* that the institution of justification requires the existence of more than one person in the world rather than that it reflects a necessary condition for there being any human communication whatsoever? More importantly, why say that such a theory *assumes* the existence of other persons rather than that it states a condition necessary for the correct understanding and proper usage of the concept of justification? Indeed, would native speakers say that Smith is justified in his belief that p if native speakers seriously doubted Smith's claim that p, and Smith, when asked, "How do you know?" could give no reason whatsoever? Hardly. Thus the facts of ordinary usage imply that the ordinary meaning of the concept of justification is tied at root to the activity of giving reasons when and only when the question "How do you know?" (asked as a request for justification and not for the causal ancestry of the belief) is appropriate. Presumably, a theory of epistemic justification, in providing a definition of the concept of justification, may stipulate what we *ought* to mean by expression such as "X is justified in believing that p" only when there is no clear sense of the conditions of correct employment in natural and typical usage. But simply to say it means something that is not captured in correct usage in ordinary discourse or current scientific practice requires some justification other than that it makes certain knowledge claims beyond rational criticism.

Besides, if, as Goldman asserts, a full theory of justification must, in principle, be able to refute solipsism, how exactly does the

intrapersonalist propose to satisfy this demand? On the one hand, if the intrapersonalist gives reasons in order to establish the falsity of solipsism then the intrapersonalist must admit that giving reasons, or being in a position to give reasons, is sometimes a necessary condition for justification. On the other hand, if the intrapersonalist does *not* give reasons, then he *assumes* the intrapersonalist theory of justification and accordingly begs the question against the interpersonalist approach. In short, even if we take seriously the question of other-person solipsism (and nobody does for the very good reason that, incidentally, the thesis has already been conclusively refuted), the intrapersonalist cannot successfully justify the falsity of such solipsism.[19]

With regard to the second argument offered above, certainly, one cannot utter or give reasons unless one has in mind the reasons to give. So, in some sense, being in a certain mental state is necessary or fundamental to the activity of reason-giving. But it by no means follows from this alone that what justifies a person is *not* the statements but the mental states those statements would express or describe. It is one thing to assert as much but quite another to prove it. Indeed, as native speakers we certainly would not say that a person was justified in his claim to know that *p* if there were some good reason to think that he were in error and if, when asked to justify his claim, he either fell silent, or refused, or was just not able to give reasons. This fact implies that, as a matter of ordinary discourse, "being justified" is not something we can always separate from the activity of giving, or being able to give, reasons when the question "How do you know?" is appropriately asked. Moreover, practitioners of the methods of natural science would never grant that a person was justified in his claim to know that *p* if, when appropriately asked "How do you know?" no reasons were given, or could be given.

In short, the core problem with the intrapersonalist thesis grounding reliabilism, is that it adopts the demonstrably false view that it is *never* a necessary condition for being justified in one's belief that one be able to give reasons for what one is said to be justified in believing. Interpersonalists and anti-reliabilists need

have no difficulty in accepting the fact that there are clear cases in which it is not necessary that one be able to give reasons in order to know that something or other is so. Nevertheless, when the question "How do you know?" is appropriate to ask of someone who claims to know something or other, her failure to be able to give convincing reasons is sufficient for her not being justified in her belief.

With respect to Goldman's third argument, in the first place, as we just noted, an interpersonalist can readily grant that one can know without being able to give a justification in the sense of inter-personal reason-giving. An interpersonalist need not hold the view that *all* knowledge requires justification. She might, for example, hold the view that justification is a necessary condition for know-ledge only when the question "How do you know?" would be an appropriate question to ask of someone making a claim to know or to be justified.[20] However, an interpersonalist will insist that where the question "How do you know?" would be appropriate, justifica-tion in terms of reason-giving is not too stringent. Indeed, to Goldman's unargued assertion that one may possess good reasons for one's belief without being able to articulate or express them, the simple truth of the matter is that if a person were to assert that *p* and were not able to answer the question "How do you know?" (when it would be appropriate to ask the question), then we would never say he is justified in his belief that *p*. And it would be crass question-begging to urge that he "might be" justified even though we would never say that he is justified. After all, the meaning of the expression "X is justified in believing that *p*" is a generalization of the conditions under which we would typically use that expression correctly. In short, the idea that we can possess good reasons but not be able to articulate them on demand seems initially intuitively plausible; but given that we would not grant that such a person is justified when she is unable to answer the question, the belief that this could be so is an unproven assumption. More on this later when we examine reliabilism as a theory of knowledge.

Goldman's fourth argument has a number of flaws. To begin with, if X claims to know that *p* at time t_1, and if it is appropriate to

ask X the question "How do you know?" then, typically, if X fails to give reasons when asked, then nobody at time t_1 would ever say that X is justified in his belief. Of course, we can easily imagine circumstances under which X claims to know that p, has conclusive and statable reasons for his claim, but is not *disposed* at t_1 time to answer the question, or refuses for some very good reason to answer the question. In such cases certainly we would grant that he is justified at time t_1 even though he does not in fact answer the question at time t_1. For example, if X failed to answer the question at time t_1 because somebody would harm him if he did, then if later at time t_2 X answers the question when the threat of harm is absent, we would say that X was justified at time t_1 in his belief that p even though he did not in fact answer the question at time t_1. In such a case, however, X's being justified at time t_1 consists in the fact that he *can*, and would, give reasons under normal circumstances in which there is no overriding reason or cause preventing him from giving reasons. So it is possible for a person to be justified in his belief that p even though he does not in fact answer the appropriately asked question "How do you know?" Whenever this is so, however, his being justified consists in his *ability* to give reasons, and in the fact that he *would* give them if he were not prevented from doing so by some overriding cause or reason. Indeed, in the absence of such overriding reasons or causes, we would never grant that he is justified if he doesn't answer the question.

What all this implies is that if X claims to know that p, and if X does not answer the justifiably asked question "How do you know?" then X is not justified in his claim to know that p (or in his belief that p) unless he is in a position (or is able) to give reasons but is prevented from doing so by some overriding reason, or cause, the absence of which renders his failing to answer the question sufficient evidence that he is not justified in his claim or belief. To repeat, even in those cases where we would grant that X is justified in his belief that p even though he does not answer the question "How do you know?" his being justified consists in the fact that he *can* answer the question and *would* answer it if only there were no overriding reasons or circumstances preventing him from doing so.

But if there is no overriding reason or cause preventing him from doing so, we would never grant or say that he is justified if he does not answer the question. Further, wherever we would grant that X is justified without his having actually given reasons, we cannot make sense of his being justified in his belief except in terms of his giving reasons either by *being able to give them* (when overriding causes or reasons prevent the actual giving of them) *or actually giving* reasons when there are no such overriding causes or reasons. Finally, if for the above-stated reasons we grant that X can be justified in his belief without actually giving reasons in response to the question "How do you know?" and if in such cases X's justification is a function of his *ability* to give reasons in the absence of overriding causes or reasons that prevent it, *then* the concept of justification *at the core* is ultimately a matter of giving reasons to answer the question "How do you know?" when and only when it is appropriate to ask the question. Identifying anything with dispositional properties makes no sense except in the context of understanding the occurrence of the manifest property as primary, core, or primitive. To identify, for example, a belief with a disposition to act in a certain way implies that in the absence of overriding or extraordinary circumstances, acting in that way is certainly necessary for saying that a person has that belief.

By implication, the assertion that one can know that *p* in virtue of reasons that one has forgotten and hence cannot state when asked to justify one's claim that *p*, is equally problematic.[21] Suppose, for example, that George forgets at time t_1 the reasons he has for believing that *p*, but remembers quite well that he had good reasons for believing that *p*. When asked "How do you know that *p*?" George cannot give any reasons at time t_1 because he forgets them. Does George know that *p* at time t_1? Certainly, nobody would say George is justified in his belief that *p* if he were not at some time able to give reasons. *Otherwise, we would not be able to distinguish George from somebody who merely says that he knows (but does not) and claims to forget the reasons that justify the claim.* Suppose, however, that George forgets at time t_1 the reasons that justify his claim to know that *p*, and then, after we refuse to grant

that he is justified, he suddenly at time t_2 up and says, "Oh yes, now I remember; the reasons are such and so. I told you I knew; I merely forgot the reasons when you asked." Must we now say that George knew that p at time t_1 even though he forgot at time t_1 the reasons (and hence could not then state such reasons) that justify his belief? It seems tempting to say yes. However, we are at liberty to regard George's being justified as a function of his *ability* to give reasons in the absence of some overriding cause or reason such as forgetfulness. Or we might simply assert that one cannot be said to have a justifying reason, or be justified in one's belief that p, unless one can, and will in the absence of overriding conditions, give the reasons when it is appropriate to ask "How do you know?" We might equally say, "George did not know that p at time t_1 because he couldn't remember the reasons for p, but knows it now because he suddenly remembered the reasons." On this construal, one cannot be said to *have* justifying reasons if one forgets the justifying reasons because as long as one forgets, one is not *able* to answer the question "How do you know?" although certainly she would have some *capacity* for doing so.

Finally, with respect to Goldman's last argument, if Einstein, or anybody else for that matter, presented us with a novel theory of the universe and then, when asked to prove it, gave reasons that nobody could understand, nobody in the scientific community would say Einstein was justified in his belief; and it does not seem to make much sense to say that we would be justified in accepting Einstein's claim simply because of his authority in physics. In physics, what counts for being justified in one's beliefs is basically a matter of being able to show to the community of physicists that what the theory implies (given certain provisos and initial probabilities) obtains, or would obtain under certain circumstances. Einstein went to his grave completely convinced that quantum theory had to be wrong; but nobody in the scientific community, for that reason alone, thinks it would be justifiable to believe that Einstein was right. Other than that, it is only a suggestive hypothesis that ought to be taken seriously because Einstein proposed it. Once again, this fact tells us what we typically *mean* in ordinary dis-

course by "X is justified in his belief that *p*." So, it will not do to suggest, as some have, that even though we would never *say* Einstein was justified in his belief, nevertheless he could still *be* justified in his belief. Here again, Einstein's *being* justified in his belief is basically a matter of whether we would grant or *say* that he is justified, and if we would *not* say he is justified (as indeed we would not if he could not ever provide suitably convincing reasons when properly challenged), then it is gratuitous to suppose that he might be justified even though we would not say that he is.

Suppose the scientific community subsequently came at a later date to understand and accept Einstein's novel theory of the universe, even though when Einstein initially gave his reasons for the theory the scientific community was too dull to understand either the theory or the reasons Einstein offered as justification. Would that show that Einstein really was justified earlier when he uttered his reasons? Yes, of course. But that is not an argument against interpersonalism, and it does not contradict what we just said in the last paragraph. Indeed, if, as we have already argued, interpersonalism does not require that one actually give reasons on any particular occasion when legitimately asked for a justification, it cannot coherently require that one actually give *persuasive* reasons on any particular occasion when properly asked for a justification. The only requirement is that one be able to give persuasive reasons and, in the absence of over-riding constraints, give them sooner or later. In this Einstein example (but not in the one in the paragraph above), the reason Einstein is justified in his beliefs is that he is able to give persuasive reasons because even though when he gives them initially nobody accepts them, the scientific community comes to accept them as persuasive; hence Einstein would be justified because the reasons he gave were persuasive because they came to be accepted by the scientific community. In short, interpersonalism requires for justification the giving of persuasive reasons in the absence of over-riding constraints, but it by no means follows that one's reasons when given are persuasive only if they are accepted as persuasive by one's immediate audience. Even so, if one never gives reasons, one never gives persuasive reasons;

and if one never gives reasons (when it is appropriate to ask for reasons) in the absence of ultimately discernible over-riding constraints, it is reasonable to assume that one cannot give reasons, and if one cannot give reasons for one's beliefs, one is not justified in one's belief.

Secondly, the "guiding idea" behind interpersonalism is *not*, as Goldman claims, that cognizers are justified only if they can show to others that their view is plausible. Although this is an implication of interpersonalism, the "guiding idea" behind it is rather that the concept of justification is not to be defined except in terms of reason-giving, or the capacity to give reasons, when the question "How do you know?" is appropriate. Admittedly, interpersonalists will need to specify just what features justifying reasons will need to have in order to succeed as good or justifying reasons. But we should not allow difficulties in the latter activity to stand as sufficient grounds for the view that reason-giving is never, under any circumstances, a necessary condition for justification, as though failing to specify just what counts for a good reason were somehow sufficient for saying that justification does not consist in the ability to give good reasons under the right circumstances. If Goldman were correct in his reasoning here we would need to accept the core thesis of intrapersonalism, namely, that a person need never give reasons for his belief that *p* (even when the question "How do you know?" is appropriate) in order that he be justified in his belief that *p*. What makes it difficult to consider seriously the latter conception of justification is that it does not allow us to distinguish between people who think that they know and happen to be lucky in guessing the truth, and those who really know. This incapacity is one strong reason why we should reject intrapersonalism. For all the above reasons, Goldman's attack on interpersonalism fails.

2.8 The Responses Examined

In direct response to these arguments, however, Goldman has argued that unfortunately what is wrong with the foregoing defense of interpersonalism is that it does not provide enough details to

make it plausible that an interpersonal theory can work.[22] He notes that since it is obviously not a sufficient condition for justification that one be able to give some reasons or other for his belief that p, interpersonalists need to say what else is sufficient. He goes on to say:

> What then is sufficient? Must S be able to give reasons that will persuade, or satisfy a relevant audience? Which audience is relevant? Let us call an audience a justification-conferring audience (a "JC audience") if their disposition to be persuaded, or satisfied by offered reasons is necessary and sufficient for those reasons to be justifying. What properties make an audience a JC audience? Some interlocutors might be extremely stubborn, counter suggestible, and difficult to persuade. They might be radical skeptics like Descartes. To include such people within the JC audience would presumably be too strong a condition on justified belief. Other interlocutors might be too gullible, too easy to persuade or satisfy. Their inclusion within the JC audience would be too weak a condition on justified belief. Similarly, people too stupid or ill-informed to understand the proffered reasons would be unsuitable. Are there, then, some sort of "ideal" agents that would fit the requirements for a JC audience? Neither Almeder and Hogg nor other writers have shown what properties such agents would have. Thus, the interpersonal theory of justification has some very high hurdles to jump before it becomes a serious and plausible theory.[23]

Before proceeding, a few comments on this reply seem appropriate. First, as we have already noted above, the issue at hand is whether the capacity to give reasons is ever a necessary condition for justification; it is not what properties a given reason must have in order to succeed as a justifying reason. The above arguments for interpersonalism are arguments for the view that it is sometimes a necessary condition for justification that one be able to give reasons in favor of one's belief, and that is certainly a thesis quite distinct from one which seeks to specify what features of a given reason will count for its succeeding as a justifying reason. Succeeding at the latter is not necessary to refute intrapersonalism and, by implication, reliabilism because reliabilism claims that it is *never* a necessary condition for justification that one give or be able to give reasons for one's belief. Goldman's response to the above arguments is, therefore, irrelevant to the question at hand.

Of course, if Goldman could *show* that there is no possible way to coherently or successfully specify what such a feature would consist in, that would be quite a compelling reason for thinking that there must be something wrong with interpersonalism. But suggesting as much is not the same as *showing* it. Certainly, as we noted above, interpersonalists will need to say what will count as sufficient for justification, but we should not fault them for failing to provide a sufficient condition for justification when what is at issue is whether the capacity to give reasons is sometimes a necessary condition for justification. Moreover, we cannot plausibly construe Goldman's response here as accepting the capacity to give reasons as a necessary condition for justification but rejecting interpersonalism for the reason that the theory cannot succeed in specifying a suitable definition that is both necessary and sufficient. As just noted, Reliabilism denies that the capacity to give reasons is ever a necessary condition for justification.

Secondly, Goldman's claim that interpersonalism is not a serious or plausible theory because no interpersonalist has yet succeeded in specifying what is a sufficient condition for justification, is also quite dubious. In short, not only is the response irrelevant, it would be unacceptable even if it were relevant. Let me explain.

Goldman asserts that the viability of interpersonalism will depend on its being able to provide a sufficient condition for justification, and that the latter will consist in the ability to give reasons that will persuade or satisfy a relevant audience. He then claims that nobody has yet shown what properties make an audience a relevant audience. Just as some people may be too stubborn, countersuggestible or skeptical thereby rendering their inclusion in a relevant audience too strong a condition on justification, others will be too gullible, too stupid, or too easy to persuade, thereby rendering their inclusion in a relevant audience too weak a condition on justification. And so, until interpersonalists can succeed in specifying the features of a relevant audience, interpersonalism is not plausible.

Interpersonalists, however, can easily respond to Goldman's challenge. They need only appeal to Peirce's scientific community

(following the methodology of the natural sciences) as the relevant audience. On this view, a justifying reason is one that would persuade the community of scientific inquirers, broadly conceived, whose methods and standards of acceptance allow us to counter the real possibility of error as a result of those who are stubborn, countersuggestible, skeptical, gullible, stupid, or easily persuaded. Hence, a reason is a justifying reason just in case, when given, it supports the claim and just in case there is no good reason anybody (or any epistemically responsible agent) can find that undermines the subject's belief. Presumably, such a reason is persuasive because it does, or could, succeed in commanding the assent of the ongoing community of responsible inquirers. Assuming we can spell out reasonably clearly what a good reason is, why exactly would a interpersonalist need anything more by way of providing a sufficient condition for justification? Does anybody think that robustly confirmed beliefs in science are not justified beliefs? If not, the interpersonalist need only specify the features of the relevant audience in terms of the ongoing community of scientific inquirers following the methods of the natural sciences. And if that specification seems just a bit too constrictive, we can always add a disjunct extending to the community of non-scientific epistemically responsible inquirers who may not be using the methods of the natural sciences. So, it certainly does not seem too difficult for the interpersonalist to meet Goldman's challenge. More importantly, the basic point here is that the interpersonalist need not respond to such a challenge because the challenge itself is irrelevant as a response to the above arguments seeking to show that it is sometimes a necessary condition for justification that one be able to give reasons in favor of one's belief.

In further replying to the above arguments against Goldman's attack on interpersonalism, Goldman has offered what he describes as a different sort of example that strongly favors intrapersonalism over interpersonalism. He asks us to consider the case of Judy and Trudy who are identical twins:

> Sam has just acquired an ability to tell these two twins apart on the basis of very subtle facial features, but he has no idea what these

features are. All he can give by way of "reasons" is: "That just looks like Judy to me" and "That just looks like Trudy to me." Are these adequate reasons to persuade someone that it *is* Judy, or that it *is* Trudy? Presumably not. Sam could have offered similar reasons when he still lacked the ability to distinguish Judy and Trudy. At that earlier time he was not justified in holding such beliefs; at least he was not in a position to know. So these must not be adequate reasons. Since they are the only reasons Sam can give now, as well as earlier, the interpersonalist approach must say that Sam is not currently justified in his beliefs. But this is counter-intuitive. It seems to me that Sam is now justified. Certainly he can *know* by means of his perceptual cues that it is Judy, or that it is Trudy. According to Almeder and Hogg, moreover, if Sam knows, then he must have justified belief as well. For they admit that justification is a necessary condition for knowledge as long as it is "appropriate," or makes sense, to ask for a justification. Surely, in this case it is appropriate, and does make sense, to ask for justification.[24]

The basic problem with this example is in the first sentence where we are asked to suppose that "Sam has just acquired an ability to tell the two twins apart on the basis of very subtle facial features." Does this mean merely that Sam knows *how* to distinguish the identical twins, or does it mean that Sam knows *that* the twin he designates as Judy is Judy, or the twin he designates as Trudy is Trudy? Presumably, because we are concerned with propositional knowledge, we are not being asked to suppose merely that Sam knows *how* to tell the twins apart. So, we are being asked to suppose that Sam knows *that* the twin he designates as Judy is Judy and the twin he designates as Trudy is Trudy. For the interpersonalist, to suppose as much implies that, if asked, Sam can or could provide persuasive reasons in justification of his claim that this one is Judy or this one is Trudy. At this point the example becomes problematic because it now asks us to suppose that the reason Sam gives to justify his claim that this one is Judy or this one is Trudy is not at all persuasive. How can a consistent interpersonalist accept simultaneously that Sam knows that *p* even though the reason Sam gives in justification for his belief is not persuasive? In short, when properly unpacked, the example begs the question against the interpersonalist by supposing that there is nothing incoherent about saying that a person can know that *p* and not need to provide

persuasive reasons when the question "How do you know?" is appropriate. Indeed, asking an interpersonalist to accept the example as particularly persuasive is asking the interpersonalist to suppose for the sake of proving the falsity of interpersonalism that interpersonalism is false. By implication, the example smuggles into the back door just what needs to be proven, namely, that Sam can know that something or other is so without being able to provide persuasive reasons when his claim to know is legitimately questioned. Why is this an example strongly supportive of intrapersonalism rather than a special pleading for the very intuition that needs to be established in some other way? That such an intuition needs to be established rather than pleaded is simply a function of the fact that all the arguments offered above for interpersonalism (and the remaining arguments that we will see below when discussing Dretske's views) should be regarded as direct attacks on the legitimacy of the intrapersonalist's basic intuition. Pleading that intuition by assuming it in counterexamples *after the arguments against it are on the table* is question-begging. The proponents of intrapersonalism can only successfully plead such an intuition after showing directly that the many arguments offered by the proponents of interpersonalism, both against intrapersonalism and for interpersonalism, are unsound. This is not done simply by pleading anew the intuition which, if the arguments offered by the interpersonalist are sound, should be rejected. Perhaps the question-begging nature of this intrapersonalist response, and a few others we will see below, will become more obvious when we examine below all the other reasons why intrapersonalism fails and why it is sometimes necessary that one be able to give, and in fact give, good reasons for one's views if they are to be items of justified belief or knowledge (see especially 132–37 below).

Moreover, there is something else wrong with this example. In the example it is inferred that if Sam were to give as justification for his claim that "This one is Judy and not Trudy" simply the reason "that just looks like Judy to me," he would not have provided an adequate reason to persuade someone that it *is* Judy because he could have used the same reason when he was not in a position to

know, when he did not have the ability to distinguish the two. In reply, however, is it meant to be obvious that if a given reason is inadequate when one does not know what one claims to know, the same reason is inadequate when one does know what one claims to know? For a number of reasons it seems like the sort of claim one needs to prove.

After all, might it not be the case that Sam now knows that "This one is Judy" because in a sufficient number of past cases when he was right in his identifications he gave as his reason "that just looks like Judy to me"? Certainly, that reason could now count as a persuasive reason whereas it would not count as persuasive when he first uttered it because when he first uttered it as a reason we had no grounds to think in virtue of the reason alone that he in fact knew that "This one is Judy." Early on we would have said "The fact that she looks like Judy to you is not enough to persuade us that it is Judy." In this case Sam would not know that it is Judy *and* his reason would be inadequate. But if Sam has established a long string of successful identifications followed by the stated reason "that just looks like Judy to me" or "that just looks like Trudy to me," we would justifiably come to regard his current claim that "this one is Judy" as justified just in case he stated as a reason "that just looks like Judy to me." In that case the same reason could be inadequate when he did not know what he claimed to know but be quite adequate when he did know what he claimed to know. So, it is hard to see how this example establishes intrapersonalism over interpersonalism.

Ostensibly, there is presently only one argument against his form of reliabilism that Goldman regards as worthy of sustained discussion. In his essay "Strong and Weak Justification," he says:

> I want to turn immediately now to an example of central interest, the case of a cognizer in a Cartesian demon world. Focus on the perceptual beliefs of such a cognizer. These beliefs are regularly or invariably false, but they are caused by the same internal processes that cause our perceptual beliefs. In the Cartesian demon world, however, those processes are unreliable. (I assume that either there is just a lone cognizer using those processes in that world or that the demon fools enough people to render those processes insufficiently reliable.) Then according

to the proposed account of *strong* justifiedness, the cognizer's beliefs are not justified. This sort of case is an ostensible problem for reliabilism, because there is a strong temptation to say that a cognizer in a demon world *does* have justified perceptual beliefs. The course of his experience, after all, may be indistinguishable from the course of your experience or mine, and we are presumably justified in holding our perceptual beliefs. So, shouldn't his beliefs be justified as well?[25]

After noting that this objection to reliabilism has been raised by a number of philosophers,[26] Goldman proceeds to show by way of appealing to the distinction between strong and weak justification that the victim of the demon has weak justification but not strong justification and, to be sure, reliabilism demands strong justification. Drawing this distinction is supposed to accommodate the strong tendency to grant that people really are justified when they believe blamelessly without knowing that there is a method that if used would defeat their claim (59). Goldman then proceeds to respond to some potential objections to this way of answering the proposed counterexample. Without examining his responses to proposed objections to his way of dealing with the counterexample, however, we should examine more closely the counterexample because there is good reason to think that the counterexample is more problematic than it initially appears. Let me explain.

To begin with, given the above stated counterexample, nobody *should* be tempted to think that the cognizers in the demon world are justified in their beliefs simply because their beliefs are produced by belief-making mechanisms (or experiences) that *seem* to be indistinguishable from those that produce justified beliefs outside the demon world. The counterexample asserts explicitly that one and the same set of belief-making perceptual mechanisms can be both reliable outside the demon world and unreliable in the demon world, but because they are the same mechanisms (since based upon allegedly indistinguishable courses of experience) which produce justified beliefs outside the demon world, beliefs produced by them in the demon world seem equally justified even though unreliable. But can they be the same mechanisms producing reliable beliefs outside the demon world and unreliable beliefs

inside the demon world? Can the *same* set of internal mechanisms be both reliable outside the demon world and unreliable in the demon world, as we are asked to assume in this counterexample?

It's one thing to imagine a mechanism, such as a compass, that is a reliable indicator of direction at the equator but an unreliable indicator of direction at the North Pole.[27] Such mechanisms can be reliable or unreliable depending on external factors, or on whether they are functioning normally in their usual setting. And it certainly seems to be the same mechanism in each case, different results occurring from its use being a function of differing circumstances in which it is used. But, in the above counterexample, *after* one is explicitly told that the cognizer's belief-making mechanisms are unreliable (as indeed we are told when we are told that they are functioning in the Cartesian demon world), it seems inconsistent to suppose that the cognizer's belief-making perceptual mechanisms are the *same* ones that are reliable outside the Cartesian demon world. After all, if a set of internal perceptual mechanisms is reliable (that is, generally produces true beliefs) outside the Cartesian demon world, but fails to be reliable in a Cartesian demon world, why is that not a good reason for saying that they cannot literally be the same internal mechanisms, otherwise it would not be possible for them to generate different results?

Are we to assume, instead, that in the demon world the mechanisms are unreliable because the demon changes the world in a way that is ever undetectable but leaves the belief-making perceptual mechanisms alone? In such a world, for example, every time anyone saw a ship and formed the perceptual belief that he was seeing a ship, the belief would be unreliable (and hence not always true) because the demon changed the world to make things appear that way when in fact they are not that way. But even if this is what the demon does in the demon world, the fact of the matter is that, whatever the cause, the belief-making mechanisms in the demon world are unreliable because they have now the property of not being able to produce reliably true beliefs whereas in the real world they are reliable and hence have the different property of being able

to produce reliably true beliefs. They are, in short, different mechanisms.

As a matter of fact, if a specific set of internal mechanisms produces true beliefs in this world but does not produce true beliefs in the Cartesian demon world, *it could only be because in the Cartesian demon world those otherwise reliable mechanisms are changed by the demon so as to fail to produce what they otherwise ordinarily produce functioning normally in their usual setting. The demon can change these mechanisms either indirectly by changing the world itself or directly by changing the mechanisms. Placing the internal mechanisms that produce true beliefs in our world into the Cartesian demon world is by definition to change the nature of the mechanisms (because they no longer produce true beliefs) and thereby to render them quite different mechanisms acting outside their usual setting.*

By implication, we can, if we like, argue that the compass which is reliable at the equator is not the same compass that is unreliable at the North Pole, even though it appears indistinguishably the same to the ordinary observer. Certainly, no parts are added, and no parts are taken away from the compass in either location; and we can also assume that none of the parts are rearranged. But now some parts of the mechanism are not working as they usually work at the equator; and this is because the North Pole *changes the compass* into an unreliable mechanism just as in the Cartesian demon world the evil demon changes the internal processes when they no longer tend to produce true beliefs. In short, we cannot justifiably suppose, as the counterexample above implies, that one and the *same* set of internal processes could produce true beliefs in our world and yet fail to produce true beliefs in the Cartesian demon world, and justifiably regard the set as functioning normally in its usual setting. For the same reason we cannot coherently suppose that one and the same set of reliable processes can fail to produce true beliefs in the Cartesian demon world and yet produce true beliefs outside the Cartesian demon world. From some limited perspective they merely appear to be the same set of processes. So, what the counterexample requires in order to justify the temptation

to think that unreliable processes could produce justified beliefs in the demon world, namely, that although reliable in our world and unreliable in the demon world they are nonetheless the same processes as produce justified beliefs in this world, is either false or at least very questionable. There is as much reason to suppose that processes that are unreliable in the demon world are just not the same processes as those that are reliable in this world, even though from some limited perspective they may appear to be the same outside the demon world. *Why should we suppose that A and B are the same causal mechanisms when they produce different results in different contexts, rather than suppose that A and B are in some clear sense not the same causal mechanisms because, altered in some way by differing context, they produce different results in different contexts?* Admittedly, this question raises more and interesting questions about the nature and criterion of identity for mechanisms and processes, a number of questions we cannot here probe. But as soon as we grant that the question makes sense, we seem to undermine the belief that if two mechanisms are seemingly indistinguishable from some point of view, they are the same even if they produce different effects in different contexts.

One possible reply to the above general argument that the counterexample fails because one and the same mechanism could not be reliable outside the demon world and unreliable in the demon world is that if we take advantage of an internalist characterization of "belief-forming mechanism," it will be easy enough to see how the same mechanism can produce reliable beliefs in one context and unreliable beliefs in another. Suppose, for example, the believer in each context is simply forming beliefs on the basis of how the world seems to her. In such a world the same belief-forming mechanism could be reliable in one context and unreliable in another. And since we cannot exclude automatically this internalist conception of mechanism or process without begging the question against he central claim in the countererxample, there is nothing wrong with the counterexample. Or so it might seem.[28] But the problem with this objection is twofold.

First of all, the conclusion that it cannot be the same mechanism or method that produces reliable beliefs outside the demon world but unreliable beliefs in the demon world is simply the best available explanation of the fact that in the counterexample the methods or mechanisms used outside the demon world are reliable but not reliable in the demon world. To the question "How can we explain the fact that one and the same method produces reliable beliefs outside the demon world but unreliable beliefs in the demon world?" there is no answer offered by those who would define the method simply in terms of somebody's *forming beliefs on the basis of how the world seems to her*. That would be something that needs to be explained, and I am arguing that it cannot be explained on the assumption that we have indeed one and the same method or mechanism or process being employed in the different contexts. When the compass does not work in one place but does work in another, the working of the compass is different in each place even though we may not have changed the physical parts; but the property of working accurately is a real property of the compass in one place and not in another place; and there is no way to explain this difference in reliability except to say that the place has in some way changed the compass rendering it accurate in one place but not in another. How else explain the reliability in one place and not the other but to say that in some crucial way it is not the same compass? Ditto for belief-making mechanisms, methods or processes: There is no way to explain their difference in reliability inside and outside the demon world on the assumption that it is one and the same mechanism, method, or process. Saying, for example, that the demon makes it so, is not an explanation because we want to know how the demon could do that without altering or changing the methods that when used in the regular world are reliable.

Secondly, as belief-forming mechanisms, methods or processes go, one can hardly claim that the method of forming belief simply in terms of how the world seems would be demonstrably reliable; and so it cannot be the reliable method outside the demon world referred to in the counterexample.

Moreover, we can question whether we ought to define a belief-making method or mechanism in terms of one's forming beliefs simply on the basis of how the world seems to her. Rather than being a belief-forming method, mechanism, or process, it seems more like a judgment on the subject's part to the effect that the belief formed by some mechanism or other is true or worthy of acceptance.

Incidentally, another difficulty with the above demon-world counterexample is that in its very statement it seems to beg the question against reliabilism rather than counter it. This it does by explicitly asserting that we are presumably justified in accepting our perceptual beliefs as reliable outside the demon world, and then imagining that the *same* mechanisms that produce these perceptual beliefs can produce unreliable beliefs in the demon world. Quite apart from what we have already argued above, can one actually imagine all this without assuming, rather than reflecting, a conception of justification that does not require reliability as a necessary condition for either justification or knowledge? Do not reliability theorists argue for and believe that their perceptual beliefs are justified only to the extent that they are the product of reliable-belief making mechanisms? If so, can they imagine consistently, even for the sake of discussion, a belief that is allegedly justified but not the product of reliable belief-making mechanisms? More importantly, we can only imagine, or assume as plausible, a world in which beliefs are justified but not the product of reliable-belief making mechanisms if we have already rejected for good reasons elsewhere the reliabilists' claim. Or so it would seem.

This last objection, of course, comes close to the implication that all counterexamples are question-begging assertions. In fact, however, the only time a counterexample should be construed as a question-begging activity occurs, as we noted earlier, when the thesis allegedly countered has already been argued for strenuously and the intuition behind the counterexample refuted by those antecedent arguments. In such a world, the intuition behind the counterexample begs the question against the thesis because there are already strong arguments on the table for the illegitimacy of

appealing to the intuition behind the counterexample. Some, but by no means all, counterexamples beg the question against what they are seeking to counter. By itself, the demon-world counterexample would be a non-question-begging counterexample only if its proponents have already examined, and found lacking, those independent arguments for reliabilism. Appealing to the counterexample without determining whether the independent arguments for reliabilism have failed, opens the counterexample to the charge of question-begging.

But even if I am wrong in claiming that the demon-world counterexample seems to beg the question against reliabilism, the first argument noted above would seem to be sufficient for the rejection the demon-world counterexample to reliabilism.

Because of the above difficulties in the very statement of the counterexample, Goldman need not have taken it seriously, much less develop a distinction between weak and strong justification in order to diffuse its alleged force. In the end, of course, even if we agree with Goldman and others in taking this counterexample seriously; and even if we accept Goldman's proposal as a response to the counterexample, there are much more interesting and persuasive objections against reliabilism as a theory of knowledge or as a theory of justification. So, it is not as though the anti-reliabilist position rises and falls with the above counterexample.

2.9 The Argument for Intrapersonalism

More positively, however, Goldman's basic reason *for* intrapersonalism lay in his belief that reason-giving is appropriate only for the activity, or the behavior of, justifying a belief. On this view, reason-giving may well be appropriate for *a person's being justified* in believing a certain proposition, but the justification of a belief is primarily a function of the evidence that makes *the belief* justified rather than *the person* justified in believing a certain proposition. Given this thesis, the behavior or the activity of reason-giving may

well serve some basic purpose properly associated with *a person being justified in accepting a certain proposition, but the concept of justification should focus on whether the proposition accepted is justified,* and this latter activity does not require the activity of reason-giving on the part of the person said to be completely justified in believing that *p*. So much seems to be implied when Goldman says (after denying that he assumes interpersonalism) that "A theory of justified belief will be a set of principles that specify the truth conditions for the schema 'S's belief in *p* at time *t* is justified,' i.e., conditions for the satisfaction of this schema in all possible cases."[29]

In other words, apart from his direct attack on interpersonalism, Goldman's argument for intrapersonalism consists in urging that the proper expression to be analyzed in explicating the concept of justification is "S's belief that *p* at time *t* is completely justified" and not "X is completely justified in believing that *p*." Only the latter expression would require of justification the activity of reason-giving.[30] Moreover, according to Goldman, the latter expression captures a sense of "justified" under which a person need not have a belief at all in order to be justified in believing. In defense of this latter claim, in the same place he says:

> There is a use of "justified" in which it is not implied or presupposed that there is a belief that is justified. For example, if S is trying to decide whether to believe *p* and asks our advice, we may tell him that he is "justified" in believing it. We do not thereby imply that he *has* a justified belief, since we know he is still suspending judgment. What we mean roughly is that he *would* or *could* be justified if he were to believe *p*. The justificational status we ascribe here cannot be a function of the causes of S's believing that *p*, for there is no belief by S in *p*. Thus, the account of justifiedness we have given thus far cannot explicate *this* use of justified. (21)

Accordingly, for Goldman, because what is crucial to whether a person knows a proposition is whether he has an actual belief in the proposition that is justified, the appropriate analysandum for the theory of justification is "S's belief that *p* at time *t* is completely justified" and *not* "X is completely justified in believing that *p*"

since the latter expression does not require of a person said to know that he actually have a belief. But does this argument succeed in establishing intrapersonalism?

2.10 Critique of the Argument for Intrapersonalism

Not really. Why? To begin with, the statement that ostensibly needs explication in the interest of analyzing the concept of justification suitable for the third condition of human knowledge is "X is completely justified in believing that p." This latter statement admittedly does not have the same meaning as "X's belief that p is completely justified." As a matter of fact, we can easily imagine circumstances under which X's belief that p is completely justified (as, for instance, in Goldman's example about Henry who sees a real barn rather than the facsimile of a barn) although X would not be justified in believing that p. Moreover, if all this is so, why should we accept as the linguistic unit to be explicated "X's belief that p is completely justified" rather than "X is completely justified in believing that p"? Goldman's answer is that the latter expression employs a sense of "justified" which allows that a person could be justified in believing that p even though the person not have the belief that p; and because it is crucial to the concept of justification that the person justified in believing that p have the belief that p, then the proper analysandum for a theory of evidence will be "X's belief that p is justified."

But this last argument is unacceptable for two reasons. In the first place, the classical definition of knowledge, the definition challenged by Gettier-type counterexamples, draws the third condition of knowledge stated in terms of *X's being justified* (or completely justified or fully warranted) *in believing* what he does believe. Indeed, if the justification condition of knowledge is explicated in terms of whether the *belief* that p is completely justified, rather than in terms of whether the *person* is completely justified in believing that p, it is difficult to see how we are any longer analyzing the

concept of justification as it applies to the classical concept of knowledge. So, as long as we insist that the concept of justification necessary for human knowledge is what emerges from the analysis of "X is completely justified in believing that p" we have little reason to accept Goldman's argument for intrapersonalism because the latter depends on the gratuitous assertion that the unit to be analyzed is "X's belief that p is completely justified." Therefore, for this reason it is difficult to see how Goldman's construal of the explicandum suitable for an adequate theory of justification is not a simple case of question-begging against interpersonalism in favor of intrapersonalism. On his own reasoning, if the explicandum were "X is completely justified in believing that p," then the activity of giving reasons would be necessary for justification under certain circumstances.

Secondly, and more importantly, Goldman claims that the sense of "justified" implied in expressions such as "X is completely justified in believing that p" allows that a person could be completely justified in believing that p and yet not have the belief that p; and thus, because it is crucial to whether a person knows that p that he actually have the belief that p, the proper analysandum for an adequate theory of justification will need to be "X's belief that p is completely justified." In response to this line of argumentation, however, it is difficult to see exactly just how the sentence "X is completely justified in believing that p" can fail to entail "X believes that p." Indeed, it seems straightforwardly contradictory to say "Smith is completely justified in believing that p, but Smith does not believe that p," or "Smith is justified in believing that p, but Smith does not have the belief that p."

2.11 Six More Arguments Favoring Intrapersonalism

William Alston argues for the distinction between *being justified* and *showing that one is justified*. For Alston, what is necessary for knowledge is that one be justified in one's belief, but being justified

in one's belief does not require that one *show*, or be able to *show*, that one is justified by the activity of giving reasons.[31] In defending this distinction, and by implication intrapersonalism against interpersonalism, Alston submits the following arguments not already implied in the arguments offered by Goldman and just discussed in the last section:

1. It is a truism in epistemology that one can be justified in believing that *p*, even on the basis of reasons, without having argued from those reasons to *p*, and thus without having engaged in the *activity* of justifying the belief. Since we do not often engage in such activities we would have precious few justified beliefs if this were not the case. . . . It even seems possible to be justified, on the basis of reasons, in believing that *p* without so much as being able to produce an argument from those reasons to *p*. It may be that the reasons are too complex, too subtle or otherwise too deeply hidden (or the subject too inarticulate) for the subject to recover and wield those reasons . . .[32]

2. If one had to justify one's beliefs by engaging in the *activity* of justifying one's beliefs we would not be able to avoid logical circularity in our beliefs.[33]

3. There is no "remotely plausible argument for the thesis that I can be justified in believing that *p* only if I have justified that belief."[34]

4. Justification as an activity of giving reasons is not necessary because it presupposes that belief-formation is voluntary.[35]

5. It seems clear that children and animals know certain things, and yet it is incongruous to even apply the concept of justification as reason-giving to them. Thus, it appears that there are clear cases of knowledge that do not require justification as a reason-giving activity.[36]

As a general and relevant summation of his position and the reasons for it, in "An Internalist Externalism" as it appears in *Epistemic Justification*, Alston says:

First I want to call attention to a view of justification I do not accept. Suppose with pragmatists like Peirce and Dewey and other contextualists, we focus on the *activity of justifying* beliefs to the exclusion of the

state of being justified in holding a belief. The whole topic of epistemic justification will then be confined to the question of what it takes to successfully carry out the activity of justifying a belief, showing it to be something one is entitled to believe, establishing its credentials, responding to the challenges to its legitimacy, and so on. But then the only considerations that can have any bearing on justification (i.e. on the successful outcome of such an activity) are those that are cognitively accessible to the subject. For only those can be appealed to in order to justify the belief.

Now I have no temptation to restrict the topic of epistemic justification to the activity of justifying. Surely epistemology is concerned with the epistemic status of beliefs with respect to which no activity of justification has been carried on. We want to know whether people are justified in holding normal perceptual beliefs, normal memory beliefs, beliefs in generalizations concerning how things generally go in the physical world, beliefs about the attitudes of other people, religious beliefs, and so on, even where as is usually the case, such beliefs have not been subjected to an attempt to justify. It is quite arbitrary to ban such concerns from epistemology.

But though the activity of responding to challenges is not the whole story, I do believe that in a way it is fundamental to the concept of *being justified*. Why is it that we have this concept of *being justified in holding a belief* and why is it important to us? I suggest that the concept was developed, and got its hold on us, because of the practice of critical reflection on our beliefs, of challenging their credentials and responding to such challenges—in short, the practice of attempting to *justify* beliefs. Suppose there were no such practice; suppose that no one ever challenges the credentials of anyone's beliefs; suppose that no one ever critically reflects on the grounds or basis of one's own beliefs.

In that case would we be interested in determining whether one or another belief *is* justified? I think not. It is only because we participate in such activities, only because we are alive to their importance, that the question of whether someone is in a state of *being justified* in holding a belief is of live interest to us. I am not suggesting that being justified is a matter of engaging in, of successfully engaging in, the activity of justifying. I am not even affirming the less obviously false thesis that being justified in believing that *p* is a matter of *being able* to successfully justify the belief. Many persons are justified in many beliefs without possessing the intellectual or verbal skills to exhibit what justified those beliefs. Thus the fact of being justified is not dependent upon any particular actual or possible activity of justifying. What I am sug-

gesting is that those facts of justification would not have the interest and importance for us that they do have if we were not party to a social practice of demanding justification and responding to such demands. (235–36)

Finally, there is an argument offered by Marshall Swain, and the argument reflects David Armstrong's view. This argument asserts that it is quite conceivable that a person make very reliable knowledge claims, provide no justification for the claims, and not even believe that his beliefs are reliable; and yet we would still say he knows—and thus must be justified in his belief.[37] This argument feeds on examples such as "The Rocking Horse Winner" and Ginet's clairvoyant weather forecaster, the latter of whom is always right when she asserts what the temperature Celsius is in Sydney, Australia; but she does not know, or have any reason to believe, that her beliefs are reliably produced.[38] Swain and Armstrong think that even if she did not know or believe that her beliefs are reliably produced, someone else who does know as much can rely on her beliefs as a good guide to the facts about the current temperature in Sydney. In short, one can use her beliefs as detectors of these facts. The clairvoyant's beliefs convey information to us in the way that a properly functioning thermometer conveys information; if they are capable of providing us with knowledge, then the clairvoyant's claims should be considered as items of knowledge, because her claims are completely reliable signs of the truth of the propositions believed. Therefore, the giving of reasons need never be a necessary condition for human knowledge. Let us consider these six arguments.

2.12 Evaluation of These Six Arguments

Alston's first argument asserts that it is simply a truism that one *can* be justified in one's belief without having engaged in the activity of justifying the belief. True enough, but from this it by no

means follows that one need never give, or be able to give, persuasive reasons in order to be justified in one's belief, and the latter is Alston's avowed position. Indeed, given all we have argued above, when asking the question "How do you know?" is appropriate, then, given the usual meaning of "justified," such a person will not be said to be justified in his claim to know *unless* he is at least able to provide persuasive reasons for the claim, and actually succeeds in doing so in the absence of overriding constraints.[39] Thus the interpersonalist will require the activity of justification as a necessary condition for knowledge only when the question "How do you know?" is appropriate. If for any reason the question is not appropriate, then one is faced with the phenomenon of knowledge without justification, because justification is primarily a matter of providing reasons, or being able to provide them, when it is fitting to ask the question "How do you know?"

Moreover, it is difficult to see how we would have only very few justified beliefs if being epistemically justified is a matter of giving, or being able to give, reasons when the question "How do you know?" is appropriate. And even if that were the case, that would not be a strong enough reason to support the claim that justification need never require providing, or being able to provide, reasons.

Finally, in evaluating Alston's position, Mark Kaplan has noted that if a person need never *show* that she is justified in believing that *p* in order to be justified in believing that *p*, then those contextualists who disagree with Alston's view need never *show*, in order to be justified, that they are justified in believing that Alston's position is unacceptable. In other words, if Alston's theory of justification is correct, then there would be no way to determine objectively whether his view or a mutually exclusive view is acceptable; and it would be incoherent for Alston to *argue* for his position, or against another position, because that would presuppose the necessity of *showing* that one's views are correct and that the opposing views are unjustified because they are not shown to be correct. If Alston is right in what he argues, the views of those who disagree with him are equally justified (although in contradiction with his own views) if there is no need to show that one's views

are justified.[40] Kaplan's argument seems quite convincing as a way of undermining the view that in order to be justified one need never show that one is justified.

Alston's second objection to interpersonalism is that if one needed to justify one's beliefs by appeal to reasons, then he would not be able to avoid logical circularity. On the contrary, however, it seems that such a predicament could occur only if one must always justify the reasons one gives to justify one's claim to know. But the interpersonalist need not adopt such a view. He may say that there are times when the question "How do you know?" is totally inappropriate, and thus the idea of providing a justification in terms of stated reasons is not necessary with regard to every knowledge claim.

Besides, in his essay "Epistemic Circularity" Alston has argued that the kind of circularity in question is not vicious, and Alston himself has agreed that one need not always have or give reasons for what one justifiably believes. Why cannot the interpersonalist avail herself of Alston's arguments on this point?[41]

Alston's third "argument" is simply his asserting that there is no remotely plausible argument for the thesis that I can be justified in my belief that p only if I have justified that belief. Here again, however, the counter-argument is that, as a matter of both scientific practice and ordinary usage, we will not grant that a person knows what she claims to know if she fails in the absence of overriding causes or conditions to provide reasons for her claim when it makes sense to ask her the question "How do you know?" Further, if the interpersonalist asserts that there are conditions under which the question "How do you know?" does not make sense, it does not thereby follow that there are cases of knowledge wherein justification obtains without reason-giving or the capacity to give reasons. What may equally well follow instead is that if there is any knowledge at all, there is some knowledge without justification, because justification is the act of providing, or being able to provide, reasons for one's beliefs when it is sensible to ask for evidence for such beliefs.

Alston's fourth argument is that interpersonalism is false

because such a view presupposes the false proposition that belief-formation is a voluntary act. But the problem with this argument is, apart from the fact that it certainly seems that some of our beliefs are deliberately chosen on the basis of evidence (a point noted by Carl Ginet), that the interpersonalist position requires only that some of our beliefs be capable of voluntary formation. Also, when one asserts that somebody or other is justified or not in his or her belief we are asserting only that if he voluntarily *were* to adopt the belief, then that belief would be either justified or not depending on the reasons that could be given. Besides, it is disturbing to see a theory of justification based upon an assertion to the effect that nobody ever voluntary believes anything, and this is because (apart from the fact that it makes the theory of justification wagged by the tail of the free-will controversy—which, *ex hypothesi*, one could never justify) it asserts what really needs to be proven, namely, that all belief is involuntary. So, even if interpersonalism did presuppose that some beliefs are voluntarily formed by the agent, how could anybody refute that without establishing a thesis of a strict determinism incompatible with freedom of choice?[42]

The last reason Alston offers (and which we have not already discussed when examining Goldman's position) is that children and animals clearly seem to know certain things, but because it would be silly to think that they could give reasons for their claims it follows that there is some knowledge that is justified but which cannot be justified by appeal to the activity of giving, or being able to give, reasons. There are two replies to this objection.

First, it is gratuitous to assert that animals have propositional knowledge. Doubtless, most animals *know how* to do many things, but the very fact that they cannot either claim to know that *p* or answer questions such as "How do you know?" raises legitimate questions as to whether it makes any sense to say that they can know or believe *that* something or other is so. Similarly, young children, like animals, surely *know how* to do various things, but why *need* we say they have any propositional beliefs? Moreover, if animals and children did have propositional beliefs, and even if they were to assert them in certain ways, how could we grant that such beliefs are

justified if they could not give reasons for their beliefs when legitimately asked? In short, unless we can reduce non-propositional knowledge to propositional knowledge by arguing that all propositional knowledge is no more than dispositions to believe in ways that are biologically adaptive, it is by no means obvious that animals and children have justified propositional beliefs.

Second, Carl Ginet has observed that even if it is incongruous to apply the concept of justification to very young children and animals (because they lack the very notion of justification), it does not follow that the concept of justification by appeal to reasons is *generally* irrelevant. Ginet is willing to admit (as many are not) that animals and children do counter the claim that no belief is knowledge unless it is justified. Even so, he goes on to say:

> But they do not counter the claim I subscribed to above, that *no* unjustified belief can be knowledge, nor the claim that the concept of knowledge does require *justification* in its primary application, namely to those who do have a notion of a belief's being justified or not. In the natural extension of the concept to others who have beliefs, this requirement must be dropped.[43]

What seems forceful about Ginet's response is that insofar as the primary application of the concept of knowledge would obtain in contexts where the question "How do you know?" could be appropriate, the concept of knowledge in its general and typical application is meant to apply or be relevant primarily in those cases where it could make sense to say of the subject that she or he is justified. Thus, counterexamples that work only because the concept of justification is irrelevant, because incongruous, would reflect very nontypical usage. The interpersonalist need not adopt Ginet's view that *all* propositional knowledge requires justification, but only that where justification is necessary, justification is always a matter of the subject's ability to give reasons.[44]

The last objection noted above is the one offered by Swain to the effect that a person's belief that p counts as knowledge only if his belief is a reliable indicator of the facts. Here again, by way of response, suppose, for example, we approached Ginet's psychic weather forecaster who believes at time t_1 that the temperature

Celsius in Sydney is 15 at time t_1. Suppose that her belief about the temperature Celsius in Sydney is always correct when she utters it, but she does not know or believe that her beliefs are reliable (and hence cannot ever answer the question "How do you know?" asked on any particular occasion by someone who does not know that her beliefs are reliable). Supposing all this, we would never say that she is justified in her belief or knows that the temperature in Sydney is such and such. We would only need to say that for some inexplicable reason she *knows how* to provide the correct temperature reading in Sydney at any time. Naturally, if she were to say that she knew what the temperature Celsius was because whenever in the past she felt it was a certain figure, she was always right, then, and only then, would we say that she knows that the temperature is such and such. In arguing against Swain and Armstrong's position on this matter, one can readily agree with Ginet that

> *All* sorts of things other than true beliefs can be reliable indicators and therefore bases or enablers of knowledge; and being a basis or enabler of knowledge must be distinguished from being knowledge, in true beliefs as in all other things. A certain category of a person's sheer guesses or a certain category of her false beliefs might be reliable indicators of a certain category of facts, but those guesses or false beliefs would not thereby be knowledge. I do not see why true beliefs should be any different in this respect.[45]

This position implies that what is needed for knowledge in addition to true beliefs reliably produced is the capacity to answer the question "How do you know?" should the question become relevant; and for all the reasons indicated above, his criticism seems quite accurate.

We may summarize our results to this point. In refuting Goldman's arguments, as well as the other available arguments, to the effect that justification is not the activity of giving reasons, and in arguing that both the facts of ordinary discourse and the canons of scientific practice sustain a definition of justification in terms of the capacity to provide suitable reasons when the question "How do you know?" is appropriate, we have rescued the earlier anti-reliabilist counterexamples (offered back in 2.4) from the charge of

begging-the-question against the intrapersonalist and in favor of the interpersonalist. In so doing we sustain those counterexamples, demonstrating that reliability is neither a necessary nor a sufficient condition for justification. Thus, not only does Goldman's reliabilism fail, reliabilism, as a theory of justification, in general fails both because there are no satisfactory arguments in favor of the intrapersonalist theory of justification and because there are no satisfactory arguments refuting the arguments offered above for interpersonalism. By general implication, how one's beliefs originate is irrelevant to their epistemic status as justified or unjustified. There are many conceivable circumstances in which we would readily grant that a person knows that p where his being completely justified is a matter of his giving conclusive reasons that have absolutely nothing to do with how the belief originates or is produced. In the interest of completeness, however, and in the interest of developing the strongest possible case against reliabilism in general, we may now turn to other objections.

2.13 Other Arguments Against Reliabilism as a Theory of Justification

There are at least six other major arguments against reliabilism as a theory of justification. These arguments are: (a) the circularity argument, (b) the ambiguity argument, (c) the Gettier argument, (d) the standard practice argument, (e) the "reliabilism guarantees skepticism" argument, and (f) the "method of establishing reliability" argument.

A. The Circularity Argument

This objection asserts that if it is either necessary or sufficient, or *both* necessary and sufficient, for a person's being justified in believing that p, that her belief be reliable and hence produced by a reliable belief-making mechanism, method, or process, then in the interest of determining whether she is justified in her belief we

must be able to determine when a particular belief is reliably produced. But, so the objection goes, this cannot be done because any argument that would seek to do so would need to be viciously circular.

Suppose, for example, that Jones claims to know that Sarah is in town and, when asked by someone who has good reason to think Sarah may not be in town "How do you know?" he answers "Because I saw her not five minutes ago." To determine whether he in fact knows what he claims to know (the capacity for such determination being a necessary condition for any reasonably adequate theory of knowledge), we must determine whether his belief is the product of a reliable belief-making mechanism, method, or process. In short, we need to determine whether the mechanism that produces simple perceptual claims such as "I saw her" is reliable in general, and then whether it is reliable in this specific case. To do so, however, we would ultimately need to rely on someone else's claim that Sarah is indeed in town because they saw her or because they saw something or other. But it is exactly these sorts of claims that need to be shown to be reliable, rather than assumed to be reliable, if we are to establish that Smith knows what he claims to know. Thus reliabilism implies an unconscionable vicious circularity, a circularity that is epistemically vicious because in crucial cases it does not allow us any non-circular way of determining whether a person knows what she claims to know.

Of course, by way of response, one might argue, as has William Alston, that because one can be justified without giving reasons for one's belief, a logically circular argument given for a particular claim need not undermine the claim or a person's knowing what he claims to know.[46] This response, however, feeds on the intrapersonalist theory of justification and the view that one need never give reasons for one's belief in order to be justified in one's belief. But we have already seen that interpersonalism, and not intrapersonalism, is the correct theory of justification. The only other response that seems appropriate to this particular argument against the reliabilist theory of justification, is to urge that *being justified*, as opposed to *showing that one is justified* in one's beliefs, is not

always necessary for propositional knowledge. But such a response, would seem to entail abandoning reliabilism as general theory of justification asserting that it is a necessary condition for X's know-ledge that p, that X's belief that p be the product of a reliable belief-making mechanism. So, there is no blocking the inference that there is no non-circular way to establish the reliability of any particular belief-making mechanism or process.

B. The Ambiguity Argument

According to this objection, reliabilism is unacceptable because the concept of a reliable belief-making mechanism, method, or pro-cess is unclear. Must the method be *generally* reliable, meaning that over a long period of time it tends to produce more true than false beliefs, but on any given day could produce nothing but un-detectably false beliefs? Most reliabilists respond affirmatively to this question. However, would we call a method reliable if it pro-duced nothing but undetectably false beliefs for three years and then nothing but true beliefs for the next five years? Would we call a method reliable if, in the long run, it produced true beliefs 51 per-cent of the time rather than 80 percent of the time? How *much* reliability will be necessary for a truth-conducive account of justification or knowledge, and will that be determined arbitrarily? Also, suppose that some methodology works in some places but not in others, or for some people but not for everyone. For example, suppose Smith is a psychic gambler who has amassed a fortune because he gambles on the number that comes into his head just before each horse race he attends. Suppose, further, that Smith has never been mistaken in his belief about what horse will win the next race in the last 7,000 consecutive races, and that when you quietly ask Smith which horse will win in the next race he says "Number seven." Finally, suppose you then immediately ask Smith "How do you know?" and he answers "I know because I've never been mistaken in the last 7,000 consecutive races, and that sort of success cannot be a matter of chance." Supposing all this, would we say that Smith knows that the next winning horse is number seven? It seems obvious that his getting the correct number so frequently

cannot be explained as a matter of luck, chance, cosmic coincidence, or blind accident; and, moreover, his defense of his claim to know on the basis of his own past record is strong. Indeed, it seems obvious that he knows that the next winner will be number seven. Even so, reliabilists have been known to reject the claim that the psychic gambler in this case knows that the next horse to win is number seven and they often do so because, as they say, the mechanism or method that produces the psychic gambler's beliefs is not suitably reliable. It lacks global reliability. But why exactly is the method or mechanism that produces Smith's beliefs not reliable? After all, it has more than satisfied the requirement of tending most of the time to produce true beliefs? Why exactly must a method be globally reliable and universally accessible in order for it to generate true beliefs? Some of these sorts of questions have also been raised by others, but until more answers are forthcoming, the concept of reliability seems much too ambiguous.[47]

C. The Gettier Argument

According to this objection, the reliabilist's attempt to specify a definition of human knowledge in terms of true belief that is the product of a reliable belief-making mechanism cannot provide us with an adequate definition of knowledge. We can easily produce the Gettier effect as long as reliability is understood in terms of a method that is reliable just insofar as it tends to produce more true than false beliefs most of the time. For example, recall Swain's example about Smith who is inductively justified in believing (hence in possession of a reliably-produced belief) that the charge of TNT wired to the detonator box will explode when he flips the switch. As things are imagined, when he flips the switch, the TNT does explode but only because some hunter coincidentally fires a high-powered shell into the charge at the moment Smith flips it; otherwise the TNT would not have exploded because, although Smith is strongly inductively justified in believing that the equipment is trustworthy, it is not. Accordingly, Smith's justified true belief is not an item of knowledge.[48] If a reliabilist accepts Swain's counterexample to the justified-true-belief definition of knowledge,

then insofar as a strong inductive inference is the product of a reliable belief-making mechanism, the reliabilist should also accept Swain's (and others') counterexample as equally powerful against the reliabilist's definition of knowledge or of justification. For somebody such as Goldman, of course, the definition of knowledge is more than simply reliably produced true belief. As we have already noted, he also insists on the condition that there be no relevant alternative belief that could defeat the knowledge claim.[49] The fact that the definition of relevance is problematic, and that there are serious problems associated with the possibility of ever showing that the latter condition is satisfied, raises important questions indicated earlier and which we will not examine here. So, the Gettier argument is an objection leveled against all reliabilists who do not add something like the Goldman condition to their definition of knowledge as reliably produced true belief. Of course, even if they do add the other condition, the definition would be problematic for other reasons.[50]

D. The Standard Practice Argument

This objection asserts that as a matter of common scientific practice, how one's beliefs about the world originate is fundamentally irrelevant to the question of their justification. When one asserts a particular claim about the physical world, for example, the justification of that claim is a function of whether, given certain standard provisos and initial probabilities, we have reasons to believe that what it virtually predicts, by way of its test implications at the sensory level, does, or would occur sufficiently frequently to warrant accepting that claim as true. In short, as we saw earlier, our common scientific practice indicates that when it comes to a question of whether a person is justified in his beliefs, we seek to confirm, or possibly falsify, the belief in terms of what is implied by the truth or falsity of the belief at the observational level; and this activity in no way fundamentally regards the way in which the belief is produced as an indicator of its truth.[51] Whether the claim is justified is basically a function of whether the belief is explicitly tested, confirmed or falsified by the occurrence of unique sensory

experiences that we would expect under certain circumstances if indeed the claim were true, given the usual provisos, conditions and relevant background theories. Thus, because the practice indicates what we mean by "justification," the origin of one's belief is irrelevant to the practice of empirical testing, which is the activity of seeking to justify or falsify claims about the factual world in terms of the explicit test implications of the hypotheses in question, however the hypotheses come to us originally. Doubtless, the reliabilist will reply that in the act of justifying or confirming a belief we are more or less successful only because our beliefs are the products of reliable belief-making mechanisms such as induction. But even so, *his* being justified in *his* non-basic belief that p has nothing to do, *per se*, with how he got his belief that p. Moreover, as is evident from our earlier discussion of the psychic gambler, there are clear cases in which we would be willing to say "He knows that p" *no matter how he acquired his belief*, and even if we did not have the foggiest idea as to how he acquired his beliefs.

E. The "Reliabilism Guarantees Skepticism" Argument

In some ways this objection may be the most important because it asserts that reliabilism as a particular theory of justification guarantees skepticism. The objection assumes that all reliabilists adopt the correspondence theory of truth, and that reliability is the product of a method that need not on any particular occasion produce a true belief. Given this, the objection is that the reliabilist will never be able to determine whether the truth condition for knowledge is satisfied in any particular case because one has no way of determining whether a particular claim is true or not if its truth is not established by the satisfaction of the justification or reliability condition. The fact that the reliability condition could be satisfied by a belief which is the product of a reliable belief-making mechanism *and* that belief be false, once again, raises the question as to how we know that some person's claim to know that p is true. Because we cannot establish as much simply by showing that the

belief is reliable, and because we have no direct way of seeing that the proposition correctly describes the world, reliabilism guarantees a kind of skepticism that makes it impossible for us to ever determine whether anybody in fact knows what they claim to know. Earlier I argued that this sort of skepticism applies whenever the satisfaction of the justification condition for knowledge fails to carry with it the satisfaction of the truth condition and hence, in the interest of avoiding such skepticism, one must avoid correspondence theories of truth when specifying the nature of the truth condition for human knowledge. Because the reliability condition, at least as specified by all reliabilists to date, need only be truth-conducive, the question of how one is to determine which of one's reliable beliefs is true seems insurmountable especially because it involves being able to make some sort of direct comparison between the way things are and a sentence asserting the way things are. If one's justified beliefs need not be true, how one determines how one's reliably produced beliefs are true is as mysterious as it is necessary to avoid skepticism.

F. The "Method of Establishing Reliability" Argument

This last, but by no means least, argument asserts that under reliabilism, the method of turning over the determination of knowledge to scientists to ascertain the presence or absence of knowledge by determining whether the belief-making mechanisms producing the knowledge claims are functioning reliably, is defective because the success of that method would already presuppose an ability to determine outside of science, or independently of science, which beliefs are items of knowledge and which are items of justified belief. Otherwise one would not be able to determine which mechanisms are reliable under which circumstances. Such scientists would be no better off than the traditional philosopher accepting a traditional explication of justification or knowledge. The success of the transformational thesis, therefore, would depend on one having an informed and persuasive understanding of justi-

fication and knowledge prior to the determination of the ways in which one's beliefs are actually produced in order to determine which mechanisms or processes are reliable. Accordingly, whether people know what they claim to know, or are justified in believing what they claim to be justified in believing, is not fundamentally a scientific question at all.[52]

2.14 The Reliability Theory of Knowledge: Dretske's Question

Can a reliability theory of knowledge fare any better than a reliability theory of justification? For some philosophers, such as Fred Dretske and D.M. Armstrong, reliability theories of justification are demonstrably false, but a reliability theory of knowledge is quite a different story.[53] Dretske, for example, has argued that epistemic justification is primarily an activity of giving reasons and, as such, is simply not necessary for human knowledge. For Dretske, human knowledge requires only reliably produced true belief, or, true belief caused by appropriate information. Accordingly, for Dretske, human knowledge does not require of the subject a cognitive grasp or awareness that the belief is reliably produced (or caused by appropriate information). Nor does it require of the subject a capacity to show, or give reasons showing, that the belief is reliably produced, or caused by appropriate information.[54]

Incidentally, Dretske believes that his definition of knowledge has certain remarkable advantages over the traditional definition offered in terms of Justified True Belief. For one thing, it presumably avoids the "bag of tricks" offered by philosophers to deal with Gettier-type counterexamples to the classical definition of knowledge. And it supposedly does this because it blocks the basic assumption behind all Gettier-type counterexamples, namely the belief that a person can be completely justified in believing a false proposition. For Dretske, if a true belief is caused by appropriate information, the information could never be false or in any way

allow a person to be completely justified in believing a false proposition.[55]

Interestingly enough, Dretske does not deny that it is important to be able to determine which beliefs are reliably produced. After all, it is sometimes necessary to find out who knows what. But being in a state of knowledge imposes no requirement on the subject to either be aware of, or to show that her belief is reliably produced in addition to its being a true belief reliably produced or caused by appropriate information. For those who would insist on requiring for human knowledge something more than true belief reliably produced or caused by appropriate information, Dretske has the following reply in defense of his own reliabilist brand of externalism:

> Critics of externalism, those who think knowledge requires something *other than*, or at least *more than*, reliably produced true belief, something (usually) in the way of justification for the belief that one's reliably produced beliefs *are* being reliably produced, have, it seems to me, an obligation to say what benefits this justification is supposed to confer. Though reliability itself contributes nothing directly to the benefits of true belief (true beliefs, indexical or otherwise, assuming one is prepared to *act* on them, are just as useful as reliably produced beliefs), the Reliability Theorist can at least demonstrate the necessity, hence the *value*, of reliability in the acquisition process. The reading glasses become as important as the headlines when you cannot read the headlines without the glasses. If, then, knowledge is something more than this, something more than true beliefs produced by reliable mechanisms, what good is this something extra? Who needs it and why? If an animal inherits a perfectly reliable belief-generating mechanism, and it also inherits a disposition, everything being equal, to *act* on the basis of the belief so generated, what additional benefits are conferred by a justification that the beliefs *are* being produced in some reliable way? If there are no additional benefits, what good is this justification? Why should we insist that no one can have *knowledge* without it? How does it contribute to the *value* of knowledge? This is not to say that justification is not a good thing. Of course it is. But it has an *instrumental* utility, a utility in promoting the reliability of the beliefs for which it is available. If it did not do that, it would be hard to see what value it would have. People who have no evidence, no reasons, no justification,

for the things they believe end up, more often than not, believing false things. And even when it does not promote reliability—because, we may suppose, the belief is generated by mechanisms that are already reliable (or whose reliability cannot be enhanced by subjective considerations)—it may acquire a utility in the way it affects a person's preparedness to *act* on the belief. Even if my informant is perfectly reliable, I won't trust him, and won't therefore benefit from his communications, if I am given no reason to think he is reliable. So, justification is important *to me*. But if it does not affect person's willingness to believe, and by this I mean a person's willingness to *act* on what he believes, nor the reliability of the belief on which he acts, as I think it is clear it doesn't in the case of most *perceptual* beliefs (paradigmatic cases of knowledge), of what possible value could a justification be? This, I submit, is why we all find justification to be largely irrelevant to what we can *see* (hence *know*) to be the case.[56]

While many have rejected any form of internalism for other reasons (reasons we have already discussed above), the line of argument here offered by Dretske is fairly common and worthy of close scrutiny.[57] The question asked in the first paragraph of this quote is poignant and cries to heaven for an answer. The comments in the second paragraph also require examination if reliabilism as a theory of knowledge will survive serious examination.

2.15 Answering Dretske's Question

In response to Dretske's question, first of all, whether one's proposed definition of knowledge is adequate is primarily a function of whether the definition captures, or extends to, all and only those cases that we as native speakers would all regard as legitimate instances of human knowledge. So, the proper fundamental question before us is not "What good would it do to require of our definition of knowledge anything more than reliably produced true belief?" Rather the question is "Can we imagine a case of reliably produced true belief which we would not accept as an instance of knowledge?" Put this way, the answer is a clear yes. Native speakers

(and most philosophers) do, and would, regard certain cases, such as the Rocking Horse Winner or Bonjour's Psychic Weather Forecaster (both of which we have already discussed above) as good examples of reliably produced true beliefs which are not items of knowledge—although the claims made in these cases are reliable indicators of the way the world is.[58] It is because of our generally deeply felt intuition that the subjects in these examples do not know, that we require an internalist component of some sort involving the capacity to give suitable reasons in addition to the conditions of reliably produced true belief.

Even so, we may, if we like, answer Dretske's question with the response that the good done by adding an internalist constraint, requiring the capacity to give persuasive reasons, is that it would thereby allow a definition of knowledge capable of capturing what we actually mean by the expression "X knows that p"; and stating clearly what we mean by this expression is certainly a good by way of providing some measure of clarity and understanding of what the expression means in ordinary discourse.

Additionally, if by adding an internalist constraint we mean to require that not only must the subject be aware of, or have some cognitive grasp of, what it is that completely justifies one's true belief, but also that she sometimes be able to state or show, what it is that justifies her belief, then the addition would have the striking advantage, or good result, of allowing us to distinguish between those who claim to know something or other, and do not, and those who claim to know something or other, and do. We cannot always determine what people know simply by watching their behavior. In other words, any theory of knowledge that requires as a result of an internalist requirement that people sometimes be able to offer answers to the justification-seeking question "How do you know?" provides us with the very useful capacity of sometimes being able to determine whether people know what they claim to know. Indeed, it is difficult to see how such a capacity would not be a necessary condition for any proposed theory of knowledge being an adequate theory of knowledge.

Incidentally, Dretske's claim in the second paragraph cited above, namely, that while adding an internalist constraint is not necessary, nevertheless justification is important *to him* in order to show which claims are justified, seems strangely inconsistent with his claim that any internalist constraint would provide no good, and that nobody needs it anyway. He clearly thinks that the activity of justification is sometimes important for some purpose or other—presumably to find out who knows what—and yet that in itself is incidental as an answer to the question of what good would it do to add an internalist condition to the definition of knowledge as reliably produced true belief. Is it not a necessary condition for an adequate theory of knowledge that the definition of knowledge provided therein allow us to in doubtful cases to determine whether people know what they claim to know? And would we say people know what they claim to know when, in the absence of any over-riding constraints, they cannot give any reasons when the question "How do you know?" is appropriate?

Finally, and perhaps most importantly, when one asks "What good would it do to require justification as a reason-giving activity?" is she not in fact involved in requiring just what she thinks one should not be involved in requiring, namely the giving of reasons in order to justify a position which she finds difficult to accept or suspects for other reasons? Can one even consistently ask the question Dretske asks while at the same time denying that one need ever give reasons in order to be justified, or in order to be a knower? Is Dretske's question not requiring justification as a reason-giving activity of those who would argue for internalism or the view that being a knower, or being justified, sometimes requires the giving of reasons? In short, in demanding of the internalist reasons to justify his position is Dretske not thereby justifying the internalist position while at the same time denying that it can be justified? Demanding reasons in the interest of showing that one need never give reasons in order to be justified seems straightfor-wardly inconsistent.[59]

In sum, the general claim that we need not add any internalist condition to the definition of knowledge as reliably produced true belief, is flawed for three basic reasons. First, the proposed definition allows for cases that violate our ordinary intuitions about what knowledge amounts to. When the question "How do you know?" is appropriate, and the subject fails to be able to give persuasive reasons showing that he knows that p, then we do not say, and would not say, that he knows that p. Second, if for any reason whatsoever we set aside the need for our definition to capture what we mean by "X knows that p" in ordinary discourse, there is good reason to suppose that in the absence of some internalist constraint, there are very clear cases where we would not be able to distinguish between those who say that they know something or other when they do not, and those who say they know something or other when they do. Put somewhat differently, the unfortunate consequence of a Dretske-like definition of knowledge is that, in the absence of an internalist constraint requiring that people sometimes be able to offer justification for their claim to know, we would end up with a theory of knowledge that excludes the occasional necessity of the question "How do you know?" and, as a consequence, would not allow us in doubtful cases to distinguish between those who really know what they claim to know and those who do not. In the absence of such an internalist constraint then, our ability to find out who knows what is severely hampered. The importance of avoiding that handicap establishes, by implication, the necessity of having such an internalist constraint added to any Dretske-like definition of knowledge in terms of reliably produced true belief without any internalist requirement that the subject be able sometimes to justify his or her claim by appeal to reasons. Third, Dretske's dreadful question is in fact a demand for reason-giving as a necessary condition for either knowing or being justified in believing that some form of internalism is acceptable. Asking such a question is inconsistent with asserting that reason-giving is never a necessary condition for knowing.

In sum, the general claim that we need not add any internalist

condition to the definition of knowledge as reliably produced true belief is flawed for two basic reasons. First, the proposed definition allows for cases that violate our ordinary intuitions about what knowledge amounts to. Second, if for any reason whatsoever we set aside the need for our definition to capture what we mean by "X knows that p" in ordinary discourse, there is good reason to suppose that in the absence of some internalist constraint requiring the capacity to give persuasive reasons when it is appropriate to ask for them, there are very clear cases where we would not be able to distinguish between those who say that they know something or other when they do not, and those who say they know something or other when they do. Put somewhat differently, the unfortunate consequence of a Dretske-like definition of knowledge is that, in the absence of an internalist constraint requiring that people sometimes be able to offer persuasive reasons for their claim to know, we would end up with a theory of knowledge that excludes the occasional necessity of the question "How do you know?" and, as a consequence, would not allow us in doubtful cases to distinguish between those who really know what they claim to know and those who do not. In the absence of such an internalist constraint then, our ability to find out who knows what is severely hampered; and the importance of avoiding that handicap establishes, by implication, the importance of having such an internalist constraint added to any Dretske-like definition of knowledge in terms of reliably produced true belief without any internalist requirement that the subject be able sometimes to justify his or her claim by appeal to reasons.

Finally, all the objections detailed in 2.13 above apply to reliabilism as a theory of knowledge as much as they do to the reliabilist theory of justification. Without caring to repeat these objections, I submit that a careful review of the Circularity Argument, the Ambiguity Argument, the Gettier Argument, the Standard Practice Argument, and the "Reliabilism Guarantees Skepticism" argument will show that theses arguments hold with equal force in the presence of a definition of knowledge in terms of reliably produced true belief.

2.16 Reliabilism and the Transformational Thesis

There are other objections to reliabilism both as a theory of justification and as a theory of knowledge, objections for which there is no space here.[60] Nevertheless, if the objections detailed above are correct, not only have Goldman, Alston, Dretske and others failed to establish any plausible form of reliabilism, the general thesis is indefensible by appeal to other considerations they in fact did not, but might have, considered. Consequently, by way of the far-reaching implications of the thesis, the distinction between epistemology and psychology remains firmly entrenched, and we cannot just yet consign the business of epistemology to the descriptive or the cognitive psychologist. However fascinating the study of the ways in which our beliefs originate, and the degree to which they are subjective constructs, the question of their justification and truth is primarily another matter.

2.17 Conclusion: Naturalized Epistemology and Cognitive Science

None of this implies, oddly enough, that reliable belief-making mechanisms, processes or methods are not in some way necessary for a person's knowing that p, or for a person's being completely justified in believing that p. If, as we saw, the capacity to give conclusive reasons is necessary for X's justification of his belief that p, then how the belief that p originates or is caused is irrelevant to the justification of the belief that p. Even so, the capacity to give conclusive reasons for the belief that p will require, of course, reliable cognitive equipment and processes. In other words, reliable cognitive equipment and processes (suitably defined) will be necessary for being justified in a particular belief, but that belief itself will not be justified simply because it is the product of, or caused to arise

from, reliable belief-making mechanisms, methods, or processes.

Recall the similar claim made by John Pollock that while reliability is not a necessary condition for justification, nevertheless a justification could be defeated by a lack of reliability.[61] If this claim is not an outright contradiction (and it is not) it can only mean that while X's being justified (or completely justified) in believing that p consists in X's being able to offer conclusive reasons for p when the question "How do you know?" is appropriate. That condition could never be satisfied by a person whose belief-making mechanisms, methods or processes are unreliable in some clear sense. But this sort of reliability is no more to be stated as a necessary condition for being justified in a belief than would be the having of a brain or being alive. It is rather a presupposition or a requirement for anybody who would satisfy the definition of justification, however it is defined. As such, the reliability of cognitive equipment would represent a precondition or a condition of adequacy for any proposed definition of justification, or knowledge. This is why reliability is not a necessary condition for justification, but also why unreliable cognitive capacities will defeat a justification even when such reliability is not a necessary condition for justification. That kind of unreliability would make it impossible for one to satisfy the definition of justification construed in terms of a capacity to give reasons under appropriate circumstances. Quite possibly, it is the failure to draw this sort of a distinction that has led many to believe that reliability is a necessary condition for justification or knowledge rather than something that is trivially necessary to satisfy *any* proposed definition of justification or knowledge.

If all this is so, naturalized epistemology, construed either in terms of the replacement thesis or in terms of the transformational thesis is indefensible. Interestingly enough, however, it would not thereby follow that there is no role for cognitive science in answering certain epistemological questions. For example, if Smith's failure to be justified in most of his beliefs derives from some cognitive disorder, tumor or disease, we might well seek the causes and the cure. Certainly, this would be to explain in natural science why

Smith is mistaken so often in his beliefs, and why his beliefs are defeated so often. But *that* Smith is mistaken so often, or *that* Smith's beliefs are so often defeated, or what it means to be mistaken in one's beliefs, is not a scientific conclusion emerging solely from the application of the methods of the natural sciences. So, it's not as though some interesting questions about the nature of human knowing are not basically scientific questions. But this is a long way from the view that the only questions are scientific questions or that whether anybody knows what they claim to know is a scientific question. Let us turn to the last form of naturalized epistemology and the characterization of harmless naturalism.

3

The Harmless Thesis and Philosophical Explanations

3.1 Introduction

The third form of naturalized epistemology mentioned back in the introduction I call "harmless naturalism." Harmless naturalism asserts that while some legitimately answerable questions about human knowledge and the world are not answerable by appeal to the methods of the natural sciences, still, for most, if not all, questions about the nature of the physical world, that is, for questions about the nature and causes of the observable regularities and properties observed therein, the methods of the natural sciences are privileged because they provide us with the only reliable explicit methodology for efficiently producing a public understanding and a public knowledge of such phenomena. This naturalism is "harmless" because, unlike the naturalism implied in the replacement thesis, it does not incoherently undermine the pursuits of traditional epistemology; and unlike the naturalism implied in the transformational thesis, it does not always turn the question of who knows what over to cognitive scientists for all the wrong reasons.

In the next few pages I will characterize more fully this harmless form of naturalized epistemology if only to distinguish it primarily from the classical and narrow reductive empiricism offered by philosophers such as Hume and Quine. Thereafter, we shall also examine the extent to which the empiricism in harmless naturalism, as so described, is privileged as a unique source of knowledge

about the physical world. Finally, after urging that there is indeed private empirical knowledge, we shall see, by way of conclusion, how a philosophical answer or explanation can be an empirical form of understanding and knowledge without simultaneously being a scientific answer or a scientific explanation of the sort typically offered in natural science. In so ending this essay, what will emerge is a distinctively naturalistic view of philosophy which is anti-*apriorism* without at the same time succumbing to the perils of the scientism implied in either the replacement thesis or the transformational thesis. The basic task here will consist in showing how philosophical explanations and answers can be both empirically testable and falsifiable while remaining logically distinct from scientific explanations and answers, as they are typically construed, under the methods of the natural sciences. In then offering examples of such explanations I shall refer to cases in the history of philosophy where philosophical explanations and answers have been empirically tested and refuted decisively. I shall also point to cases in which it seems quite clear, at least implicitly, that certain philosophical answers or explanations admit of strong empirical support without thereby becoming instances of good scientific explanations.

3.2 Harmless Naturalism and Humean Empiricism

Harmless naturalism is antithetical to Humean empiricism because Humean empiricism is an instance of the view that whether one justifiably believes something or other about the world is a function of how one's ideas or beliefs originate, or are caused to exist. For Hume, unless we can either directly or indirectly reduce our ideas or beliefs about the world to some original corresponding impressions of sense from which they are derived, then those beliefs or ideas are meaningless. By implication, if our beliefs or ideas about matters of fact are not caused to arise by direct impressions of sense, and thus cannot be suitably paraphrased and thereby reduced to a statement descriptive of those impressions of

sense, then such beliefs are meaningless and hence cannot be true or worthy of rational adoption.[1]

For all the reasons offered back in Chapter 2 against causal and reliability analyses of knowledge, Humean empiricism, as an explication of rational belief, seems no better off than causal or reliability analyses of knowledge. This is not to say, of course, that Hume's fundamental sensism, along with his views on the nature of thinking and the nature of the way ideas are supposed to represent the impressions from which they are derived, has not been trenchantly criticized by a number of philosophers for other reasons.[2] As we shall see, such criticisms have made it impossible to take Humean solipsism seriously because the latter depends quite directly on the success of Hume's theory of ideas and representation. Even so, when we examine all the criticisms of Hume's theory of ideas we end up with a compelling critique of the view that the epistemic legitimacy or justification of beliefs about matters of fact is basically a function of how those beliefs are caused to arise from sensory experience.

The only remaining form of naturalism is that form offered by philosophers and scientists who basically regard all claims about the physical world as hypotheses to be empirically tested in some way as conjectures (or educated guesses) however they originate. In such a naturalism the truth or rational acceptability of one's hypothesis is not established in terms of how the hypothesis originates; that is an interesting but purely psychological question. The testing and confirmation (or disconfirmation) of such hypotheses typically and essentially (but not necessarily exclusively) consists in the deduction and checking of observational consequences implied by the hypothesis, given certain initial probabilities, provisoes and *ceteris paribus* clauses. In other words, for harmless naturalists, empirical belief is basically belief in objects and properties which, by definition, are mind-independent and function causally to create states of affairs that are sensory, public and open to public examination. Belief in the existence of any object or property that could not be ascertained to exist in terms of its causal effects at the sensory level is not an empirical belief, is not a scientific belief. As

Peirce would have it, for example, our concept of an object is our concept of the sensible differences its existence causes in the world. In his own inimitable style, he said:

> Consider what effects, that might conceivably have practical bearing, we conceive the object of our conceptions to have, then our conception of these effects is the whole of our conception of the object. (C.P. 5.61)

In the various ways in which he later explicated this maxim, it seems clear that Peirce intended to convey something of a verificationist thesis to the effect that meaning is a function of truth (or justification) conditions and not a function of the way in which the belief is generated.[3] For Peirce, the truth (or justification) conditions of a belief are a function of the conditions of confirmation and that is basically a matter of whether the belief, taken as a hypothesis, actually leads, or could lead, to the observational data one would expect of the belief if it were true, or to observational data one would expect if the belief were false. The truth of the hypothesis will be a function of whether what the hypothesis implies deductively at the sensory level obtains or would obtain, and whether what would be implied for its falsity obtains or would obtain at the sensory level. In short, the naturalism proposed here is distinct from Humean empiricism in that it involves a commitment to some minimal form of the deductivism implied in the hypothetico-deductive model of confirmation (hereafter the H-D model). But it certainly does not endorse the simple-minded deductivism often associated with the traditional H-D model of confirmation. The latter form of deductivism asserts that the testing and confirmation (or disconfirmation) of a hypothesis consists entirely in the deduction and checking of observational consequences, and that with each positive instance of the hypothesis, the hypothesis tends to be confirmed. This so-called traditional form of the H-D model has been subjected to pervasive and persuasive criticism, and we shall discuss that criticism very shortly, if only to distinguish the traditional H-D model more clearly from the highly qualified form of deductivism implied in harmless naturalism.

Moreover, as a form of deductivism, it seems fair to distinguish the H-D model implied by harmless naturalism, from the pure deductivism offered by somebody like Karl Popper, for whom positive instances of a hypothesis, implied by the hypothesis, cannot, and do not, confirm the hypothesis. Doubtless, the dispute between Popperians and non-Popperians on whether positive instances confirm a hypothesis is more than we have time sufficient to examine here. More importantly, for our major point on what the distinction between philosophy and science amounts to, it is not necessary to do so. After all, Popperians and non-Popperians agree that explicit testability in terms of sensory implications of the hypothesis is necessary. Holistic views about confirmation notwithstanding, the dispute here is over whether positive instances of a hypothesis confirm the hypothesis and render it inductively more likely to be true. Although I side with the non-Popperians on this issue when insisting that all robustly confirmed hypotheses will require some positive instances, Popperians would still agree that it is a necessary condition for the scientific status of a hypothesis that it be testable in some way in terms of the sensory implications of the hypothesis. That's the core point of harmless naturalism, distinguishing it from Humean naturalism, and it remains unaffected by the dispute over whether positive instances of the hypothesis are necessary for robust confirmation and over whether one should construe confirmation holistically or non-holistically. Even if the unit of significance is the whole theory itself, it is what is implied at the sensory level by the hypothesis within the theory that counts for confirming or falsifying the hypothesis. In other words, Popperians and non-Popperians alike will be harmless naturalists because both will insist that testability in terms of the sensory consequences or implications of the hypothesis will be necessary for the rational acceptance of the hypothesis. I offer no advice here on whether one should be a harmless naturalist of the Popperian persuasion or of the non-Popperian persuasion.

There are more recent efforts both to distinguish a harmless naturalism from Humean naturalism, and to defend the former

against its detractors. Ernest Nagel, for example, once claimed that while all knowledge (he meant public propositional non-basic knowledge) must be capable of being tested, this does not mean, as some critics of naturalism seem to suppose, that "transempirical" commitments must be characterized exclusively in terms of the observable properties of the world, any more than that the sub-microscopic particles and processes which current physical theory postulates, must be logical constructions out of the observable traits of macroscopic objects. He went on to say:

> But it does mean that unless the hypothesis implies, even if only by a circuitous route, some statements about empirical data, it is not adequate to the task for which it is proposed. If naturalists reject hypotheses about transempirical substances, they do not do so arbitrarily. They reject such hypotheses either because their relevance to the going concerns of nature is not established, or because, though their relevance is not in question, the actual evidence does not support them.[4]

On this view, then, a necessary condition for a belief being empirically meaningful is that the objects posited or implied by the belief have, or cause, some conceivable sensible effects (however indirect) the publicly observed occurrence of which would count as solid grounds for justified belief in the existence of the object(s) asserted to exist, or implied to exist by acceptance of the belief as warranted. Either that or there must be some observational data implied by the belief that would count for justifiably rejecting the belief.

In short, for philosophers as diverse as Charles Peirce, William James, Ernest Nagel, Rudolph Carnap, Carl Hempel, and others,[5] what makes a belief an empirical belief is whether there is implied by the belief some conceivable sensible state of affairs open to public inspection whose occurrence or non-occurrence would count for rationally accepting or rejecting the existence of those objects or properties asserted to exist in the belief, however that belief originates.

Recall that the chemist Kekule fell asleep before the fire and dreamt the structure of the benzene ring. Whether his assertion

about the nature of the structure was rationally acceptable or not had nothing whatever to do with how the belief originated, but rather with whether the belief could serve as an empirical hypothesis with sensory implications that would confirm or disconfirm it.[6]

Similarly, if, like Kekule, one were to sleep and dream of some object, currently and immediately unobservable, with a complete description of its properties and its effects in the world, whether that belief is worthy of rational adoption is a matter of whether there are any public and sensible effects that would uniquely confirm it. Thus, the form of empiricism offered by Peirce, James, Nagel and others, basically accommodates the many arguments offered earlier against causal and reliability analyses of knowledge and justification. It also reflects what is typically uncontested scientific practice, namely, the practice of postulating or conjecturing what the causes of public sensible phenomena are, and then testing the conjectures, when possible, in terms of what is implied by the hypothesis at the sensory level if the posits or conjectures were correct causal hypotheses. If Cartesian Egos, for example, were to have some unique observational effects in the world, then there would be no reason why such an empiricist could not also be a believer in Cartesian Egos.[7] But, again, how one's basic beliefs originate from experience, how one acquires one's beliefs, is basically irrelevant to the question of whether these beliefs are more or less completely justified and hence worthy of rational acceptance. Although some methods of acquiring beliefs are demonstrably more reliable than others, when it comes to the question of whether those beliefs are justified and worthy of rational acceptance, it makes no difference how those beliefs are in fact acquired or what causes them to arise.[8] It is this form of naturalism that is harmless and, assuming we can defend as a necessary condition (at least) some form of the inherent deductivism implied in its theory of confirmation, it offers a privileged method for coming to a public knowledge and understanding of the world. But let's turn to some objections to all this.

3.3 Objections to Harmless Naturalism: The Problem of Induction and the H-D Model

As remarked above, harmless naturalism, as a form of empiricism, may avoid the pitfalls of the reliabilism and causalism inherent in classical Humean empiricism, but because it also makes the epistemic justification of a belief about the world a function of whether the belief deductively implies specific observational data the occurrence of which tends to either falsify or confirm the belief, this harmless naturalism ostensibly leans on some elementary form of the H-D model of confirmation. The latter model of confirmation, at least in any of its non-Popperian forms, assumes, first and foremost, the validity of inductive inference in allowing generalization from a limited but large number of positive instances implied by the hypothesis and that support the hypothesis. Let's say something briefly about this problem with the non-Popperian form of the H-D model. Thereafter we shall look at a few of the other problems with adopting an unconstrained form of the H-D model. In doing all this we shall see that, however problematic it may be to state clearly the proper and refined model for confirmation, the requirement of empirical testability in terms of observational consequences deductively implied by the hypothesis, combined with the rejection of Humean empiricism, leaves us no alternative but to adopt some revised form of the H-D model, a form that does not make confirmation of a belief consist entirely in the deducing and checking of observational consequences.

Bypassing Hume, we can proceed directly to Bertrand Russell, for example, who attacked inductive reasoning in general, and the non-Popperian H-D model by implication, when he argued that unless one were willing to place certain kinds of constraints on what hypotheses can be supported by their positive instances, we would be forced to conclude that all Xs are observed from the fact that we had observed a large sample of the existing Xs. Russell did not know what logical feature rendered some hypotheses, but not

all, confirmed by their positive instances, but he was sure that not all were.[9] In a more sophisticated way, Nelson Goodman later made the same point in *Fact, Fiction, and Forecast*; and it led Goodman to the view that the new riddle of induction is not whether hypotheses can be supported, and thus justified, by their positive instances (that was the old riddle of induction), but rather *which* hypotheses are supported by their positive instances.[10]

Various philosophers have responded, more or less persuasively, to Goodman's argument in ways that restore some form of the H-D model in the light of Goodman's reflections. Goodman's thesis, after all, requires that the confirmation of a hypothesis have positive instances of the hypothesis implied by the hypothesis, even though some hypotheses would not be supported by their positive instances. For reasons of focus and limited space, however, we need not re-examine those responses here, rather than simply refer to the work of others.[11]

Nor does it seem particularly difficult to respond to Russell's concern that generalizing from positive data in support of the hypothesis may lead to falsity as often as to truth. Indeed, it hardly seems arbitrary to require of a confirmable hypothesis that the property in question not be a property that accrues to the object simply in virtue of somebody thinking about the object. That kind of constraint would prevent our inferring that all cows are observed from the fact that we have observed a fair sample of all the cows in existence. Typically, being observed is not a causal property of the object observed. As a matter of fact, we usually talk about inferring from the observed members of the class to the unobserved members of the class as a way of drawing legitimate inferences about properties that do not depend on the existence of the observers.

Russell's example about the chicken is different, however. Recall that for Russell, the chicken that infers that his master will feed him today because his master has fed him on each of the past days for the past five years, has fully satisfied the demands of inductive reasoning even though on that very day the master makes a stew of him. It was examples such as this that also led Russell to view induction by simple enumeration as just as likely to lead to falsity as

to truth. Even so, nowadays it is not difficult to believe that the chicken may have overlooked a few crucial *ceteris paribus* clauses that would have given some strong prior probability to the claim that on some particular day or other the master will make a stew of the chicken. Russell's chicken is no better off as an inductive reasoner than the fellow who accidentally falls off the Empire State Building and who shouts confidently to someone apparently horrified and looking out the seventh floor, "Not to worry, everything will be fine because everything has been just fine so far!" In short, Russell's chicken may not be much of an example of the sort of inductive reasoning that is supposed to lead more often than not to expectations that are not frustrated. The moral of the story is that unless we place, as we generally do, certain constraints on inductive inference, Russell's story about the chicken would seem good grounds to question the traditional H-D model. Of course, in some ways and on some issues, we are as much in the dark as Russell's chicken; fortunately, when we lose our heads, so to speak, other chickens are quick to inform us about the nature of *ceteris paribus* clauses in the neighborhood and such things as Bayesian prior probabilities associated with contrary and conflicting hypotheses equally well supported by the data.

Then there is the additional problem of the status of the observational data. Is the observational data to which one appeals in order to confirm or disconfirm proposed empirical hypotheses sufficiently theory-independent to warrant the confidence we typically have in appealing to it in order to confirm the theory or hypothesis? The answer to this question is that the problem of the objectivity of observational beliefs is not a problem unique to the H-D model of confirmation. It is pervasive for any epistemological endeavor, and a source of persistent consternation for those who wish to establish in a non-circular way the reliability of perception as a source of justified belief or knowledge.[12] And while this is not the place to discuss the question of the objectivity and reliability of perceptual beliefs in detail, we have already seen above that the principle that should be operative (if we are to justify any claim) is the one to the effect that unless one has some substantive reason to

believe that one may in fact be wrong about what one perceives, then one should regard one's immediate perceptual claims as worthy of adoption. Of course, we must add the proviso that, as Aune has also stated, we hold these claims tentatively and are willing to countenance reasoned claims or empirical evidence that we are wrong in any particular belief. As we shall see, this latter condition is not satisfied by any mere logical possibility, such as the possibility of being brains in a vat of nutrients.[13] Fortunately, a number of philosophers adopt this general principle on the reliability of observational data and perceptual claims. It is one of those claims that even skeptics must adopt if they want us to take them seriously.[14]

There are other pervasive problems associated with accepting the traditional H-D model as a theory of confirmation and as a methodology for comparing and accepting theories and empirical hypotheses. Among such problems looms large the question of how we are to compare and evaluate competing theories equally well supported by their positive instances and not falsified. This of course is a problem only for the non-Popperian form of the H-D model, that is, that form of the H-D model that requires testing in terms of the deductive implications of the hypothesis but disallows positive instances as confirming instances. Traditionally, the early proponents of what we are calling here the non-Popperian form of the H-D model of scientific confirmation thought it would be sufficient for the confirmation of a hypothesis that we find enough positive instances of the hypothesis, instances deductively implied by the hypothesis, provided we could also deduce the observational date that would be sufficient for disconfirming the claim, and that no such data existed. But it turns out that the history of science provides ample evidence of two mutually exclusive hypotheses equally well supported by the same confirming data. In commenting on a particular case of this sort, Wesley Salmon, for example, notes that the implication of such cases is that the traditional H-D model is thoroughly discredited, at least in so far as it sought to provide a sufficient criterion for hypothesis confirmation. For Salmon, and others, such cases of themselves carry a strong

Bayesian message to the effect that theory confirmation in addition to requiring positive instance confirmation, a variety of confirming evidence, and a clear possibility of decisive refutation in terms of observational data, must also have prior probabilities based on plausibility considerations rooting in background information and other assumptions.[15] Certainly, it is not difficult to agree with Salmon and others who, for various reasons, argue that the traditional non-Popperian form of the H-D model of confirmation has failed as a criterion sufficient for confirmation. If this conclusion makes one fundamentally a Bayesian in confirmation theory, then such Bayesianism seems, on the face of it, quite desirable.[16] But, assuming a non-Popperian stance, this conclusion is a long way from saying that instance-confirmation in terms of observational data deductively implied by the hypothesis is not a necessary condition for the confirmation and rational acceptance of a theory or hypothesis.

For other reasons, a number of philosophers think that an unreconstructed or unrestrained non-Popperian H-D model is seriously defective not only for failing to provide a sufficient criterion for confirmation, but also for failing to provide even a necessary criterion for confirmation. This latter charge is important to examine because if it is true, then it would not even be a necessary condition for a well-confirmed theory that it be tested in terms of its observational consequences and have at least some positive instances at the observational level. It is one thing to say that we are not sure which hypotheses are confirmed by their positive instances, but it is quite another thing to say that a well-confirmed hypothesis requires no positive instances in terms of observational consequences implied by the hypothesis. Paul Horwich, for example, in commenting on Clark Glymour's "bootstrapping" strategy to overcome alleged defects of the unconstrained traditional H-D model, including the claim (which Horwich rejects) that the whole theory is not confirmed simply because one of its parts is (evidence for p does not confirm (p or q)), has said:

It seems, in conclusion, that both Glymour's strategy and the H-D method are seriously defective. Both of them imply that data are irrelevant in cases when we are inclined to say that the hypothesis is confirmed. Neither can accommodate the most valuable and philosophically challenging cases—those in which the data are not entailed by what is confirmed. Neither may be rescued by tacking on the consequence condition. And the fundamental reason for these difficulties is that neither theory provides a solution to the problem of simplicity, including the so-called new riddle of induction. (emphasis added)[17]

With regard to the above question of whether a well-confirmed theory, or hypothesis, requires positive instances in terms of observational data deductively implied by the theory, or hypothesis, perhaps the most interesting point Horwich makes in this passage is that sometimes a hypothesis is confirmed by data that is not implied by the hypothesis; and this further implies that a suitably revised non-Popperian H-D model does not even provide a necessary criterion for confirmation. In defending this last claim, Horwich asserts that there will clearly be components of a theory that do not entail the evidence that confirms them (57). He asserts, for example, that the observation of many black ravens confirms the belief that future ravens will be black (57). Is Horwich's point defensible?

Probably not. After all, nobody, including Horwich himself, has yet shown an instance of a well-confirmed theory, or hypothesis, in the history of science that did not have some positive instances of observational data deductively implied (either directly or indirectly) by the hypothesis or theory in question. And the example Horwich gives to support the claim that some hypotheses are confirmed by data not implied by the hypotheses seems strangely irrelevant. The hypothesis that all future ravens will be black is not confirmed by the fact that all past observed ravens have been black. Nor will that hypothesis be confirmed if nobody ever examines future occurrences of ravens. In other words, if the history of natural science testifies to anything at all, it certainly testifies to the view that it is at least a necessary condition for a well-confirmed theory, or hypothesis within a theory, that it have some positive instances in terms

of observational consequences implied by the theory, or hypothesis. Doubtless there will be cases where the hypothesis under test is rendered more credible by data that is not implied explicitly in the hypothesis. Balmer's formula, for example, was rendered more credible and confirmed by Bohr's work on the hydrogen atom which implied Balmer's formula. But even that sort of case does not show that it is not necessary for the robust confirmation of a hypothesis that it have positive instances and be confirmed by data implied by the hypothesis. And it is not even clear whether Balmer's formula was sufficiently rationally confirmed before Bohr's work on the hydrogen atom. It might well be a case of overconfirmation, or adding more, but not particularly necessary, evidence that provides minimal credibility for the hypothesis. After all, suppose for the sake of discussion, that Bohr had never done his work on the hydrogen atom. Would not Balmer's formula still have been accepted as a strongly-confirmed hypothesis with maximal empirical adequacy by way of providing for predictions that would not be frustrated? In any event, it is difficult to see how having positive instances of a hypothesis, instances implied by the hypothesis, is rendered unnecessary for confirmation simply from the fact that there can be data confirming (or rendering more credible) a hypothesis that is not implied by the hypothesis. That can only be shown by pointing to some noncontroversially well-confirmed theory or hypothesis that has no positive instances in terms of what the hypothesis implies; and surely this requirement is not satisfied by anything one can point to in the history of science.

Given the history of science, then, it does not seem to be a particularly controversial claim that scientific theories require for confirmation testability in terms of observational consequences implied by the hypothesis. Many items in confirmation theory are controversial, but this is not one of them; and a harmless naturalism will need to reflect as much while being willing to wait for more clarity on what a sufficient criterion for confirmation may be. If that is so, then a suitably revised H-D model (one that possibly allows for the sorts of Baysean or "bootstrapping" considerations noted above and one that requires a special consequence condition)

will certainly represent a minimally necessary condition (and possibly a sufficient condition) for an adequate theory of confirmation.

Given the volume of literature on confirmation theory in science, incidentally, it would take us too far afield right now to attempt to offer more by way of a minimally adequate defense of a suitably revised H-D model (for non-Popperians) that represents a criterion for confirmation that is both necessary and sufficient. Here I can only offer a promissory note and return to the issue later. But, again, presumably, we would all agree minimally that scientific theories or explanations must be empirically testable in some way in terms of what they imply at the sensory level if the theories are to be empirically adequate or true, and that therefore there must be some relevant observational evidence implied by the hypothesis and necessary to test successfully any theory or part of that theory. Formal considerations, simplicity, and logical coherence alone, no matter how well-defined, will not be sufficient for confirmation. In defense of a revised (non-Popperian) H-D model (with an appropriate consequence condition) as representing a necessary condition, we must examine very carefully the claim that some theories, or parts of theories, are allegedly strongly confirmed solely by data not implying them. Again, I would urge that no theory (and no part of a theory) has ever been confirmed to any strong degree by observational data that did not at least weakly imply the theory, or was not implied, by the theory or hypothesis. The simple and undeveloped point of these brief reflections is that the usual (and not so usual) objections to the H-D model of confirmation, at least as a necessary condition for confirmation, do not lead to the conclusion that the core insight behind it is tragically and irreparably epistemically defective, as some have claimed. When we combine this conclusion with the demonstrable failure of classical or Humean empiricism, and note that our customary scientific practice roots deeply in the non-Popperian form of the H-D model (as representing at least a necessary condition for theory confirmation) with some Bayesian inspiration on antecedent likelihoods associated with competing or mutually exclusive hypo-

theses fitting the same data, the case for this harmless form of naturalism seems quite attractive.[18]

Bear in mind that we are talking about the methodology for acquiring public knowledge of the world, and even though it is important to note that while there is only one method for publicly understanding the physical world, there is a knowledge of the physical world that is not public, and hence there is a knowledge of the physical world that is not the product of the application of the methods of the natural sciences as we currently understand them. Such knowledge is private and a matter of personal privilege.

Before discussing the logical differences between scientific and philosophical explanations as sources of public knowledge, it may prove helpful to defend briefly this last claim that there is private knowledge of the physical world.

3.4 Private Knowledge

Most epistemologists believe that knowledge is a public concept and that private knowledge is a contradiction in terms. Some of us believe that scientific inquiry provides us with privileged beliefs, beliefs publicly and robustly confirmed by the community of scientific inquirers at large and defensible before the community by appeal to methods accepted by the community as reliable for producing publicly rational beliefs about the physical world. But there are few willing to say that there can be reliable information about the physical world outside the practice of ordinary science—if, indeed, there is any such thing as "ordinary science." The prevailing attitude seems to be that empirical knowledge, by definition, is a public affair—meaning that if I cannot publicly *show* sooner or later evidence for the belief (evidence that the scientific community would publicly accept as sufficiently confirmatory of the belief, then the knowledge claim is just that—a knowledge claim—with no good reason for the scientific community to accept it. But is this prevailing attitude correct?

To begin with, suppose for the sake of discussion that there was a fairly rare species of bird, the "Garrulous Minor bird," living only

in Central Park in New York City. Suppose also that only one of these birds occasionally flew along side the same solitary jogger and talked with her, saying such things as "Hello, my name is Joe, what is yours?" "Have a nice day," "No pain, no gain." Suppose also that one day these birds, for some reason or other, subsequently became totally extinct, and fifty years later a well-known senior jogger asserts that she had numerous conversations while jogging with one member of the recently extinct species of "Garrulous Minor bird" when they inhabited Central Park. Isn't it just possible that she knows something nobody else knows or could know? Of course, if her knowing what she claims to know depends on her being able to present such a bird, or otherwise publicly verify that such conversations sometimes took place, she does not know what she says he knows.

But might it not be the case that there is a kind of knowledge based on evidence that is transitory, and accessible only to one person? Such a person would not be able to prove or justify her claim to anyone else. The evidence that made her a knower is in principle incapable of being reproduced and presented to the community in order to make believers out of them. Do we not all have a great deal of private knowledge, knowledge we could not demonstrate having even if we so desired?

What my father said to me on his deathbed when nobody else was present is something I know, for example. Suppose my father had said, immediately before expiring, that he thought my brother George was an incompetent trout fisherman and then, after leaving the room, suppose I told my brother what my father had said. Incredulous, he might require proof that my father said as much. Here, as with the example of the Garrulous Minor bird, the words uttered are gone and incapable of being reproduced. Is being certain of something necessarily a matter of being able to make somebody else certain of the same item? If we say yes, then we have a concept of public knowledge; but if we say no because we all have knowledge based on evidence or experiences that are private, transitory, and open only to us for a brief period of time, then we have a concept of private knowledge.

There are those who might say that I really could not know what my father said as he lay dying, that my claim about what he said is anecdotal. Such a response, however, is simply an elliptical way of saying that my belief about what my father said cannot be a matter of public knowledge. True enough, but if the claim that my belief is anecdotal is meant to imply that I do not have knowledge of what my father said, then the only reply one can make is that such a response seems to beg the question in favor of public knowledge and against the existence of private knowledge and our deepest intuitions suggest just the opposite.

There are at least two important points to remember about private knowledge. The first is that we all have some of it because we all know something or other based on evidence transitory and accessible only to us at a particular time. Like Russell, I have no way of proving that I had an egg for breakfast three mornings ago; but I do know that I did. The second point is that it is private, meaning that by definition, questions such as "How do you know?" make absolutely no sense because there is by definition no way of reproducing the evidence in the interest of making anybody else a knower of the same fact. If one does not answer the question "How do you know?" by producing evidence sufficient to convince the questioner and any other questioner, then one's claim will not, as a matter of course, be accepted as an item of public knowledge. If one says, for example, "I know extra-terrestrials exist because I saw them," the evidence offered by this testimony does not answer the question "How do you know?" because it does not provide the evidence that is publicly confirmable in the public realm. The evidence that might make Smith a justifiable believer in the existence of extraterrestrial aliens is not offered by Smith's testimony that he has the evidence. Even if Smith is generally reliable, honest and has no reason to deceive us, his sincere testimony that he has seen aliens does not provide the kind of public evidence necessary for public confirmation of the belief, and hence for public knowledge. Naturally, personal testimony based on evidence that cannot be publicly reproduced in the interest of answering the question "How do you know?" may not be totally worthless if the person testifying

to the event is generally reliable and honest. But if there is some honest doubt about the events to which he testifies (as would occur if the event to which he testifies is at all unusual, important and not capable of being publicly confirmed), his failure to provide public evidence that makes believers out of those asking "How do you know?" is sufficient for saying that while he may have some private knowledge here, he does not have any public knowledge of the event to which he testifies. For this reason there is also good reason to argue that it may make no sense whatever even to characterize such knowledge as evidence-based because evidence is typically what one gives, or can give, when the question "How do you know?" makes sense. If such a question made no sense, or would be pointless to ask, because of the impossibility of providing public evidence that would answer the question, the evidence involved here would also need to be private. Either that or we could give up on calling it evidence-based and opt instead for the view that it is knowledge warranted by the experience but incapable of being reproduced in the interest of establishing the warrant as public. Because private knowledge does not lend itself to public confirmation there is no public reason to accept such claims when there is some reason to suppose that the claim may be false or that the subject may not be in a position to know.

Much more can, and probably, should be said in defense of private knowledge. For present purposes, however, this all-too-brief discussion may suffice to establish that there is another kind of factual knowledge eluding the methodological net of the natural sciences. The issue to which we must now return is the logical difference between philosophical and scientific explanations and the way in which both are forms of empirical knowledge.

3.5 Philosophy and Natural Science

In rejecting the replacement thesis we argued in Chapter 1 above that it is false that the only legitimately answerable questions about

the world are scientific questions, and it is false that the only correct answers or explanations that we have at any time are those that emerge from the application of the methods of the natural sciences.[19] It follows that we have some correct answers and explanations that do not emerge from the application of the methods of the natural sciences. But if such answers tell us anything about the world, they cannot be *a priori* and hence must in some sense be constrained by empirical fact.

We have also argued that nevertheless, for most, if not all, questions about the causes of the regularities and properties observed in the physical world, the methods of the natural sciences are privileged because they provide us with the only efficient and explicit methodology for producing public answers that are items of public and communal knowledge. These latter questions, moreover, are answerable only within an empiricism or naturalism characterized in the way Peirce, James, and Nagel (among others) basically characterized empiricism. Such an empiricism, unlike its Humean ancestor, minimally requires belief confirmation in terms of the observational consequences deductively implied by one's beliefs or hypotheses. Such an empiricism is also perfectly consistent with rejecting the replacement thesis as well as the transformational thesis, both of which we rejected for all the reasons stated earlier.

Moreover, the fact that there must be some legitimately answerable questions and some correct answers and explanations about the world that do not emerge from the methods of the natural sciences is an interesting but unsettling conclusion. Indeed, apart from raising the problem of how to characterize further these two different kinds of questions about the world, it leaves unclarified what exactly an explanation is that is not a scientific explanation. Minimally, if only to demarcate between sound scientific explanations and sound philosophical explanations, it is desirable to point to what is a necessary condition for former but not for the latter. We seem to have a sense of what is minimally and non-controversially necessary for a good scientific explanation, namely explicit testability in terms of sensory implications of the hypothe-

sis. But what is necessary for a sound explanation that is not a scientific explanation? How does one answer such a question? That such explanations or answers exist follows, as we have noted, from the refutation of the replacement thesis as described above. So where are they, and what logically distinguishes them from sound scientific explanations or answers?

It is tempting, and may be the better part of prudence, simply to end the discussion with this basic conclusion. Doing so would leave the world fairly safe for naturalists who feel the need to philosophize in the context of traditional epistemology. But doing so would hardly shed any light on the pervasively undiscussed problem of what a sound explanation is which is not a scientific explanation. Although rushing in here, or even casually walking in, is the stuff of which fools are made, let us turn our attention to the inevitable question hanging over our refutation of both the replacement thesis and the transformational thesis, namely, "What are the logical features of an explanation or answer which is not a scientific explanation or answer?"

Questions such as this, incidentally, have not had much of a run in philosophy for the plausible reason that a convincing answer to such a question would seem to presuppose that there is some consensus in the philosophical community on just where we have had some noncontroversial success in offering persuasive philosophical answers or explanations. Given this, it seems only natural to conclude that we do not even know what conditions are necessary for a sound philosophical explanation. Apparently, failure to get consensus on this item has sent even people like Wittgenstein into the depths of his *Investigations* happy to have argued simply that philosophy is not science, and not involved in increasing our factual information about the world. Unfortunately, it does not seem to have occurred to Wittgenstein that while philosophy may not be science, that while philosophical explanations are not scientific explanations, philosophical explanations may yet be sources of factual information about the world.

But, here again, even if we cannot not say fully what a successful philosophical explanation is, we ought to be able to specify

some logical feature distinguishing correct philosophical, from correct scientific, explanations. Let us start at the beginning, and determine whether we can discern some logical features of an explanation that are properly philosophical rather than scientific.

If philosophical answers flowing from philosophical explanations are to count as items of public knowledge about the physical world, rather than as non-cognitive proposals, or recommendations, or empirically non-falsifiable interpretations holding vacuously and independently of any contrary findings in natural science, they cannot be *a priori*, in the sense of being true by definition and hence irrefutable unto eternity by appeal to any public sensory data or experience. Their content must in some sense be empirically testable and falsifiable. Barring questions of internal logical coherence, sound deductive inference, parsimony, simplicity, freedom from logical contradiction, and "consistency of fit" with empirical data alone, if nothing at the sensory level counts, or could count, for error in one's philosophical answers, then it is difficult to see how such proposed answers can have anything to offer as a statement of, or picture about, the world. Similarly, if we were to construe mathematics as providing literally true statements about the physical world, then the existence of triangles not measuring 180 degrees would falsify the claim that all triangles have 180 degrees.[20]

Generally, as we saw back in Chapter 1, we can refute a philosophical explanation on logical grounds alone if, for example, the explanation is logically incoherent, simply invalid, or self-defeating in various ways under usual assumptions. In this respect, philosophical explanations do not differ from scientific explanations. But, as we all know, freedom from logical defect can be a feature of mutually exclusive hypotheses each of which fit equally the available observational data.

In philosophy, moreover, while knowing at least implicitly and generally what "facts" could and would undermine one's logically acceptable answer is certainly desirable in order to avoid a sterile *apriorism* consistent with any particular fact of the matter, it is not necessary that one be able to state *explicitly*, and in particular, what specific observational data under what conditions and provisos,

would refute one's philosophical views. The latter condition, *explicit testability*, is rather a necessary, or defining, condition of a meaningful scientific explanation or hypothesis. The former requirement of *implicit testability*, however, while not satisfying a sufficient definitional requirement for a claim being a philosophical answer or explanation, would nonetheless provide some measure of objectivity for philosophical claims. There are of course some fairly predictable objections to this proposal, objections which we shall take up shortly.

But certainly it is a necessary condition for an explanation being philosophical that even if we cannot explicitly state the test conditions for our explanation, we should be willing to hold it as tentative and in principle refutable by some empirical fact or other. In the interest of avoiding an unsavory *apriorism*, our philosophical explanations and answers must also be fallible and hence empirically falsifiable in the implicit and general way just indicated.

But how can a statement be both empirically testable, and hence generally falsifiable or confirmable by appeal to observation statements implied generally under usual proviso conditions, and not at the same time be a statement that falls squarely into the domain of natural science? How distinguish, more specifically, between natural science and philosophy without turning philosophy into some form of *apriorism* wherein one's philosophical answers need only be fairly "rich" and internally coherent to warrant justifiable and eternal acceptance?

3.6 Philosophical Explanations: Not Explicitly, But Implicitly, Testable

Recall our discussion in Chapter 1 when we examined and rejected Lycan's argument to the effect that philosophy is natural science. Lycan's position seems quite convincing as soon as we abandon the *a priori* or the analytic and then classify all claims as *a posteriori*

and hence empirically testable. Add the Humean predicament as the human condition, and we end up with a fairly strong thrust in the direction of the replacement thesis. There we also urged that while philosophical conclusions may be rationally acceptable without being explicitly empirically confirmable, they still admit of empirical falsifiability. But while empirical falsifiability (suitably characterized) is sufficient for a claim not being *a priori* or dogmatic, by itself it is not obviously sufficient for a claim being a scientific, or a scientifically, meaningful claim within natural science. Scientific explanations, but not philosophical explanations, require *explicit* testability and falsifiability.[21] If this is so, both natural science and philosophy are a posteriori but logically distinct to the degree that we can state precisely the difference between explicit and implicit testability.

More accurately, in natural science *explicit* empirical testability by appeal to the observational consequences deductively implied by one's hypothesis is certainly a necessary condition for an explanation being a scientific explanation. In philosophy, however, if we are to avoid *apriorism*, *implicit* (and not *explicit*) empirical testability is a necessary condition for an explanation being philosophical. The difference between the two is the following: For any statement or explanation X,

> PE. "X is *explicitly* empirically testable at time *t*"=df "Somebody at time *t* states, or is able to state, in detail specific test conditions for X by appeal to public observational data implied by X, data the occurrence or non-occurrence of which would, under standard provisos and specific conditions implied by X, tend to confirm or disconfirm either X or X's logical contradictory; and the specification meets, or would meet, with the general approval of the scientific community."

By contrast, for any statement or explanation X,

> PI. "X is *implicitly* empirically testable at time *t*"=df "There is some real probability greater than zero at time t that there are some public observational data, implied by the content of X, that would, under standard provisos, epistemically justify anyone in rejecting or accepting X even though nobody at time *t*, or any time earlier, did,

or was able to, explicitly state any specific (rather than general) conditions that would produce or reveal the observational data publicly justifying or informing rational acceptance of X as an item of public knowledge."

These definitions, or explications, admit of refinement. Even so, as stated, they clearly do not support naive conceptions of testability, confirmability, or of falsifiability.[22] They are, for example, consistent with (but do not require) the Duhem-Quine thesis to the effect that individual hypotheses or explanations cannot be conclusively or even strongly falsified by experiential findings deductively implied by those individual hypotheses and explanations because the deduction from the hypotheses of the falsifying observation sentences requires an extensive system of background hypotheses, so that typically only a comprehensive set of hypotheses will entail or contradict the observation sentences. Moreover, the above definitions are perfectly consistent with Hempel's view, for example, that the test conditions are not simply the deductive implications of the hypotheses or explanations themselves, rather than the deductive implications *combined* with the proviso that in the application of the theory (or explanation) in the context at hand no other factors are present other than those explicitly taken into account. It is tempting to pause and say more about these views on testability and the nature of falsifiability. But the important point worth harping on is that when all is said and done, whether one favors the Duhem-Quine thesis, or whether, like Hempel and others, one adopts less naive views about testability, proviso clauses, and the H-D model, in order for a claim to be a publicly acceptable scientific explanation (or answer), somebody at the time of the claim must either state, or be able to state, explicitly the specific conditions implied by the explanation. These are the conditions that allow for public empirical testing of the claim, the specific conditions which, if satisfied, would, under appropriate provisos, produce or reveal public observational data either confirming or falsifying X.[23] Whatever disputes we may have had, and continue to have, in the philosophy of science about the nature of testability and falsifiability, the

scientific community nonetheless pervasively agrees that in order
for a claim to be a legitimate scientific claim there must be some
conceivable sensory data directly implied by (or implied by
background theories assumed by) the hypothesis or explanation
offered—sensory data the occurrence of which, under suitable
provisos, either supports or undermines the hypothesis or explana-
tion. This is what I meant earlier when claiming that empirical
testability is a straightforward requirement for scientific explana-
tions or hypotheses. But it does not follow from this that there are
not more or less naive views of what testability and falsifiability
consists in, even when it is clear that testability and falsifiability are
a function of the appearance of sensory phenomena implied in
some way by the truth or falsity of the explanation or hypothesis
offered.

If philosophical explanations are to be empirically testable
without being scientific explanations, however, then the testability
involved must be implicit and in accord with PI. Under PI there is
no explicit requirement that anyone at time t either state, or be able
to state, specifically what empirical conditions under what circum-
stances need to be satisfied for X to be either rejected or accepted.
The only requirement, assuming logical coherence and general
deductive validity, is that there be some real probability that there
is some specific observational data implied by the hypothesis and
the occurrence of which data, under suitable provisos, would allow
us to accept or reject the hypothesis.

Although desirable, it would not seem to be a necessary condi-
tion for a philosophical explanation that someone be able to say in
some general way what sort of observational evidence would refute
or confirm the explanation, were such evidence to occur. But it is
necessary that one be willing to hold the explanation tentatively,
and be willing to set it aside on some observational evidence
implied by the explanatory hypothesis, even though one may not be
able to state antecedently just what the evidence should be (or what
the specific sensory test implications of the hypothesis are) in order
to refute the explanation. As it is, the general condition that there
be some real probability of empirical refutation is automatically

satisfied simply because in the past there have been some arguments and answers which have been empirically falsified by observational data even though at the time of their original assertion nobody explicitly stated, or was able to state, what specific test conditions and observational data would falsify the claim. Essentially, what made such claims philosophical is that they were implicitly empirically testable and falsifiable even though at the original time of their utterance they were not explicitly falsifiable in the way specified in PE.

As we saw above, there are cases in which philosophical explanations or answers satisfying PI have been empirically refuted. These are refutations of non-scientific explanations or answers. Although there are not many, two fairly clear cases come to mind immediately, one of which we have already discussed. In an effort to make clear just what a philosophical explanation is and how it can be empirically refuted without being a scientific hypothesis or explanation, I offer them as clear examples of successfully refuted philosophical explanations which are philosophical, and not scientific, because they satisfy PI and not PE. I further submit that if any explanation is to be philosophical rather than scientific, it must satisfy PI if it is to be empirically testable and refutable without being an instance of a scientific explanation.

3.7 Two Examples: Aristotle on Human Intelligence and Hume's Other-Mind Solipsism

The first case is Aristotle's philosophical argument that humans have rational souls, whereas non-human animals do not, because the latter do not use tools. Presumably, when he offered this argument, Aristotle would doubtless have agreed to drop the claim if confronted with evidence of animals making and using tools. But he did not know specifically how to produce conditions that would demonstrate either that there were such animals or that such animals did not exist. He had no specific idea of what to do under

what circumstances to produce disconfirming observational data. He did not state explicitly and in detail what evidence he would count, under what provisos, as evidence refuting his claim. Nor is it clear that he was able to do so, but simply chose not to do so. He simply generalized from what he took to be a defining trait of a representative sample of animals, a sample which obviously did not include chimps or gorillas. Like all philosophical arguments about the world, incidentally, Aristotle's argument assumed that certain empirical generalizations (e.g. that no non-human animals use tools) were true and that their truth was essential to the success of the argument that rested upon them. I submit that all "philosophical" arguments rest on some factual assumptions which, if false, undermine the arguments in question.

At any rate, what made Aristotle's answer and explanation *philosophical* was that at the time of its utterance it was *implicitly* testable and falsifiable. At the time he offered the explanation or answer, there was in fact some probability greater than zero that there was sufficient evidence justifying rejecting the hypothesis even though nobody, including Aristotle, then explicitly stated, or was demonstrably able to state, the specific conditions that would produce or reveal the observational data falsifying the hypothesis. At the same time, Aristotle would likely have admitted what general sort of empirical data would succeed in refuting his claim, thereby showing a willingness to set aside the explanation in the presence of the appropriate observational data. Thus, at the time of its utterance, Aristotle's answer was neither a scientific claim nor an *a priori* claim holding no matter what evidence the future would bring. Presumably, Aristotle would now agree that his thesis is wrong, that his philosophical explanation of why animals do not speak or use tools, has been refuted by the sorts of facts revealed to all of us by Jane Goodall, for example, in her celebrated research on chimps and gorillas.

Incidentally, it is tempting to respond that this refutation of Aristotle's argument shows merely that Aristotle was not really offering a philosophical answer but rather a scientific one. To this response, however, there are two replies. The first is that this sort of response begs the question against the thesis by assuming or

implying that *philosophical* answers, explanations, or arguments can never be empirically tested and refuted. After all, if every time an ostensibly philosophical argument or claim gets refuted by some observational fact what is shown thereby is simply that it was a scientific claim to begin with, we have made it an *a priori* truth that philosophical claims cannot be rejected by appeal to any fact of the matter. So it would not help to say for example, that Aristotle was simply doing armchair zoology when he offered this argument, and that therefore it was not an example of a philosophical argument to begin with.

Secondly, and more importantly perhaps, the reply fails because it denies without any justification the fact that the scientific community will not generally consider an explanation, hypothesis, or answer a scientific one unless somebody can state explicitly and specifically the test conditions and observational data requisite for confirmation or rejection. As it is, it seems clear that Aristotle's original *philosophical* argument for the rational superiority of humans over animals based on the use of tools, stands thoroughly refuted by the facts as we now understand them. And it was indeed a philosophical argument because at the time of its utterance it was not *explicitly testable* in the way scientific hypotheses must be testable if they are to be scientific at all.

The second case that comes to mind, a case that seems equally non-problematic, is David Hume's argument for other-mind solipsism. Any reasonably accurate formulation or reconstruction of Hume's argument will need to list as a premise in the argument Hume's claim that there is no idea for which there is not a corresponding impression of sense from which it is derived.[24] As we all know, Hume noted an exception to this principle, and then proceeded to argue for various theses based upon the principle anyway, as if the exception (because it was so "singular") had no epistemic value by way of assessing the principle itself.

At any rate, in so far as Hume's argument for other-mind solipsism is dependent upon this principle, it is refuted empirically by the fact that there are some ideas which are not derived from some corresponding impression of sense. Unless Hume is stipulating

arbitrarily how we *ought* to understand the concept of an idea (and nobody really believes that) the principle is straightforwardly refuted by the empirical fact, for example, that we do have an idea of a chiligon which could not plausibly be regarded as derived from a sensory impression of a thousand-sided figure. If Hume were simply stipulating how we ought to understand the concept of an idea, then, in the absence of a strong argument justifying the recommendation there would seem to be no grounds for assigning a positive truth value to this premise; and that would be to show that a crucial premise in the argument is certainly not demonstrably true. Thus it seems clear that Hume's argument has been empirically refuted even though, strangely enough, he stated empirical evidence that refuted it, and then went on as though the thesis had not been refuted.[25]

Similarly, if this principle in Hume's theory of ideas has been empirically refuted, it would appear that any of Hume's major theses that depend on this principle as a core premise (and this affects his theses arguing for the non-existence of the self, the non-existence of God, the non-existence of necessary connections and causality, and the non-existence of the external world) are equally empirically refuted. There may be some temptation to think that the empirical refutation of Hume's argument for other-mind solipsism is not as clear or as forceful as the empirical refutation of Aristotle's argument for the view that animals do not have rational souls. But I submit that neither Aristotle's argument, nor Hume's argument, should ever again be considered as anything but examples of empirically refuted philosophical arguments. Once again, what made these arguments or explanations philosophical rather than scientific is that at the time of their assertion nobody either did, or was demonstrably able to, explicitly specify just what particular fact (or facts) of the matter would need to occur at the observational level in order to refute them; and there was some real probability greater than zero that there was refuting evidence. This is how philosophical explanations are empirically refutable without being scientific. Doubtless there are other examples of a clean empirical refutation of a philosophical answer or explanation.[26]

Once again, any response that these are not philosophical arguments, that Hume was merely an armchair cognitive scientist, seems *ad hoc* and question-begging in favor of the view that philosophical arguments necessarily root in the a priori and cannot in principle be tested and refuted by appeal to any fact of the matter. Such a claim arbitrarily makes Hume and Aristotle, for example, scientists because their claims were implicitly testable and falsifiable when in fact the scientific community requires explicit testability as a necessary condition for any claim being a scientific claim.

It may prove helpful at this point to view a current philosophical explanation which has not been empirically refuted but which is implicitly rather than explicitly testable.

3.8 Another Example: Scientific Realism

Consider the philosophical dispute over realism vs instrumentalism in science. This philosophical dispute essentially involves two mutually exclusive answers to the question of whether natural science provides us with knowledge of, or accurate beliefs about, the physical world, or whether we can simply conclude that such beliefs are merely instrumentally reliable, or empirically adequate, independently of whether they provide us with real knowledge of the world. Consider now the minimalist realist thesis that some of our empirical beliefs about the physical world must be correct (even if only partial) descriptions of the world, because otherwise we would have no equally plausible way to explain the long-term predictive success of some of our empirical beliefs or theories.[27] Earlier we noted that neither the realist nor the instrumentalist position in this dispute admits of any specific test implications that we can now explicitly state. This is what makes the dispute philosophical rather than scientific. As the case now stands, the issue is argued one way or the other purely in terms of the plausibility of the formal implications of the thesis defended.

The minimal realist has argued her position on the grounds that there is no equally plausible explanation for the long term predictive success of some theories or empirical hypotheses. But the plausibility involved here seems decidedly formal in the absence of anyone's being able to state explicitly the specific observational data, implied by the hypotheses, that would confirm or falsify one or the other of these two positions. What relevant empirical evidence would one accept as confirming either one or the other? It seems very difficult to say.[28] Both theses do not seem to have anything but exceedingly vague and general empirical test implications. Even so, if by some fact or other one could show that instrumentalism really does offer the most plausible explanation for long-term success, or if by appeal to some fact or other one could show that we do not need to offer an explanation for the long term success of some scientific hypotheses or empirical claims, then the minimal realist would need to abandon her thesis to the extent that the thesis depends for its plausibility on these considerations. Thus, we do not know what specific test implications one might explicitly state in order to establish such a conclusion, and for that reason the thesis is not now testable or empirically confirmable (or falsifiable) by the minimal standards authorized in natural science.

However, if the history of science is any indicator at all, and if we accept that both Hume's argument for other-mind solipsism and Aristotle's thesis on human rationality have been decisively empirically refuted, there is some probability that either realism or instrumentalism will be empirically falsified by some bit of observational data. There is also some probability that this may not happen. Rationality would then devolve into purely formal considerations and the sort of plausibility associated with the purely formal. If all available positions other than minimal realism, for example, were to involve some clear contradiction, then one would be poorly advised not to accept minimal realism as the correct answer, and that would be because there could be no empirical plausibility at all associated with such positions. As it is, one should not regard such a conclusion as incapable of empirical refutation. If one's philosophical views are to face the tribunal of lived ex-

perience, one should be willing to set aside any belief, philosophical or otherwise, owing to some empirical fact or observational data in some way implied by one's beliefs even if one does not become aware of the implication until after the fact. Otherwise we have not escaped the clutches of *apriorism*.

Naturally, it will be difficult for some to accept the view that philosophical explanations and arguments are a species of empirically falsifiable claims that are not straightforwardly scientific claims. In fact, the idea that the realist-instrumentalist debate, or the question of the existence of Cartesian Egos, could be answered by appeal to some empirical fact will certainly seem ludicrous to some philosophers. Even so, it may be that progress in philosophy is more likely to go forward on basic philosophical issues if we come to regard philosophical problems and explanations as a special species of the empirical. For example, while some philosophers have come to believe that we cannot in principle solve the mind-body problem, and that that in itself dissolves the problem as one worthy of consideration, others have found belief in the existence of minds, construed as Cartesian Egos ("immaterial" substances), preeminently an empirical question. Among the first group, for example, Colin McGinn has argued (persuasively I believe), that as long as we regard the mind-body problem in traditional philosophical terms, our minds are incapable of seeing what is necessary to solve the problem. If one thinks of philosophical explanations in traditional terms, that is, if one thinks of philosophical explanations as unfalsifiable by appeal to any fact of the matter, it is difficult to reject McGinn's argument.[29] But it is also difficult to regard his conclusion as evidence of real progress in philosophy, rather than as an act of despair resulting from a misconception of the nature of philosophy itself. Among the second group, however, Derek Parfit has argued that, in terms of what it would have taken to prove the existence of Cartesian Egos, namely the empirical evidence implied and predicted by the belief in reincarnation, it simply has not occurred and hence we do not have the appropriate empirical evidence for belief in the existence of Cartesian minds.[30] Clearly, Parfit's view is that had such evidence

occurred, we would have solved the mind-body problem in favor of some form of Cartesian mind-body dualism. (See note 7 above.) One can agree with Parfit that if the predictions implied by the belief in reincarnation were to occur, anti-Cartesian materialism would stand as well refuted as Aristotle's and Hume's arguments noted above. Would McGinn claim that, if the evidence implied by, or predicted by, the belief in reincarnation had occurred as predicted, that the mind-body problem would still not be solved? If he did agree that the problem is solved only because we now know that it was really a scientific problem and not a philosophical one, would he not be making the same mistakes (noted above) one makes when claiming that Aristotle and Hume were in fact armchair scientists? In short, it is not at all difficult to see how certain traditionally metaphysical problems, problems such as whether there are Cartesian Egos, can be solved as soon as we see such problems as problems about explanations that are empirically implicitly testable. Again, this view of philosophy seems necessary if we are to avoid the philosophical horror of *apriorism* at its worst.

In summary, philosophical claims and explanations are empirically testable and falsifiable, but, unlike scientific claims and explanations, it is not a necessary condition for their being falsifiable that anybody be able to state explicitly the specific test conditions or observational data that would falsify the claim. For philosophical claims, but not scientific claims, it will be enough that someone be able to state very generally what sort of observational data would warrant our rejecting the claim even if one cannot explicitly state the specific test conditions for revealing or producing such data.

Of course, for philosophical claims it will also be necessary that there be some real probability that the claim can be tested and falsified. This latter condition is automatically satisfied as soon as we grant that some philosophical claims or explanations (such as Aristotle's thesis about human rationality or Hume's other-mind solipsism) have been empirically refuted even though at the time of their original assertion nobody was able to state explicitly either the

test conditions or the observational data necessary for empirical refutation or confirmation.

This proposed distinction between scientific and philosophical explanations may well depend on whether we agree that certain philosophical theses or explanations in the history of philosophy have been empirically refuted. Although most philosophers will probably agree that Hume's argument for other-mind solipsism, along with Aristotle's argument about animal rationality, have been empirically refuted, they may for that reason be inclined, as we have noted above, to assert that this just shows that these hypotheses were at the outset fundamentally scientific and not philosophical. For the same reasons indicated a few paragraphs back, we have already seen that this reply will not work without begging the question against every form of philosophical naturalism and, at the same time misconstruing what scientific practice dictates as necessary for a claim being a scientific claim.

Before concluding all this, it might be helpful to confront a few other likely objections to the basic theses offered in this chapter.

3.9 Other Objections

As we have characterized it, "harmless naturalism" asserts in part that although there are some answerable questions about the world not answerable by appeal to the methods of the natural sciences, for all questions about the nature of the physical world, the causes of the regularities and properties observed therein, the method, or methods, of the natural sciences are privileged because they provide us with the only reliable method for a public knowledge of the world. This thesis would seem to imply straightforwardly that the answers provided in philosophical explanations, although implicitly falsifiable, fall outside the method of the natural sciences and hence never provide us with a public knowledge of the physical world. From a naturalistic perspective is this not an undesirable result for the view that legitimate philosophical explanations are not a priori but rather informative about the real world?

The response to this predictable question consists in noting that while philosophical claims and explanations fall outside the methods of the natural sciences because they are not explicitly, rather than implicitly, testable and falsifiable, they still provide us with a public knowledge when they are falsified or confirmed by some unanticipated test implication and fact.

It's just that there is no method for explicitly testing the explanations or answers when they are initially asserted because either we are unsure about what specific observational data to look for, or we do not know how to produce or find relevant observational data. This methodological deficit is not allowed for proposed explanations in natural science, and that is the reason why the methods of the natural sciences are privileged by way of providing the only method for achieving a public knowledge of the physical world. From the viewpoint of natural science, then, lack of explicit testability renders a claim meaningless because currently outside our methodological capacity to test it. But such a claim might well be a meaningful answer to some question and provide us with public information just because it is implicitly testable and in fact falsified at a later date by some specific observational data implied by the explanation.

As another objection, someone may well observe that there is no way of determining whether any particular explanation offered to us is in fact a legitimate or correct philosophical explanation, if it is only implicitly testable. As long as one need not say explicitly what specific observational data will or will not falsify the explanation offered, it might very well be that the hypothesis is one for which there is in fact no relevant observational data even though there is some probability that there is. Or so it might be objected.

True enough. Any proposed philosophical explanation may in fact never be empirically falsified (or confirmed) even though it satisfies the definition of implicit testability. The only rational procedure here is to regard them all as empirically falsifiable, and be willing to abandon them in the presence of unexpected observational data. If they are truly philosophical claims or explanations we have no current way of knowing whether they will suddenly

stand refuted by some unexpected observational data. Again, we have no way of currently stating explicitly what, if any, specific observational data will decide the case between the scientific realist and the instrumentalist, for example. But there is some probability that there is an observational state of affairs that will decide the issue; and that makes both positions implicitly testable. Some implicitly testable explanations will actually become tested later and falsified, and some may never be tested. Until then we can, as we will, argue for one position over the other purely in terms of the inner logic and non-empirical plausibility of the positions in question. We might, for example, argue impeccably that all available arguments favoring one position are formally invalid and that any conceivable argument for that position would be logically incoherent. If we do, and if there must be an answer to the question for which these positions are purported explanations, then we would have a great deal of rational credibility favoring the one position over the other. It may be the only coherent and logically plausible position to adopt. And that of course would provide some strong *prima facie* rational justification for the one position over the other, even if there is no currently discernible or conceivable observational data favoring one position over the other. But in the absence of explicit observational data falsifying or confirming one position over the other, we must still be prepared to allow some unexpected observational data to undermine our cherished thesis. That much seems implied by the fact that there is some real probability that the claim will be falsified by some unexpected observational data. And this real possibility of refutation is present equally even when our cherished explanation has been supported to some degree by observational data.

A third possible objection runs as follows. To the extent that philosophical explanations are increasingly legitimatized in virtue of their capacity to be constrained by observational data, the more likely they are to pick up the characteristics of revolutionary science; and this may well lead to the charge that philosophical explanations and answers, like scientific theories, are born dead. Indeed, if the history of science is any indicator at all, we seem

quite inductively warranted in asserting that all theories in an indefinite future will be eclipsed and replaced by theories in which what had been essential to the previous theory is replaced in the way that, for example, the phlogiston theory of combustion, or the caloric theory of heat, was replaced.

This particular objection rests on the credibility of the general argument to the effect that all scientific theories are born dead; and often this argument feeds on the thesis that scientific theories are incommensurable. Elsewhere I have argued at length that the general argument here misdescribes what actually transpires when one theory replaces another, that when one theory replaces another it is a serious mistake to think that all the statements in the replaced theory are false. Some of the statements in the replaced theory find their way, either explicitly or implicitly, into the replacing theory in ways supportive of the view that there is a cumulative increase in understanding and knowledge throughout the revolutionary process. The major interesting question thereafter is whether the revolutionary process will go on indefinitely long, or whether there is any reason to suppose that we may well come to an end of scientific revolutions.[31] This is not the place to repeat those arguments.

Moreover, even if the argument for the view that all scientific theories are born dead were a sound argument, there is good reason to suppose that it would not apply in the case of philosophical explanations and answers. This is because, apart from the two cases we examined above (and a few others we have not mentioned), we do not have anything like a broad general consensus on which philosophical answers or explanations have gone the way of the geocentric hypothesis, so to speak. Indeed, one would be sore pressed to argue that progress in philosophy has been as revolutionary and as conspicuous as it has been in natural science. As a matter of fact, the distinctly prevalent attitude is that there is no way to establish the claim that there has been real progress in philosophy just because philosophy is not at all like natural science. On the latter view, the only progress we can make in philosophy is a fuller or deeper understanding of the implications of the general

position we stake out. But there is no reason to think that this sort of progress has ever carried with it a refutation of any other opposing philosophical view or basic commitment.[32] If what we have concluded with regard to cases such as Hume's other-mind solipsism and Aristotle's argument on animal intelligence is correct, however, we certainly have made some progress in philosophy by way of empirical refutation. But the scope of this progress, as it now stands, scarcely allows the substantial inductive basis to justify the view that philosophical progress is revolutionary in the way scientific theorizing has been.

In the end, perhaps the most telling objection to the above may be that the distinction between explicit and implicit testability or falsifiability seems just a bit too thin, so to speak, to justify anything like a robust autonomy for philosophy; that philosophy, in the end, turns out under such a distinction to be only superficially different from natural science because the core feature of scientific claims turns out to be their testability and falsifiability in terms of the test implications at the sensory level. Whether this testability or falsifiability is explicit or implicit does not, so the objection continues, seem to change the essential character of the explanations offered in natural science and the explanations offered in philosophy. Even though it is difficult not to feel the force of this objection, the proper reply is that while philosophy and natural science are both forms of empirical knowledge whose essential feature is testability and falsifiability in terms of the test implications at the sensory level, by standard practice we do not count as a scientific explanation or answer anything that is not explicitly testable and falsifiable, in the way noted above, by appeal to conceivable implications at the sensory level. This allows us to draw the real distinction between implicit and explicit testability, and it is therefore a distinction that carries a real difference between two kinds of empirical understanding and knowledge. And the fact that noncontroversially successful refutations of philosophical explanations do so in terms of implicit, rather than explicit, testability adds more credibility to construing philosophical explanations in terms of implicit testability.

3.10 Conclusion

According to Gilbert Ryle, Wittgenstein was intent on showing in the *Tractatus* that philosophy was not a science; that all logic and all philosophy are inquiries into what makes it significant or nonsensical to say certain things. For Wittgenstein, the sciences aim at saying what is true about the world whereas philosophy aims at disclosing only the logic of what can be truly or even falsely said about the world. For Ryle, this is why Wittgenstein thought the business of philosophy was not to add to the number of scientific statements, but to disclose their logic. After the *Tractatus*, however, Wittgenstein avoided saying precisely just what philosophy is.[33] Although Ryle states approvingly that Wittgenstein demolished the idea that philosophy is a sort of science (431), there is good reason to suppose that while scientific explanations are quite logically distinct from philosophical explanations, philosophical explanations are nonetheless constrained by observational fact if they are to have any role in providing us with an understanding of the world. Here again, the fact that there must be some legitimate and answerable questions that are not answerable by appeal to the methods of the natural sciences as we know them, and the fact that such answers are subject to rejection and acceptance by observational data if they are to avoid the purely *a priori*, has forced us to try to say just what the difference is between them. In doing the latter we have examined, rather than generalized from, two clear cases in which ostensibly philosophical claims have been refuted by observational data. These cases show clearly what the logic of a philosophical explanation must be if such explanations are to avoid both *apriorism* and explicit subsumption into a minimalist requirement of explanation in the natural sciences. While philosophical answers and explanations are by no means the same as scientific answers and explanations, they are, for the above reasons, implicit empirical claims about the world that we can and ought to regard as revisable and eliminable by appeal to observational data.

Wittgenstein was right in claiming that philosophy is not science, but he was also surely wrong in thinking that philosophy

only discloses the logic of what can be truly or falsely said about the world. For those of us with a naturalistic bent and who reject a dogmatic *apriorism* in which philosophical claims can turn out to be everlastingly true no matter what the facts may be, there does not seems to be any other way to understand the nature of a philosophical explanation, or answer, when it is clear that there must be some legitimate and answerable questions that are not answerable by appeal to the methods of natural science and yet subject to rejection in some basic way by appeal to observational facts if they are to offer us anything significant by way of understanding how the real world is.

Notes

Notes to Chapter 1

1. Quine, in *Ontological Relativity and Other Essays*.

2. See Quine, "Epistemology Naturalized," 70.

3. In defense of Quine, incidentally, naturalized epistemology is indeed normative because natural science is not simply descriptive. Natural science is normative, but not in the way traditional epistemology is normative. In the former, but not in the latter, the norms for correct scientific methodology and inference are prescriptive of, and evolve from, the practice of natural science. In the latter, but not the former, the norms are not prescriptive of, and do not evolve from, the practice of natural science. Traditional epistemology is normative only in the sense that it prescribes standards of certainty and warrantedness that the practice of science must achieve if it is to live up to our pre-scientific concept of knowledge and justification. Such standards themselves are not warranted by the practice of natural science rather than prescriptive of what the practices must produce if science is to provide us with a correct understanding of the physical world. The normativity of natural science derives from the canons of justification specified in science, and those canons derive their normativity from their instrumental effectiveness in achieving the major goals of natural science. For the replacement theorist, instrumental normativity of the sort just described does not require "first philosophy" or any concept of normative rationality whose justification would rest on premises not established under the canons of acceptable inference in natural science. In short, Quine has not abandoned normativity in adopting naturalized epistemology, but he has abandoned the normativity of traditional epistemology for the reasons that would justify abandoning "first philosophy." To argue against the replacement thesis on the ground that it abandons the

185

normativity of classical or traditional epistemology is simply to beg the
question against Quine's argument against "first philosophy." Even so, the
objection is not uncommon. See, for example, Jagwon Kim, "What Is
'Naturalized Epistemology'?"

4. In Kornblith, ed., *Naturalizing Epistemology*, 71–85. For another
interesting and critical assessment of Quine's thesis in the context of a
critical appraisal of naturalized epistemology, see Jagwon Kim's "What Is
'Naturalized Epistemology'?" 405. See also Shimony and Nails, *Naturalistic
Epistemology*.

5. Quine, *Roots of Reference*.

6. In Guttenplan, ed., *Mind and Language*. Some people have argued,
incidentally, that Quine should not be interpreted as holding the replace-
ment thesis, as I have described it. Susan Haack, for example, urges that
Quine's essay "Naturalized Epistemology" is ambivalent between a modest
reformist naturalism, according to which epistemology is an *a posteriori*
discipline, and an integral part of the web of empirical belief, and a
scientistic revolutionary naturalism, according to which epistemology is to
be conducted wholly within the natural sciences. This ambivalence is en-
couraged by Quine's ambiguous use of the term "science" to mean some-
times, broadly, "our presumed empirical knowledge," and sometimes "the
natural sciences." She thinks Quine's modest reformist naturalism is quite
viable insofar as it simply repeats a rejection of *apriorism* on all questions,
epistemology notwithstanding. (See Haack, "Recent Obituaries of Episte-
mology," 202; "Rebuilding the Ship While Sailing on the Water," in *Perspec-
tives on Quine*, 118ff; and "Two Faces of Quine's Naturalism.") Elaborating
on the above thesis, she claims that although Quine rejects *apriorism*, he
does not repudiate traditional epistemological concerns rather than handle
them within the web of empirical belief. In short, she urges that we are at
liberty to read Quine as a harmless non-revolutionary, a reformist against
apriorism rather than an advocate of the replacement thesis.

The basic point she makes is that rejecting *apriorism* is consistent with
two distinct forms of naturalism: that which argues for truth *in* natural
science, and that which argues for truth in some sense *based upon* natural
science. She believes the most favorable way of reading Quine is as an ad-
vocate of the latter form of naturalism (which she wholeheartedly endorses
as the acceptable way of construing philosophy) rather than as an advocate
of the replacement thesis, as so many seem driven to read him. Inter-
estingly, Quine agrees with her reading of his position. (See his comments
on Haack's interpretation in *Perspectives on Quine*, 209.)

But the important question is whether Quine's agreement with Haack's
general thesis constitutes a fundamental change in his empiricism. Apart
from the fact that Haack's thesis provides a way of reading Quine that may
make him come out right, along with the rest of empiricists who have
trouble with the replacement thesis, the scholarly point is a bit forced albeit
charitable. After all, Quine does say, and (as we have seen) has defended
quite clearly the position that traditional epistemology is dead (it has failed

and will continue to fail at its basic project) and will continue on as a chapter in descriptive psychology concerned with how beliefs are generated.

Moreover, there is a deep ambiguity between what Haack calls scientistic reformist naturalism, wherein ratification of conditions of justification are accomplished in science, and modest reformist naturalism, wherein the latter task will need to rely on science. She seeks to distinguish *in kind* between propositions established by the methods of natural science, and those that have some empirical basis and validity, but are not established by appeal to the methods of the natural sciences. Her idea here is that there is empirical knowledge about the physical world, knowledge that is not the product of the application of the methods of the natural sciences. But that seems to be more a causal claim than a logical claim. Isn't the belief that there is an elephant in my basement a belief *in* science even if it is not established causally by a scientific study? It is certainly explicitly empirically testable and falsifiable. Anyway, everything that Quine suggests supports the view that all epistemically legitimate claims are in science; and there can be no non-circular defense of science or induction, because there are no justifications outside of scientific methodology. In short, it seems that construing Quine as a modest reformist naturalist primarily opposed to *apriorism*, is a mistake, not because he is not opposed to *apriorism*, but because there is good evidence to think that for Quine, the ultimate intelligibility and acceptability of one's beliefs is a function of their necessary place in scientific theory. However helpful the intent, as an interpretation of Quine's naturalism, the problem with Haack's modest reformist naturalism is not that all claims are understood as *a posteriori*, but that it allows that there are, or could be, privileged factual claims that are not scientific, that is, claims that supposedly rest *on* science but are not true *in* science. It is difficult to find that position in Quine, and even if we could, there is that added problem, as we shall see, of defending the claim that there are privileged empirical claims that could not be justified or defended by appeal to the methods of natural science as we know them. It is by no means obvious that there are true factual claims that are not truths *in* science.

This is not to say that the distinction offered by Haack is untenable in the interest of defending a suitably defined modest naturalism. Indeed, the position that there must be two different kinds of *a posteriori* claims, and that all knowledge is empirical seems compelling. But the problem is one of making clear and defending in a non-circular way just how a proposition can be empirical, but by way of its testability, not dependent on the methods of the natural sciences for its confirmation or falsification. Indeed, why is it that a proposition whose alleged truth is dependent on science is not a true proposition in science? Mightn't the distinction between "true *in* science" and "true dependent *on* science" be a distinction without a real difference? If so, the very idea that there could be empirical knowledge outside science is questionable. And what would that mean for traditional epistemology? What are the true factual claims about the physical world

that cannot be established in natural science? Moreover, what exactly would it mean to establish a factual claim in natural science, as opposed to outside of natural science and therefore dependent upon natural science? See also Papineau, "Is Epistemology Dead?" 129–42.

7. Quine, "Reply to Stroud," 474.

8. See Sosa, "Nature Unmirrored, Epistemology Naturalized," 69. Also, in criticizing Quine's replacement thesis, Bas Van Fraassen has noted that Quine's construal of traditional epistemology is a construal of an extremist empiricist dream and, as such, only one strand in traditional epistemology. He goes on to characterize this construal by saying:

> Why think that it has no, or could have no, rival alternatives? Such programs as the one described by Quine, or even the more liberal one I described as naive empiricism, are extreme in their demands for justification, warrant, support, and defense. I call it *defensive epistemology*, and I agree with Quine that it is dead. But it is not all of epistemology. Epistemology is the study of knowledge, belief, opinion, with its focus on questions of rationality, and it lives today. ("Against Naturalized Empiricism," currently unpublished, 19)

9. See, for example, Rorty, "Metaphilosophical Problems in Linguistic Philosophy," 16. See also Nielsen, "Farewell to the Tradition."

10. Aristotle, *Metaphysics*, Book 1, Chapter 1. In the argument in question, incidentally, Aristotle did not *explicitly* state that the use of tools is sufficient as a criterion for determining the presence of rational intelligence. But he does assert that the difference between rational and non-rational intelligence roots in the ability to have a general understanding of the means-end relationship. Many medieval and modern commentators after Aristotle generally understood the argument to imply straightforwardly that the use of tools would be sufficient as a criterion for rational intelligence, and hence as evidence for a distinctly higher order of being relative to non-human animals that do not use tools. With this qualification in mind, I will henceforth refer to this argument (here and later in Chapter 3) as Aristotle's argument. Referring to this argument is simply meant to *show* that there have been widely accepted arguments in philosophy and these arguments, owing to certain empirical considerations emerging in the last century, are generally considered soundly refuted . . . as *philosophical* arguments.

11. See Russell, *Human Knowledge: Its Scope and Limits*, 181. See also note 26 in Chapter 3 below.

12. See Lycan, *Judgement and Justification*.

13. See Hempel's discussion on why derivability from above, with special reference to Balmer's formula, is an important criterion for confirmation and hence, by implication, for increasing the plausibility of Balmer's formula, in Hempel, *Introduction to the Philosophy of Natural Science*, Chapter 2.

14. This same point is made by Skagestadt in "Hypothetical Realism," 92.

15. It should be clear by now that Lycan's general argument achieves its effect only because it harbors a false dilemma as between either the deductivist model of philosophy or the inductivist model. In fact, there is the third model in which philosophy can be conceived of as neither one or the other, but one in which the philosopher offers deductive arguments whose premises are in some sense testable and falsifiable by appeal to empirical fact. Aristotle's philosophical argument to the effect that humans are quite distinct from thoughtless brutes because the latter do not use tools (thereby giving evidence that they do not understand the means-end relationship) seems quite clearly refuted by National Geographic film footage showing, through the singular contribution of Jane Goodall, various chimps and gorillas using tools. Of course, as in science, without being a scientist, the classical defender of Aristotle's distinction may want to argue that this particular instance of tool usage was not typical, and so forth. But, as in science, as long as we see such behavior displayed over a broad range of animals, it is hard to take seriously any longer Aristotle's argument or to return to it as a source of defending the view that animals, unlike humans, do not think.

16. Giere, *Explaining Science.*

17. See Patricia Churchland, *Neurophilosophy*; Paul Churchland, "Eliminative Materialism and Propositional Attitudes" and "Some Reductive Strategies in Cognitive Neurobiology." For a similar argument see Stephen Stich's, *From Folk Psychology to Cognitive Science.*

18. For an interesting argument to the effect that folk psychology is not likely to be eliminated in the way the Churchlands assert that it will, see McCauley's "Epistemology in an Age of Cognitive Science," 147–49; Horgan and Woodard, "Folk Psychology Is Here to Stay"; and the arguments offered by Susan Haack discussed below.

19. See, for example, Patricia Churchland's "Epistemology in an Age of Neuroscience," 546, where she asserts, without benefit of proof, that the basic question in epistemology is indeed the question, "How does the brain work?" Also, as an interesting example of an argument seeking to show that traditional epistemological questions can be eliminated owing to advances in cognitive science (advances that presumably show how we can understand human knowledge on a non-propositional basis), see Bechtel and Abrahamson, "Beyond the Exclusively Propositional Era."

20. This same point is made by Sosa in "Nature Unmirrored: Epistemology Naturalized," 70. Naturally, if one were able to defend a form of reliabilism similar to that offered by Alvin Goldman, the question "How does the brain work?" would turn out to be a most crucial question in epistemology; but at that point we would not be defending the sort of naturalized epistemology defended by Quine rather than the form offered and defended by Goldman. For another argument asserting that in science the justification of a belief has absolutely nothing to do with the origin of the belief, see Siegel, "Justification, Discovery, and the Naturalizing of

Epistemology," 297–321.

21. See Haack, "Recent Obituaries of Epistemology," 204.

22. See *Synthese* 52 (1982): 3–23 (as cited by Giere, *Explaining Science*, 9).

23. See Siegel, "What Is the Question Concerning the Rationality of Science?" 517–37. For a similar claim see also Siegel, "Justification, Discovery and the Naturalization of Epistemology."

24. See p. 50 of Siegel's "Naturalism, Instrumental Rationality, and the Normativity of Epistemology" (presently unpublished).

25. See "Naturalism, Instrumental Rationality, and the Normativity of Epistemology," 31ff. For a fuller discussion of Siegel's analysis of Giere's general position, see also "Philosophy of Science Naturalized? Some Problems with Giere's Naturalism."

26. This argument appears in Siegel, "Empirical Psychology, Naturalized Epistemology, and First Philosophy," 675.

27. See Patricia Churchland, "Epistemology in the Age of Neuroscience."

28. See Bradie, "Evolutionary Epistemology as Naturalized Epistemology," 3 (forthcoming).

29. See Munz, *Our Knowledge of the Growth of Knowledge: Popper or Wittgenstein?*, 371. For a defense of a similar argument, see also Ruse, *Taking Darwin Seriously: A Naturalistic Approach to Philosophy*, and Bartley, "Philosophy of Biology versus Philosophy of Physics."

30. See Kornblith, *Naturalizing Epistemology*, 4.

31. Rescher, *Methodological Pragmatism*, Chapter 6.

32. For further reasons why evolutionary epistemology has in fact failed to offer any compelling explanation of how what we take to be knowledge, especially scientific knowledge, has developed, see Bechtel's "Toward Making Evolutionary Epistemology into a Truly Naturalized Epistemology," in Rescher, *Evolution, Cognition, and Realism*.

33. Stich, *From Folk Psychology to Cognitive Science: The Case Against Belief*, 228.

34. Paul Churchland, *Scientific Realism and the Plasticity of Mind*, 9–10 and Sections 12–16.

35. Paul Churchland, *Matter and Consciousness*, 43.

36. Paul Churchland, "Eliminative Materialism and Propositional Attitudes," 76.

37. See, for example, Baker, *Saving Belief: A Critique of Physicalism*, 113.

38. Ibid., 113.

39. Haack, "Recent Obituaries of Epistemology," 204. As will be seen in the following pages, I have very much endorsed Haack's critique of the argument(s) from cognitive science as they appear in this essay. I hope I

will be forgiven the tendency in the next few pages to quote extensively from this essay, rather than paraphrase. I do so because I find the criticisms well-written and thoroughly convincing.

40. Ibid., 204. Incidentally, this criticism was also offered by Horgan and Woodard in "Folk Psychology Is Here to Stay"; and it is also discussed in Colin McGinn's *Mental Content*, 123–26 (as cited by Jacob, "Review of Daniel Dennett's *Mental Content*," 723ff.).

41. Nisbett and Wilson, "Telling More than We Can Know: Verbal Reports on Mental Processes," 231–59; Wilson,"Strangers to Ourselves: The Origin and Accuracy of Beliefs about One's Own Mental States," 1–35.

42. Stich, *From Folk Psychology to Cognitive Science*, 230–37.

43. Haack makes this same point in "Recent Obituaries of Epistemology," 206. Incidentally, Haack also points out that this is the interpretation offered by Nisbett and Wilson themselves. According to Haack, their only concern was to examine the reliability of introspection and their basic conclusion, as stated in their abstract to the paper, is that there may be little or no direct introspective access to higher order cognitive processes (206). Wilson's paper itself is merely a discussion of the origin and accuracy of beliefs about one's own mental states. See Wilson, "Strangers to Ourselves," 16.

44. Incidentally, Lynn Baker offers essentially the same criticism of Stich's argument on p. 126 of her *Saving Belief*.

45. Stich, *From Folk Psychology to Cognitive Science*, 238.

46. See Haack, "Recent Obituaries of Epistemology," 207.

47. See, for example, Haack, "Recent Obituaries of Epistemology," 207.

48. Winograd, "What Does it Mean to Understand a Language?" 248–49.

49. Haack, "Recent Obituaries of Epistemology," 207. See also Woolridge, *The Machinery of the Brain*, as cited in Dennett, *Brainstorms*, 65–66, on the "behavior" of the sphex wasp.

50. Paul Churchland, *Scientific Realism and the Plasticity of Mind*, 249.

51. It is for this reason, incidentally, that Susan Haack has urged that proponents of the no-belief thesis stand in urgent need of a reconstructed, post-revolutionary concept to replace the old notion of assertion, whether sincere or insincere. See Haack, "Recent Obituaries of Epistemology," 209. Patricia Churchland, incidentally, discusses this objection in "Is Determinism Self-refuting?" 100. Also, for an argument similar to the one we just offered (but more radical for asserting that without belief there would be no semantics), see Baker, *Saving Belief*, 123.

52. See for example, Horgan and Woodard, "Folk Psychology Is Here to Stay." Some of the above arguments are also to be found in Horgan and Woodard.

53. In her excellent book, *Saving Belief*, Lynn Rudder Baker also examines the many arguments offered by cognitive science for the view that

there are no beliefs. And she offers other arguments against the thesis.

For example, in response to Stitch and the Churchlands' argument that folk psychology is no more science than Ptolemaic Astronomy, she asserts that construing folk psychology as an outmoded scientific or empirical theory is a faulty analogy. For Haack it was a faulty analogy because it simply begged the question against folk psychology by erroneously and gratuitously identifying it with past false theories. For Baker the analogy is false just because it is a function of a successor theory to show where and why the predecessor theory failed and in virtue of which it has become outmoded; and nobody who rejects folk psychology as outmoded theory has succeeded in showing as much in even a small way (124–25).

Predictably, cognitive scientists will urge that it is not a necessary condition for a theory being a good empirical theory that it explain why other competing theories fail, even if that is a typical feature of a successor theory. Even so, what Baker's argument seemingly suggests is that there is some good reason here not to call folk psychology a scientific theory replaced by a successor theory because it looks as though they are incommensurable for the reason indicated. Or so it would seem. These arguments for the faulty analogy seem persuasive.

Furthermore, among her other arguments, Baker asserts that there are unacceptably serious consequences that come with rejecting folk psychology and the existence of beliefs. Social practices that depend upon ordinary expectations and predictions of behavior would become unintelligible. Imagine, for example, dinner with no that-clauses, nobody would have any expectations or disappointments, behavior would never go wrong. Moreover, moral and legal practices would be senseless (no explanation of an action in terms of what one believed or did not believe would ever express a truth); linguistic practices would become very mysterious (uttering sentences about one's own or another's beliefs would make no sense and it would be a marvel that everybody without beliefs would be able to utter truths from time to time); and psychology would become problematic because without beliefs there would be nothing to be explained (130).

Apart from a number of other compelling arguments against the physicalistic thesis arguing that there are no beliefs, arguments it would be tedious to recount, Baker argues, in a chapter entitled "The Threat of Cognitive Suicide," that in the absence of belief, the concepts of rational acceptability, of assertion, of cognitive error, even of truth and falsity come into question. On the question of rational acceptability she argues that denying the common sense conception of belief may be self-defeating because anybody who claims that the thesis is rationally acceptable lapses into pragmatic incoherence because the thesis denying the common sense conception undermines the concept of rational acceptability. She also goes on to urge that those who deny the commonsense conception have two problems: the first is that they cannot be said even to believe their own thesis and the second is that they cannot be justified in believing their own thesis because there are no beliefs under it. In other words, for those who

would assert it, it's difficult to see how the thesis is not self-defeating from the bottom up.

Moreover, if the thesis denying the commonsense conception is true, then it is unclear that there could ever be good arguments for it or that anyone could ever be justified in "accepting" (the successor of accepting) it. The thesis seems to undermine the possibility of good argument and justification generally (135–36).

She further suggests another way in which the skeptic's thesis is self-defeating when she argues at length that without a new account of how there can be assertions in the absence of belief and intentions, we have no way to interpret the claim denying the commonsense conception (142).

And, finally, the third way in which the denial of common sense may be self-defeating hinges upon her claim that we can formulate a thesis if and only if we can specify what would make it true. In addition to undermining concepts of rational acceptability, and of assertibility, the thesis denying the commonsense view may make incoherent the concepts of truth and falsity (143). Could content-free mental states or propositions have truth value? If not, as the denial of the commonsense thesis implies, then the common sense thesis cannot be shown to be false (143).

Admittedly, one response to this last criticism is that it founders on good arguments denying the need for any concept of truth; and Baker readily admits as much when she then suggests that for those who believe in the redundancy theory of truth, the self-defeating nature of the denial of commonsense thesis will emerge quite nicely under the second argument for self-defeating nature of the thesis, namely the one that shows that assertibility is impossible under the denial of the commonsense thesis.

54. Ketchum, "The Paradox of Epistemology: A Defense of Naturalism."

Variations on this basic argument have been offered elsewhere as the problem of analysis or, alternatively, as the Problem of the Circle. See, for example, Nelson, *Socratic Method and Critical Philosophy*, 188–89; Chisholm, *The Theory of Knowledge* and *The Problem of the Criterion*. Incidentally, James Van Cleve has argued that we can break out of the circle simply by denying that we must be justified in believing an epistemic principle of justification in order to be justified in believing anything else. See his "Foundationalism, Epistemic Principles, and the Cartesian Circle," 55–91. William Alston also agrees with this thesis in "Epistemic Circularity." See also Ernest Sosa in "'Circular' Coherence and 'Absurd' Foundations," 390ff. Alvin Goldman has also asserted that if we do not simply accept some definition of justification without justifying it, we end up with what the tortoise said to Achilles. In other words, taking the question seriously entails skepticism, so we must not take it seriously. For an interesting discussion on Goldman's position, see also Winblad, "Skepticism and Naturalized Epistemology," 103–106. I will examine Goldman's general position shortly.

55. Lycan, *Judgement and Justification*, 134.

56. It is certainly tempting, incidentally, to urge that there is nothing

contradictory about the skeptic's position because our failure to defend successfully a definition of justification only establishes the methodological point that we cannot successfully define the concept of justification; and from this it by no means follows that nobody is justified in his or her belief. Admittedly, from the fact that we cannot successfully define justification it does not follow that nobody is justified in his or her belief that p. But it does follow that nobody is demonstrably and non-arbitrarily justified in his or her belief that p. And the contradiction in the skeptic's position occurs because the skeptic must be asserting her position as demonstrably and non-arbitrarily justified. Certainly, in some privileged sense of "justified" known only to God, a person could be justified in his or her belief that p, even though we could not successfully define the concept of justification. In such a world, however, we cannot coherently say that somebody's belief is demonstrably and non-arbitrarily justified. Just as we cannot argue successfully that arguments do not count, we cannot assert as demonstrably and non-arbitrarily justified the view that nobody is demonstrably and non-arbitrarily justified in believing that p.

Another imaginable way of denying the incoherent nature of the skeptic's position would consist in asserting that the skeptic's position about justification is a meta-claim about the nature of justification as the concept appears in the natural or object language. On this view asserting as a meta-claim that we cannot successfully define "justification" in the object language is not contradictory because such a contradiction could occur only if the skeptic's claim and the position asserting the skeptic's claim occur in the same language. In response, however, the point is that if meta-claims are more or less justified, the sense in which they are justified can only be specified by appealing to the meaning of the term as it appears in the object language. And because there are not, presumably, a separate set of epistemic concepts for the meta-language in addition to the set of concepts for the object language, it seems *ad hoc* to deny the incoherence of the skeptic's position in this way.

57. I owe this objection to Douglas Winblad.

58. For an earlier but distinctly different (and less persuasive) formulation of this basic argument, see the last section of my "Naturalizing Epistemology," as reprinted in Fetzer, *Foundations of the Philosophy of Science: Contemporary Developments*. As also noted above, the current argument is different in that it is a more refined development of the original argument and also confronts some other likely objections to the conclusion.

59. A Popperian, for example, might well assert that the replacement thesis is quite testable and that it has, in fact, survived tests and attempts to falsify it. Others, of course, might well argue that the thesis has been tested empirically and been falsified by such tests. This latter group would profess to have strong empirical evidence that there are some answers that are not the product of the methods of the natural sciences. Either way, both would find the replacement thesis not only testable, but actually tested, and

either strongly refuted or strongly corroborated. Interestingly, and consistently so, those who would so refute the hypothesis would be doing so by appeal to the methods of the natural sciences.

60. See for example, Putnam, "The Corroboration of a Theory."

61. Admittedly, if we came across some set of psychic gamblers of the sort described above, it seems inescapable that we would need to conclude that the replacement thesis is false, and that the thesis has been tested and conclusively falsified as a general thesis about the limits of human knowledge. Certainly, some Popperians (and neo-Popperians would accept this conclusion and hence, for them, the replacement thesis has empirical content, is in fact testable because in principle falsifiable, and has frequently been tested only to hold up in the presence of failed attempts to strongly falsify it.

Even so, it seems clear that non-Popperians insist on a richer concept of empirical content and, along with philosophers such as Rudolf Carnap, insist that an essential goal of cognitive inquiry is the precise prediction of our sensory experience, that empirical content, for that reason, cannot be construed solely in terms of the evidence that would falsify, or fail to falsify, the hypothesis. I favor Carnap's view on this matter and believe that there is nowhere in the history of science a well-confirmed hypothesis that did not have positive instances in terms of what the hypothesis predicted at the sensory level. It seems, therefore, that those who would defend the replacement thesis as a testable hypothesis, need to do so in the light of accepting the early Popperian conception of testing and confirmation (or "corroboration"). Apart from the logical critique and the insinuating inductivism written into the concept of "severe testing" and corroboration, such anti-inductivism does not seem to be unquestionably part and parcel of standard confirmation theory in the actual conduct of natural science. In the end, good scientific hypotheses predict, in addition to the absence of falsifying evidence, positive data supporting the hypothesis at the sensory level. Thus while it may be possible to conclusively falsify (in some appropriate sense of "conclusive") a particular hypothesis in terms of sensory data that would be inconsistent with the hypothesis, the testability of a hypothesis, in the interest of confirming a hypothesis requires more than showing that what would defeat the hypothesis has not occurred.

The conclusion to be drawn here is this: the replacement thesis is certainly falsifiable and hence testable in the presence of a group of successful psychics as characterized above. If, along with some Popperians we characterize the empirical content solely in terms of the evidence that would falsify the hypothesis, then the replacement thesis is quite testable and the only real question is whether we have the requisite falsifying evidence when we examine alleged phenomena such as psychic gamblers or other ways of knowing that do not emerge from the practice of natural science. But if we take a non-Popperian stance and insist on some form of inductivism and the need for positive support in terms of positive instances, as necessary for the testing and positive confirmation of a proposed

hypothesis, the replacement thesis will not be testable because it predicts nothing at the sensory level except the absence of such items as demonstrably successful psychic gamblers. The history of science, in spite of Popper's defense to the contrary, sides with the non-Popperians and requires in the interest of predicting precisely our sensory experience that there must be testable content in terms of positive instances implied by the truth (or robust warrantability) of the hypothesis. I conclude then that the replacement thesis is indeed falsifiable, and hence testable for the purpose of falsifying; but for the general purpose of confirming a hypothesis, the thesis is not testable because it has no positive instances and predicts nothing by way of implication at the sensory level.

62. Quine's particular argument for the replacement thesis, incidentally, is unsound because the thesis and some of the crucial premises upon which it is based cannot both be true. As noted above, the replacement thesis, for which Quine argues, denies that there is any first philosophy and, as such, asserts that the only legitimate questions about the nature and extent of human knowledge are those answerable by appeal to the generally recognized methods of the natural sciences. By implication, proposed answers to such questions would, as hypotheses, need to be explicitly empirically testable and empirically falsifiable. One essential premise in Quine's argument for the replacement thesis is Hume's skeptical answer to the problem of induction or to the question of whether we have any knowledge of the physical world. Hume's answer is based in part on the claim that we cannot prove the future will be like the past. Hume's thesis is certainly not explicitly testable or empirically falsifiable. The so-called "problem of induction" is a philosophical problem based upon a certain philosophical view about what is necessary for scientific knowledge. It is certainly not a problem in natural science or naturalized epistemology. Another essential premise in Quine's argument is the denial of the analytic-synthetic distinction based as it is on a number of demonstrably philosophical premises about the nature of meaning and synonymy. This denial of the analytic-synthetic distinction is an answer to the question of whether there are some propositions which are necessarily true purely and simply in terms of their syntactic or semantic properties. At any rate, neither premise, as an answer to a question about the limits of human knowledge, is explicitly empirically testable and falsifiable, as far as we now know. Neither premise can be established or refuted by appeal to the methods of the natural sciences. Thus the argument is incoherent because it asserts a conclusion which, if true, shows that the premises upon which it is based must be false. If such premises were true, they would contradict what is asserted in the conclusion.

Nor should we believe that because, allegedly, we have never achieved a consensus in traditional epistemology on the grounds of certainty, we have good inductive grounds to think that the program of traditional epistemology will never work. That sort of argument begs the question in favor of a concept of success appropriate only for the methods of the

natural sciences and, by implication, begs the question in favor of the replacement thesis. Besides, it also assumes that philosophers never agree on anything; and we do agree on enough items to warrant some measure of modest optimism for those who will continue the effort.

More importantly, as a premise in the argument for the replacement thesis, the claim that the basic project of traditional epistemology has failed is very suspect. Indeed, there is good reason to think that the primary concern of traditional epistemology is one of *defining* or explicating concepts of knowledge, belief, certainty, justification and truth; and only then of determining in legitimately doubtful cases whether anybody has the sort of certainty associated with the correct definition or explication of knowledge. The history of epistemology is as apt to criticize the program of the Cartesian skeptic (and the definition of knowledge implied therein) as it is to accept it. Certainly, if the concepts of knowledge and justification had been defined differently from the way in which Hume had defined them, Hume's predicament would never have occurred. Traditional epistemology is probably as concerned with what it means for a belief to be certain, as it is with determining whether scientific knowledge is certain.

63. In discussion, Robert Nozick raised this objection.

64. Rosenberg, "A Field Guide to Recent Species of Naturalism," 24–25.

65. But it is important to see that these are two quite different arguments, and that the argument based on vicious circularity might turn out to be weaker than supposed simply because the circularity may not be particularly vicious. Given a successful pragmatic defense of inductive inference, the challenge of vicious circularity could conceivably recede into the background; but we would still have the problem of trying to offer a coherent defense of the replacement thesis while acknowledging that the thesis is not explicitly testable. If we were to hold out for a less imperialistic form of naturalism, one which would allow that there are some meaningful questions about the world that we cannot answer by appeal to the methods of the natural sciences, and that there are some acceptable answers about the world that did not emerge from the use or application of the natural sciences, these problems would disappear in the presence of a viable naturalism insisting only that the natural sciences are privileged in providing us with the only method for publicly answering not all questions about the world but only those questions about the nature and existence of physical objects and the nomic forces governing them. The latter construal would be justified by the extensive predictive power and control provided by the application of these methods to answer these questions. In other words, Rosenberg's proposed defense of scientism against the problem of vicious circularity might well fail as a defense of the replacement thesis, but it could well survive as a defense of a less imperialistic naturalism, one that adopts what I have characterized above in the introduction as the third form of naturalized epistemology.

66. Incidentally, in spite of its seeming transparency, the fundamentally self-defeating nature of Quine's thesis has gone largely unnoticed. The first

sustained and compelling argument indicating the nature of this funda-
mental flaw appears, I believe, in Siegel's "Empirical Psychology, Natur-
alized Epistemology, and First Philosophy," 657. In the same essay, Siegel
also generalizes somewhat tentatively to *any* argument for the replacement
thesis. In the closing pages of that essay he says:

> It is worth re-emphasizing that in one respect the naturalized epistemologist's
> position is self-defeating. For it seeks to justify naturalized epistemology in
> precisely the way in which, according to it, justification cannot be had. The
> Duhemian thesis cannot lead to the rejection of "old-fashioned" justification, for
> it must itself be justified, as I argued earlier and as Roth admits, in the old-
> fashioned and extra-scientific way. Roth needs traditional epistemology (as does
> Quine) to get naturalized epistemology off the ground. This seems to me to be
> a very deep problem for the naturalized epistemologist: it must assume the
> legitimacy of, and strive to achieve, the very sort of justification it seeks to show
> cannot be had. (675)

To the extent that one may be tempted to identify naturalized epistemology
with the replacement thesis, the generalization offered in this quote seems
unassailable. The only reservation one might offer here is that it would not
apply to the transformational thesis or even to the more harmless form of
naturalism described in the last section of this book. But it certainly does
apply to the replacement thesis.

Moreover, as a critique of the replacement thesis, it seems that Siegel
actually understates the force of the critique. After all, if what he urges here
(and if what I have argued independently above) is correct, what follows is
that *any* argument for the replacement thesis will be unsound, because self-
defeating in the way described. Suggesting, as Siegel does, that the position
of the naturalized epistemologist (the replacement theorist) is "self-de-
feating in one respect" and "a very deep problem for the naturalized epis-
temologist" deserves to be recast in a way consistent with the strength of
the position as an argument against any argument favoring the replacement
thesis. So recast, the more accurate conclusion is that *any* argument in
favor of the replacement thesis will be unjustifiable because incapable of
a sound defense, and this conclusion is less "a problem" for the replace-
ment thesis than it is as solid a refutation of the position as one could
possibly imagine.

Subsequent to Siegel's argument, others who have urged that
naturalized epistemology in the form of the replacement thesis is self-
defeating (because it is not testable as a scientific thesis) include Sagal,
"Naturalized Epistemology and the Harakiri of Philosophy"; Rescher, "The
Editor's Page," 301–302; and more recently Bonjour, "Against Naturalized
Epistemology," 22–23. Referring to the replacement thesis, Bonjour has
said that naturalized epistemology is self-referentially inconsistent: its own
epistemological claims exclude the possibility of there being any cogent
reason for thinking that those claims are true (23).

Finally, it is important to distinguish between the main argument I offer
above and the argument offered for the incoherence, or the self-defeating

nature, of a thesis asserting the truth of a condition that is sufficient to falsify the thesis in question. For example, philosophers have said that the classical positivist's criterion of significance is itself insignificant because it itself is neither analytic nor empirically verifiable. And perhaps this is the sort of argument Bonjour has in mind, but does not clearly explicate, in the quote just above. But the *main* argument I offered above asserts *more* than that the replacement thesis asserts a necessary condition for epistemic legitimacy that the thesis itself does not satisfy. It asserts that, assuming testablility is a necessary condition for confirmation in natural science, *any argument* which would seek to support the replacement thesis would necessarily be unsound because the thesis cannot be established scientifically, *and hence must include as essential premises statements which the conclusion would need to regard as false*. So, this is not just another transparent instance of the verifiability thesis being refuted on the grounds that the thesis is itself not verifiable, and is hence self-referentially inconsistent. It extends further to the implication that no argument anybody could ever offer for the thesis will be sound.

Notes to Chapter 2

1. Although we are granting, for the sake of discussion, that the replacement thesis is logically distinct from the transformational thesis, there is very good reason to think that, in the end, the distinction between these two may not be very deep, that we have here a distinction without a real difference, and that the transformational thesis is simply a less direct form of the replacement thesis. After all, if the question of whether anybody knows about anything at all is a matter to be answered by scientists, it would appear that our alleged philosophical knowledge of what human knowledge, justification and truth are, for example, is ultimately a scientific question. But could a scientist grant that some philosopher's view about human knowledge or truth is correct even though the view expressed is not explicitly empirically testable in some fashion or other? Could that be a scientific determination of whether the philosopher in question knows what she claims to know? In short, it is all well and good to say that there are some questions that are not scientific and that they are answerable outside of science, but if those non-scientific answers are judged more or less adequate only by appeal to empirical scientists using the methods of the natural sciences, it is difficult to see how even these so-called non-scientific answers are in fact anything other than scientific answers. Indeed, they seem to be second-order scientific answers and, as such, fall indirectly under the replacement thesis. If this is so, then the critique of the replacement thesis will hold equally well for the transformational thesis, because the latter is a veritable but indirect instance of the claim that in the end the only legitimate questions about the nature of human knowledge are those that can be, or have been, answered by appeal to the methods and

practices of the natural sciences.

In any case, the transformational thesis, as it is usually explicated, roots in reliabilism and, even if it is an unusual instance of the replacement thesis, depends crucially upon the truth of reliabilism. Thus a critique of reliabilism will be sufficient to undermine it, although there certainly is a form of the replacement thesis that does not rely on reliabilism. For the latter, the critique offered above in Chapter 1 will be adequate. So, if it should turn out that the transformational thesis reduces in some way to the replacement thesis, then it will suffer the same fate of the replacement thesis; if it does not, then it will rise or fall depending on the strength of reliabilism as either a theory of justification or a theory of knowledge.

2. In his essay "An Internalist Externalism," William Alston defines Internalism as minimally requiring that there be a ground of one's belief and that the ground:

> must be a psychological state of the subject and hence "internal" to the subject in an important sense. Facts that obtain independently of the subject's psyche, however favorable to the truth of the belief in question, cannot be *grounds* of the belief in the required sense.

Given this minimal and general requirement, Alston then distinguishes three different types of Internalism: "Perspectival Internalism" (PI), according to which only what is within the subject's perspective, in the sense of being something the subject knows or justifiably believes can serve to justify, "Accessibility Internalism" (AI), according to which only that to which the subject has cognitive access in some specially strong form can be a justifier, and "Consciousness Internalism" (CI), according to which only those states of affairs of which the subject is actually conscious or aware can serve to justify. See Alston, *Epistemic Justification*, 233. Alston goes on to argue against (PI) and (CI) in favor of (AI) although he believes that (AI) has been formulated much too strongly by philosophers such as Carl Ginet in his *Knowledge, Perception and Memory*, 34.

3. This classification admits of interesting exceptions depending on how one chooses to use the terms "externalist" and "internalist." As I am using the terms here the basic difference between reliabilists who are externalists and reliabilists who are internalists has to do with whether it will be necessary for knowledge or justification that the subject be internally or reflectively aware that his belief is reliably produced and hence justified or known. Even so, under this classification there will be internalists who will, and internalists who will not, further require the ability to give reasons as a necessary condition for knowledge under certain circumstances.

Further, it is possible that justification is, or may be, a question of the logical relationship between some observable fact external to the agent which is the cause of the agent's true belief when it is reliably produced, and, in order to be justified in one's belief, that the subject also be internally or reflectively aware of what it is that justifies the belief as

reliably produced, and moreover that, under certain circumstances, the subject be able to give reasons showing that the belief is justified because reliably produced. Such a position would combine both internalist and externalist features. See, for example, Lehrer, "How Reasons Give us Knowledge, or the Case of the Gypsy Lawyer," 311–13. For a different position which combines both Externalism and Internalism, see Alston, "An Internalist Externalism," 265–83, and "Internalism and Externalism in Epistemology." See also Bonjour, "Externalist Theories of Empirical Knowledge."

4. Most philosophers seem to agree that Plato's classical definition of knowledge as completely justified true belief is defective because we can imagine cases where those conditions can be satisfied but we would not say the person in question knows what they claim to know. Consider the familiar type of counterexample proposed by Edmund Gettier: Assume that Smith is completely justified in believing the proposition p, and that the proposition q is a logical consequence. Seeing that p entails q, Smith infers that q must also be true. However, suppose that (unbeknownst to Smith) even though Smith is completely justified in believing that p, p is false and q is true. It would then follow that (1) q is true, (2) Smith believes that q is true, and (3) Smith is completely justified in believing that q. But of course, Smith does not know that q is true, because even though he is completely justified in believing that q is true, his justification is in some defense defective. See Gettier, "Is Justified True Belief Knowledge?" 121–23. Incidentally, Bertrand Russell fashioned the same type of counterexample a good deal earlier in *The Problems of Philosophy*, 121.

5. The point here is that Gettier-type counterexamples always assume as a condition of their effectiveness that a person can be completely justified in believing a false proposition. If that assumption should turn out to be false, then all such counterexamples fail to show that a person can be completely justified in believing a true proposition and yet not know it. For a full defense of the claim that all such counterexamples fail for this reason, see my *Blind Realism*, 6–18 and 51–69.

6. See Swain, *Reasons and Knowledge*. See also Goldman's earlier paper, "A Causal Theory of Knowing," 355–72; and Dretske and Enc, "Causal Theories of Knowledge," 517–27. Incidentally, defeasibility analyses of justification all share the view that, in addition to being completely justified in believing what is true, a person's belief must be nondefective which it will be if it is non-defeasible. Such defeasibility analyses then go on to define the non-defeasibility of a justification in terms of the capacity of the justification to prevent there being some true proposition which, if it were added to a person's justification, she would no longer be justified in believing what she does believe. For a fuller discussion on this item and reasons why such analyses fail to prevent Gettier-type counterexamples, see my "Defeasibility and Skepticism," 238–44.

7. For an examination of such analyses, see my "Defeasibility and Skepticism," 238–44. See also my *Blind Realism*, 54ff.

8. See Goldman, "Discrimination and Perceptual Knowledge," 120ff, and "What is Justified Belief?" 1–23; and later in Goldman's, "The Relation Between Epistemology and Psychology," 29ff.

9. See Dretske, "Precis of *Knowledge and the Flow of Information*," 179. This point was also made by Goldman in "Discrimination and Perceptual Knowledge," 771–91. When citing the Gettier-type counterexample involving Henry and the barn-facsimiles. Dretske, of course, does not adopt a reliability theory of justification rather than a reliability theory of knowledge. On this item see also Dretske, "The Need to Know," note 2.

10. See Goldman, "Discrimination and Perceptual Knowledge," 771–79, as reprinted in *Essays on Knowledge and Justification*, 121–22. Like Fred Dretske's example about Jimmy and Johnnie in the paragraph above, Goldman's barn-facsimile example is one in which there is a direct causal relationship between the state of affairs which causes the belief and the truth of the belief. In both cases the belief is true because it is caused by that state of affairs that makes the belief true. In Goldman's example, Henry looks at a barn and it causes him to believe truly that what he sees is a real barn. Henry is completely justified in believing truly that he sees a real barn, and the belief is caused by the real barn which causes Henry's belief to be a true belief. Even so, according to Goldman (and Dretske would agree), Henry does not know that there is a real barn before him, because had it not been a real barn, had it been a barn-facsimile, Henry would not have thought or believed any differently. His belief would have been caused by an unreliable mechanism because it would not have been able to distinguish between real barns and barn-facsimiles. In such a case the causal condition would have been met, but the mechanism would not have excluded a relevant alternative belief equally supported by the evidence.

11. Goldman, "Discrimination and Perception," 122. Presumably, for Goldman, defeasibility analyses would block Gettier-type counterexamples but be too strong because they could only have that effect if they precluded the logical possibility of a person being completely justified in believing a false proposition. For a supportive analysis showing that defeasibility analyses are much too strong, see my *Blind Realism*, 53–59.

In addition to the analyses offered by Goldman, other reliability analyses include: Swain, "Justification and Reliable Belief," 389–407; Barker, "What You Don't Know Won't Hurt You," 1–3; Armstrong, *Belief, Truth, and Knowledge*, 182; Firth, "Are Epistemic Concepts Reducible to Ethical Ones?" 215–29; Bonjour, "Externalist Theories of Empirical Knowledge," 1–40; Schmitt, "Reliability, Objectivity and the Background of Justification," 1–15; Kornblith, "Beyond Foundationalism and the Coherence Theory," 597-610; and Alston, "What's Wrong with Immediate Knowledge," 73-96. Alston, as we shall see, does not offer his reliabilism as an account of justification, understood as a reason-giving activity. For Alston, as well as for Goldman, a person need not *have*, in a sense that implies being able to give, a justification for a belief in order that belief be an item of knowledge; the subject need only *be justified* and for that his

belief need only be the product of a reliable belief-making mechanism process. For a critique of Alston's vision see Ginet, "Contra Reliabilism," 175–87.

12. Goldman, *Epistemology and Cognition*, 57.

13. Ginet, "Contra Reliabilism," 180. For other examples similar to the Aunt Hattie example see cited works of Foley, Feldman, Dretske, Putnam.

14. Pollock, "Reliability and Justified Belief," 104.

15. Bonjour, "Externalist Theories of Empirical Knowledge," 53–73.

16. Swain, "Justification, Reasons and Reliability," 89. William Alston also agrees, after reflecting on Bonjour's example, that reliability of itself will not be sufficient for being justified. See his "An Internalist Externalism," as it appears in *Epistemic Justification*, 235. Also, in "Reliability and Justified Belief" (104–105), John Pollock, citing examples such as D.H. Lawrence's "Rocking Horse Winner," also agrees, that reliability is not sufficient for justification because in such cases the subject "has no right to believe his own predictions." Incidentally, one interesting virtue of Pollock's essay is that while arguing that reliability is neither a necessary nor a sufficient condition for justification, he seeks to explain why people have so often made the mistake of thinking it is at least a necessary condition for justification. His answer is that they unjustifiably infer from the fact that unreliability of belief is a defeater that reliability of belief is necessary for justification.

17. The only philosopher who seems to have felt this problem is William Alston, who, in examining Bonjour's counterexample, says:

> Next he (Bonjour) more boldly argues that in the case in which the subject has no reasons for or against the reliability of her powers or the truth of the belief (whether or not she believes that the powers are reliable), she is not justified in holding the beliefs, however reliable her clairvoyant powers are in fact. However, these "arguments" simply consist in Bonjour displaying his intuitions in opposition to those of his opponent. (See "Internalism and Externalism in Epistemology," 189–90.)

Incidentally, contrary to what is asserted above, it might be thought that there is a certain kind of counterexample to reliabilism that does not assume that reason-giving is sometimes a necessary condition for justification or knowledge. Such a counterexample, if sound, would not need for its force that we establish that reason-giving is sometimes a necessary condition for justification or knowledge. For example, in *Judgement and Justification*, William Lycan presents what he characterizes as a difficulty for externalism, but it is also ostensibly a counterexample to reliabilism insofar as it insists that reliability will not be sufficient for a true belief being an item of knowledge. The sort of counterexample presented is (as Lycan also notes) not unlike one other philosophers have also offered or discussed. In stating and discussing this counterexample, he says:

> Suppose that Albert is looking at his cat, as before, and that everything is going

perfectly, so far as cat, light, retina, perceptual mechanisms, and perceptual experience is concerned; let us even suppose that the likelihood of error is actually zero. But this time suppose that Albert has good reason to think that his perceptual mechanisms are not functioning reliably. A very trustworthy friend (with a strong interest in stimulants) has just told Albert that the champagne they are drinking has been infused with a powerful hallucinogen that produces visual experiences as of household pets. (He says their host is playing a nasty practical joke on an ailurophobic guest.) Perhaps Albert has even seen the host doctor the champagne. Yet Albert irrationally forms his belief about the cat anyway. Now, unbeknownst to Albert, he happens to be immune to the drug; still, it seems, he does not know.

Manipulation of Goldman's (1975) or Dretske's (1981) Peircean distinction between relevant possibilities and idle ones would handle this case perfectly; since the possibility of hallucination has been explicitly called to Albert's attention and indeed been made highly probable on his evidence, it ought certainly to count as a "relevant," "real" possibility (although it still is not realizable in the present hardware of Albert's visual system, owing to Albert's immunity), and this would explain why Albert does not know. But Armstrong allows no such distinction, and according to his analysis, Albert does know; his belief is an absolutely reliable sign of the cat's fatness, whether he himself knows that or not. (109–110)

Ostensibly, the counterexample shows that reliability is not sufficient for a true belief being an item of knowledge. But it is by no means clear that it is an example that does not assume that justification is a reason-giving activity. After all, why exactly is it that it seems as though Albert does not know? Is it not because Albert has acted irrationally in refusing to accept strong evidence for the view that he is hallucinating, and cannot for that reason give reasons to justify his claim that it is a real cat rather than an hallucinatory cat? I submit that it is. Even so, if this particular counter-example does not assume that the capacity to give reasons is sometimes a necessary condition for justification, then it would appear without further comment to be a fine counterexample to the claim that reliability is sufficient to make a true belief knowledge, or a true belief justified.

18. Goldman, *Epistemology and Cognition*, 75–77.

19. Incidentally, the conclusive refutation of other-mind solipsism occurred when Christine Ladd-Franklin wrote to Bertrand Russell and noted that because of the persuasiveness of his argument for other-mind solipsism, she too was a solipsist. If a sound argument is something which everybody ought to accept, then Russell's argument and anybody else's argument for the same conclusion could be sound only if there could be many solipsists. Nobody could rationally accept the conclusion of such an argument without simultaneously refuting it. Christine Ladd-Franklin's explicit acceptance of Russell's argument was an empirical fact and Russell, as a consequence, gave up the claim that one could prove the truth of solipsism, even though he also claimed that it could not be disproven. For a fuller discussion of why this counts as a decisive refutation of a philosophical explanation or answer, see Chapter 3 below, note 26.

20. See Almeder, "Basic Knowledge and Justification," 115–27.

21. For a similar argument, see George Pappas, "Lost Justification."

22. Goldman, "Reply to Almeder and Hogg," 309–311.

23. Ibid., 309.

24. Ibid., 310.

25. Goldman, "Strong and Weak Justification," 59.

26. Goldman notes that the number of philosophers who raise and discuss this objection include Pollock in "Reliability and Justified Belief" (103–14), Stuart Cohen in "Justification and Truth" (279–95), Lehrer and Cohen in "Justification, Truth and Coherence" (191–207), Ginet in "Contra Reliabilism" (175–87), Foley in "What's Wrong with Reliabilism" (175–87), and Luper-Foy in "The Reliabilist Theory of Rational Belief" (203–25).

Stuart Cohen, like others, takes the evil demon example as evidence that reliability (as Goldman defines it) is not even necessary for justification because on Goldman's earlier response, the cognizer in the demon world is not justified since it is an evil demon world in which, by definition, no mechanisms can be demonstrably reliable. The problem for reliabilism, according to those who favor these sorts of counterexamples, is that Goldman's reply is counter-intuitive because we are all supposed to feel that the cognizer in the Cartesian demon world has justified beliefs simply because the beliefs are products of mechanisms which, outside the demon world, produce justified beliefs. Cohen offers another example which is similar, one in which, according to reliabilism, nobody in the Cartesian demon world can have justified beliefs, when in fact we have in that world one who is an intuitively reliable reasoner and one who is not. I think Goldman's initial response to the counterexample was quite correct. In the Cartesian evil demon world, no belief making mechanism, and no number of them, however intuitively acceptable some may seem, can be reliable as a source of justified belief. In such a world, everything the cognizers would think is a justified belief, will not be justified, regardless of how the belief is produced. For another related discussion on this counterexample, see Clarke, "Reliability and Two Kinds of Epistemic Justification," 159–69.

27. I owe this example to Steven Rieber whose comments on an earlier draft helped immensely.

28. This objection was raised by an anonymous referee.

29. Goldman, "What Is Justified Belief?" 3.

30. Ibid., 22.

31. See, for example, Alston's "Epistemic Circularity," 16; "Internalism and Externalism in Epistemology," 217 and 194; and in *Epistemic Justification*, 235ff.

32. Alston, "Internalism and Externalism in Epistemology," 191.

33. See Alston, "Epistemic Circularity," 16; and "An Internalist Externalism," 14.

34. See Alston, "Internalism and Externalism in Epistemology," as it

appears in *Epistemic Justification*, 198. In fuller context he says:

> From the fact that I can *justify* a belief only by relating it to other beliefs that constitute a support, it does not follow that a belief can *be justified* only by its relations to other beliefs. Analogously, from the fact that I cannot justify my expenses without saying something in support of my having made them, it does not follow that my expenses cannot be justified unless I say something in support of my having made them. Indeed, we all have innumerable beliefs that are commonly taken to be justified but for which we never so much as attempt to produce reasons. It might be argued with some show of plausibility that one can be justified in believing that *p* only if it is *possible* for one to justify that belief; but I cannot imagine any remotely plausible argument for the thesis that I can be justified in believing that *p* only if I *have justified* that belief. Hence the point made by Lehrer about justifying leaves completely intact the possibility that one might *be justified* in a belief by something other than one's other beliefs.

35. Alston, "Internalism and Externalism in Epistemology," 196. See also the same essay as it appears in *Epistemic Justification*, 205.

36. Ibid., p. 217, n. 45. See also Alston, "What's Wrong with Immediate Knowledge."

37. See Swain, "Justification, Reasons and Reliability," 76, and Armstrong, *Belief, Truth, and Knowledge*, 166. For an interesting discussion on Swain's essay, see Foley, "What's Wrong with Reliabilism?"

38. Ginet, "Contra Reliabilism," 181. The "Rocking Horse Winner," incidentally, refers to D.H. Lawrence's short story about a young person who acquires the winning lottery number (it pops into his head) whenever he rides his rocking horse; but he does not claim to know or be justified in believing that the number that pops into his head is the winning number. He's a very reliable indicator of what the winning number is, but the question is whether we would say he knows that the number that pops into his head is the winning number.

39. When criticizing Alston's reliabilism, Marshall Swain, in his paper "Internalistic Externalism." offers as a counterexample to Alston's definition of justification the mystic who manages to satisfy Alston's definition. He then says:

> Why are we inclined to deny justification for the mystic's belief even though (as we have imagined) the grounds are objectively reliable? A plausible explanation is that the mystic is defective in an important way as a belief-forming mechanism. The mystic is unable to provide even the slightest proof, or any shred of evidence, of the adequacy of his grounds for belief in a supreme being. And yet the mystic is prepared to believe on the basis of those grounds. A subject who is so disposed is (I submit) defective as a cognizer. If consistently followed, the strategy of believing on the basis of grounds for which you have no indication of reliability would not be truth conducive. The objective reliability of the mystic's grounds is overridden by his tendency to believe on the basis of evidence whose truth-conduciveness is completely unestablished. (471)

Presumably, Alston will regard Swain's counterexample as a blatant question-begging move based on the assumption that justification

sometimes requires providing reasons or a proof that one's beliefs are reliable, truth-conducive or otherwise rationally justified. Indeed, Alston would claim that if everything he has said about justification, and especially about the non-necessity of *showing* that one is justified in one's beliefs, is correct, what follows is that the mystic's beliefs certainly can be justified. As a matter of fact, that is precisely the point of Alston's paper "Perceiving God." It is difficult to see how Swain can succeed in his repudiation of the justifiedness of mystical claims without first establishing more fully the view that it is at least sometimes necessary and sufficient for justification that one be able to give persuasive reasons for what one believes.

40. Kaplan, "Epistemology on a Holiday," 145.

41. Alston, "Epistemic Circularity," as cited in *Epistemic Justification*, 319–49.

42. In arguing against this particular objection, Ginet simply argues that belief-formation certainly can be formed by extrinsic motivation forces. The basic point here, of course, is that if anybody is to attack successfully the interpersonalist position for the reason that nobody ever forms a belief in such a way that he or she is responsible, then the argument they give will need to establish the general thesis that determinism is true. But arguing for such a thesis makes no sense unless one assumes that justification is normative and, by implication, that one has it in one's power either to accept or not accept the thesis. Otherwise, it isn't an argument. See Ginet, "Contra Reliabilism," 182.

43. Ibid., 181.

44. For a defense of the view that there is some knowledge that is not justified see my "Basic Knowledge and Justification," 115–127; and Sosa, "The Virtue of Coherence and the Coherence of Virtue." I have also omitted discussing an argument offered by Alston to show that one can know without being justified; Alston's argument is criticized by Ginet in "Contra Reliabilism," 181.

45. Ginet, "Contra Reliabilism," 181.

46. See Alston, "Epistemic Circularity," 16ff.

47. See, for example, Foley, "Epistemic Luck and the Purely Epistemic," 123, note, and his "What's Wrong with Reliabilism?"

48. See Swain, "An Analysis of Knowledge," 429–30. For a similar example, see Lehrer, "A Fourth Condition of Knowledge: A Defense," 125.

49. Goldman, *Epistemology and Cognition*, 55.

50. It is important to remember that most reliability and causal analyses have been motivated, historically at least, by the desire to overcome Gettier-type counterexamples, and one test of whether such analyses succeed in defining human knowledge is whether they in fact overcome or block Gettier-type counterexamples. But this is precisely what they cannot do. Let me explain.

Any analysis of knowledge that begins by accepting Gettier-type counterexamples cannot succeed in blocking such counterexamples without requiring of any nondefective justification (or reliable belief-making mechanism) that it be an *entailing* justification, or that it prevent the logical possibility of a person being completely justified in believing a false proposition. After all, as long as the condition of nondefectiveness, however it is defined, could be satisfied by nonentailing evidence, we can easily imagine a situation under which that condition is satisfied and yet we would not want to say that the person knows what she claims to know. *In other words, as long as we accept Gettier-type counterexamples and insist on some justification condition, we can always run a Gettier-type counterexample through any proposed definition of knowledge if the justification condition does not require of evidence sufficient for knowledge that it be entailing. We need only imagine the existence of a true proposition that the subject does not know about and that would defeat the subject's knowledge claim were we to add it to the subject's existing justification.*

Consider, for example, Goldman's early reliability analysis. Presumably, under this analysis a person will know what he claims to know if his belief is true and if his belief is the product of a reliable belief-making mechanism, process or method. Moreover, for Goldman, a person's belief making-mechanism is reliable if the mechanism *generally* produces true beliefs *and* if there is available to the believer no other reliable process which, if used, would have led him not to have the belief. Here again, we can easily imagine circumstances under which a person's belief is reliable in the sense specified but defeated by some true proposition unknown to that person even though that person's belief-making mechanism usually is reliable in excluding true propositions that defeat his claim. And we can imagine that the process that would, if used, uncover the falsity of his belief is simply not available to him. For those who accept the Gettier-type counterexamples, in such a universe we would not say that the person knew what he claimed to know. Interestingly, it appears that Goldman's example involving Henry and the barn facsimiles could be made to satisfy the condition of reliability if only we imagine that Henry does not have access to a reliable process which, if used, would have led him not to have the belief. But in such a world we would never say that Henry knew that the object he saw was a barn. Here again, if we accept the Gettier-type counterexamples, we need to say that Henry *fails* to know because there is a true proposition such that if it were added to his justification he would no longer be justified in believing what he does believe. As long as evidence sufficient for knowledge need not be *entailing* we can imagine circumstances under which the definition of knowledge is satisfied and yet we would *not* say that person knows what he claims to know.

Admittedly, defeasibility analyses of justification sought to block the Gettier-type counterexamples simply by insisting that one's justification will be nondefective if, and only if, given it, there is no true proposition such that if it were added to one's justification one would no longer be justified

in believing what one believes. True enough, but when one actually gets down to specifying what logical features a justification must have to satisfy that definition of nondefectiveness, it becomes clear that unless we make such justifications entailing we can always run Gettier-type counter-examples over them, thereby guaranteeing that such a condition could never be satisfied. So the only way we could succeed in offering a satisfiable condition of non-defectiveness would be to require of any justification that it be an entailing justification.

Nor do things get any better when we give up justification altogether and argue that knowledge is simply reliably produced true belief. As long as reliability is not a property that logically guarantees the truth of the true belief reliably produced, it is obvious that we could run Gettier-type counterexamples through such definitions of knowledge.

Somewhat later (as we shall see) in *Epistemology and Cognition*, Goldman added another condition to his definition of knowledge in order to prevent our always being able to run a Gettier-type counterexample through the definition. The condition added asserts that in order for a person to know what she claims to know, her belief must be true, reliable (in the sense specified above) and there be no relevant alternative belief that could defeat the knowledge claim. The problem with this addition, however, is twofold. In the first place, we will not be able to determine whether anybody knows what they claim to know unless we can determine reasonably noncontroversially which alternative beliefs that could defeat a proposed knowledge claim are relevant. In the absence of providing us with a clear definition of *relevant alternative*, the added condition may provide us with what seems to be an adequate definition of knowledge although we would never be able to use the definition to determine whether anybody knows what they claim to know. This result guarantees second-order skepticism, which is the view that one might have an adequate definition of knowledge but fail to be able to determine whether anybody knows anything at all; and if one cannot know whether anybody knows anything at all, it raises the serious question of whether the so-called noncontroversial cases from which we generated our definition in the first place are indeed to be relied upon as legitimate cases from which to generate the definition. Secondly, even if we suppose that we had some reasonably adequate definition of *relevant alternative*, then how could we show that the condition is satisfied in any case? If the evidence we cite is not entailing, then we will be able to imagine the unknowable defeater, and, as we have argued elsewhere, unless we can eliminate the logical possibility of the unknowable defeater, the definition will be inadequate. For these reasons, Goldman's attempt to block the eternal counterexample fails. Once again, the only way to block the Gettier-type counterexamples is to require of evidence sufficient for knowledge that it be *entailing*. Such is the effect of the unknowable defeater.

51. On this matter see also note 9 in Chapter 3 below.

52. In his review of Goldman's book *Epistemology and Cognition*, Paul

Thagaard offers, I believe, a similar objection to the transformational thesis when he notes that, with regard to justifying scientific inferences by reliabilism, we cannot get reliability ratings when we have no method of establishing the truth of theories independently of the inferential method of theory justification. (Thagaard, "Goldman's Psychologism," 117ff)

53. Dretske, "The Need to Know," 90–100, see also 100, note 2; Armstrong, *Belief, Truth, and Knowledge*.

54. Dretske, "Precis of *Knowledge and the Flow of Information*," 178–180.

55. Much earlier in "Conclusive Reasons," 1–22, Dretske had argued that one must have conclusive reasons for what one believes in order to be justified in what one believes; and that as long as one's reasons were conclusive, then she could never be justified in believing a false proposition. After all, if one has a *conclusive reason* for believing that *p*, then *p* cannot be false. For a full discussion on, and defense of, the force of this principle, see my *Blind Realism*, 6–18. See also Robert Shope's similar proposal to block Gettier-type counterexamples by appealing to much the same principle in "Knowledge and Falsity," 128–36.

56. Dretske, "The Need to Know," 95–96.

57. For a similar argument, see Sartwell, "Why Knowledge Is Merely True Belief," 167ff. See also Armstrong, *Belief, Truth, and Knowledge*.

58. The example offered by William Lycan about Albert and the cat, and cited above in note 17, is also a good example of reliably produced true belief that is not an item of knowledge.

59. Douglas Winblad pointed out to me the nature of the inconsistency between Dretske's asking his question and the position he defends.

60. For other arguments against reliabilism see Feldman, "Goldman on Epistemology and Cognitive Science," 197–208; Shope. "Justification, Reliability and Knowledge," 133–54; Moser, "Reliabilism and Relevant Worlds," 155–64; Winblad, "Skepticism and Naturalized Epistemology," 99–114; Foley, "What's Wrong with Reliabilism," 188–202; Luper-Foy, "The Reliabilist Theory of Rational Belief," 203–223; Pollock, "Reliability and Justified Belief," 104ff; Moser, "Recent Work in Epistemology"; Thagaard's review of Goldman's book, "Goldman's Psychologism," 120ff; and Annis, "A Contextualist Theory of Justification," 213–19.

61. See note 12 above.

Notes to Chapter 3

1. Hume, *Treatise of Human Nature*, 3ff, *Enquiry Concerning Human Understanding*, Section IX, 104; Section II, 19–22. See also Hume's Preface to *An Abstract of a Treatise on Human Nature*, quoted in *Essays in Philosophy*, 10–27.

2. Most recently, for example, in his interesting book *Knowledge of the External World*, Bruce Aune has offered a demonstrably decisive refutation of Hume's views on this matter.

3. For a fuller account of the nature of Peirce's empiricism and the way in which it differs from the classical empiricism of Hume and Quine, see my *The Philosophy of Charles Peirce: A Critical Introduction*, Chapter 1.

4. Ernest Nagel, "Naturalism Reconsidered," as cited in *Essays in Philosophy*, 493.

5. Recently this form of empiricism has also been defended by Bruce Aune in his fine book *Knowledge of the External World*. This form of naturalism is also sometimes described as "radical empiricism" (William James' expression) and, to repeat, asserts basically that whether one's beliefs about the world are meaningful or worthy of rational acceptance is not a matter of how those beliefs originate, or are caused to arise, in human consciousness; rather it is a matter of whether what those beliefs, if true, virtually predict in sensory experience, and whether what they predict occurs, or would occur, sufficiently frequently to warrant rational adoption or rejection, given the usual provisos and *ceteris paribus* clauses.

6. For a discussion on this, see Hempel's *Introduction to the Philosophy of Natural Science*, Chapter 2. Hempel's naturalism, with its qualified endorsement of instance confirmation, is an instance of harmless naturalism although, as we noted above, strict Popperian deductivism would also be an instance of harmless naturalism.

7. Susan Haack, for example, claims to be just such a Cartesian naturalist in her essay "Rebuilding the Ship While Sailing on the Water." I have elsewhere defended this liberal form of empiricism in defending Peirce's theory of meaning against Quine's in my "Peirce on Meaning," 1–26.

Also, Derek Parfit has argued in *Reasons and Persons* that belief in the existence of Cartesian Egos (and by implication in Cartesian mind-body dualism) is certainly empirically testable because belief in *reincarnation* is certainly empirically testable. The reincarnation hypothesis is unique as a form of mind-body dualism because it has test implications at the sensory level, once one grants that the criterion for personal identity includes having certain systemic memories. People who allegedly reincarnate, for example, ought minimally to have certain confirmed memories of past events known to have been witnessed by the former personality, and they also ought to have confirmed memories that *only* the former personality could have. Napoleon Bonaparte reincarnated, ought, by implication, to have confirmed memories that *only* Napoleon could have had. Parfit holds that as a matter of fact, the specific and statable evidence that would have confirmed belief in reincarnation has just not occurred. Had such evidence occurred, however, the reincarnation hypothesis would be the only hypothesis that could explain the data. Naturally, had such data occurred and confirmed the reincarnation hypothesis, the reincarnation hypothesis

would not have explained how (or even why) reincarnation occurs. But it would have been a testable explanation of the facts implied by the hypothesis without explaining how reincarnation occurs. So, from a liberal empiricist's point of view, belief in reincarnation is a straightforward empirical hypothesis. See Parfit, *Reasons and Persons*, 287ff. In this regard, incidentally, I have argued elsewhere for the view that the recent evidence supporting belief in reincarnation is actually quite strong, and that as an empirical thesis we have good reason to believe in reincarnation—although, to be sure, the explanation offered for the data by the hypothesis in question is not a causal explanation showing how or why the phenomenon occurs. Even so, if the evidence for reincarnation is strong and available, it is difficult to see how we can avoid the conclusion that Cartesian Egos exist. See my *Death and Personal Survival: The Evidence For Life After Death*, Chapter 1.

8. This is not to say, of course, that it makes *absolutely* no epistemological difference how one acquires one's beliefs. After all, some methods of acquiring beliefs are demonstrably more reliable than others simply because some methods of acquiring beliefs are demonstrably more likely to produce beliefs having test implications that would in fact justify the beliefs so acquired. Acquiring one's beliefs by reading the *New York Times* rather than reading the *National Enquirer*, or reading tea leaves, is, for example, more likely to produce justified beliefs just because we have ample inductive evidence that the *New York Times* is generally the more reliable source of information. But what makes the *New York Times* more reliable is that, however its reporters acquire their beliefs, the beliefs asserted in the paper usually have test implications that lead to robust confirmation of the claims made in terms of the sensible implications of the claims. If the reporters were to acquire all their beliefs by reading crystal balls and tea leaves, and if all those beliefs had test implications that typically robustly confirmed the beliefs, then those beliefs would be justified and the method of acquiring them irrelevant to the determination of their justifiedness because, however those beliefs were acquired, their justifiedness would depend on whether what they virtually predict, if true, obtained or would obtain in sensory experience. This conclusion reflects not only what we argued back in Chapter 2 when we argued against causal and reliability theories of justification, but also standard scientific practice which, in seeking to confirm or justify proposed hypotheses, is basically indifferent to the question of how the hypothesis is generated.

9. Russell, *Human Knowledge: Its Scope and Limits*, 419–38 and 451–55.

10. Goodman, *Fact, Fiction, and Forecast*. Goodman, incidentally, may well have been among the very first to find the traditional non-Popperian H-D model of theory confirmation defective, simply by showing that some hypotheses, at least logically, cannot be confirmed by their positive instances. It is noteworthy, however, that for Goodman, a confirmed hypothesis must have some positive instances deductively implied by the hypothesis.

11. See for example, Bruce Aune's recent and convincing discussion in

Knowledge of the External World.

12. See, for example, Alston's "Epistemic Circularity," 16, and as cited in *Epistemic Justification*, 319–49. See also note 56 in Chapter 1 above.

13. See Chapter 3 of my *Blind Realism*. See also Bruce Aune's adoption of the same principle in *Knowledge of the External World*, 191.

14. The skeptic seems to think that any argument in favor of the reliability of our basic belief-making mechanisms, such as perception, must be question-begging or viciously circular reasoning; but if we were to grant that the skeptic is right on this matter, the skeptic could not successfully offer a non-question begging argument to the effect that all reasoning is flawed because unavoidably circular or question-begging at the root. In short, the skeptic's argument is self-defeating, and observational data to which we appeal in theory confirmation need not be an unreliable source of confirmation for the reasons offered by this form of skepticism.

15. For a recent example of mutually exclusive theories equally well supported by the same body of data and hence, observationally equivalent, see Marcello Pera's excellent book, *The Ambiguous Frog: The Galvani-Volta Controversy on Animal Electricity*. See also Wesley Salmon's review of the book in *Philosophy of Science* (March 1995): 164–65.

16. One of the problems, however, with making a stronger endorsement of Bayesianism for the reasons just given is that in the history of science wherever we have had two observationally equivalent or two equally empirically adequate hypotheses, the acceptance of one theory over the other for extra-empirical factors or for Bayesian considerations was subsequently made more or less acceptable in terms of observational data implied by one hypothesis and not the other. Salmon says as much, for example, when he notes in his review of Pera's book (see note 15 above) that, with regard to the Galvani-Volta controversy on animal magnetism, "substantial experimental support for Volta's viewpoint came later (1828) with Wohler's synthesis of the 'organic compound' urea from 'inorganic substances'" (165). In other words, in the end, the so-called extra-empirical factors that go into the social accepting the one theory over the other are *post factum* justifiable depending on the ultimate observational implications of the hypothesis involved. Moreover, I take it that Bayesian "plausibility" considerations root in already-accepted theories or hypotheses which are also subject to rejection pending the remote, and possibly only implicit, observational consequences of the hypothesis being tested.

In *Theory and Evidence*, and elsewhere, Clark Glymour has defended a position which he regards as falling between the Bayesian model and the traditional H-D model of confirmation, both of which he regards as defective. For a fuller discussion than we need here encounter on Glymour's intriguing proposal (which he calls "bootstrapping") see John Earman's *Bayes or Bust*? See also Sam Mitchell, "Toward a Defensible Bootstrapping," 241–60.

17. In Horwich, "Explanations of Irrelevance," 55–65.

18. Naturally, even under a suitably revised H-D model, there will still be the problem of what (if any) is the role of the probability calculus in assessing the evidence supporting a hypothesis, whether, and to what degree, holism (rather than instance confirmation) is desirable, whether the proper calculus for hypothesis testing within theories should reflect instance confirmation in some contexts while still allowing theory confirmation to be theory-relative, whether evidential support is a way of gauging the likelihood of *truth*, whether the auxiliary assumptions of the theory to be tested can be assumed in the testing of the theory itself (bootstrapping), what the logic of evidential support should look like, and whether we can say clearly what counts for *relevant* testing.

19. It does not follow from the falsity of the claim that the only legitimately answerable questions are those we can answer by appeal to the methods of the natural sciences that the only correct answers and explanations we have at any time are those that emerge from the application of the methods of the natural sciences. The latter follows from the former only if we accept the claim that in fact we do have some correct explanations and answers in natural science; and advocates of the replacement thesis have no problem accepting this last claim. At any rate, whichever of these ways the advocates of the replacement thesis characterize the thesis, the argument offered back in the final part of Chapter 1 applies equally well against the view that the only correct answers and explanations we have at any time are those that emerge solely from the application of the methods of the natural sciences. That thesis is also incapable of being explicitly empirically tested and, as we have seen, any argument for it will be self-defeating because at least one of the essential premises will need to be "philosophical" (not explicitly testable) which would be false if the conclusion is true.

20. Construing mathematics as *a priori* in the sense of not being empirically falsifiable, does not thereby mean that mathematical claims are infallible, even when judged to be true by the mathematical community. Obviously, one can still make reasoning mistakes in mathematics even when one construes such claims as *a priori*, but the fallibilism here is different because the mistakes involved have to do with defects in calculation or deductive inference or infelicitous choice of axioms or postulates. On this view, *a priori* simply means "not empirically falsifiable"; it does not mean infallible in the sense of not being able to be mistaken or in error for any reason whatever. Along with Hume, Peirce and Quine, one may hold that fallibilism applies everywhere, even in mathematics, and that the apparent certainty of mathematical claims owes to the fact that we are simply deducing the consequences of our own definitions which are not meant to be literal descriptions or true statements about empirical experience. Mistakes in deduction will occur even here, however. On this matter Hume also said:

> There is no algebraist nor mathematician so expert in his science, as to place entire confidence in any truth immediately upon his discovery of it, or regard

it as anything but a mere probability. Every time he runs over his proofs his confidence increases; but still more by the approbation of his friends; and is raised to its utmost perfection by the universal assent and applause of the learned world. Now it is evident that this gradual increase of assurance is nothing but the addition of new probabilities, and is caused by the constant union of causes and effects, according to past experience and observation. (*A Treatise on Human Nature*, 180)

21. This of course is *not* to adopt the Popperian position that falsifiability is both a necessary *and a sufficient condition* for an explanation or a hypothesis being scientific. Thus there is no need here to defend Popper's position against his critics on whether positive instances of a hypothesis support the hypothesis as confirmed. I have already argued above that it is a necessary condition for confirmation that one have positive instances of the hypothesis deductively implied by the hypothesis. If we reject Popper's views here, as our revised H-D model does, there is still the question of which hypotheses are supported by their positive instances. More on this below.

22. See, for example, the naive conceptions of testability, verifiability, and falsifiability originally employed in the discussion on the demarcation problem between science and non-science in Laudan, "The Demise of the Demarcation Problem." One might, incidentally, agree with Laudan's arguments that we cannot effectively demarcate between science and non-science by appeal to verificationist and falsificationist theories of meaning without thereby abandoning the distinction between science and non-science to "our intuitive distinction between the scientific and the non-scientific" (ibid., 124). The distinction between explicit and implicit testability should suffice as a criterion of demarcation between science and philosophy, and I would include mathematics in the latter category. On this last point see, for example, Horowitz, "A Priori Truth," 225–39, and Butts, "Science and Pseudoscience."

23. That PE is basically a non-controversial and fairly explicit requirement for a claim being an empirically significant or scientific claim, see, for example, Hempel, *Introduction to the Philosophy of Natural Science*.

Incidentally, Hempel's more recent paper "Provisoes: A Problem Concerning the Inferential Function of Scientific Theories" does not repudiate empirical testability as a requirement for explanatory significance in science; but it does show that scientific hypotheses do not straightforwardly deductively imply their sensory test conditions without general provisos or assumptions to the effect that no other factors are influencing the phenomena other than those explicitly taken into consideration (p. 132 in Fetzer). The necessity for proviso clauses (not to be confused, incidentally, with *ceteris paribus* clauses) not only undermines strict empirical deductivist views of testability (because the test implications of the explanation or theory have been derived conditionally by assuming that certain theoretical conditions have been met under standard proviso clauses), but it also renders falsification subject to review in terms of unstated provisos.

Even granting the Duhem-Quine thesis and the role of provisos in understanding the nature of testability and falsifiability, explicit empirical testability is still, for Hempel, both necessary and sufficient for a claim or explanation being scientific. But naive views of testability and falsification, strict deductivist views or non-holistic views countered by the Duhem-Quine thesis, for example, are no longer acceptable. As James Fetzer has noted, the notion of empirical content is oversimplified in most accounts on testability, including Hempel's own past accounts, because the relationship is not so straightforward as previously assumed. This holds equally well for falsifiability and attempts to reduce theoretical claims to observational claims. Theories must still be empirically testable explicitly, but our understanding of the logic of testing theories has undergone some transformation in the past quarter century.

Also, as stated, PE implies that if in fact at time *t* nobody exists, then testability is a function of whether one could state the conditions were one to exist at the time the explanation is asserted.

24. Hume, *Enquiry Concerning Human Understanding*, in Selby-Bigge (ed), *Hume's Enquiries*, Section II, 19–22; Section IV, Part 1, 25; Section IX, 104. See also *Treatise of Human Nature*, 3.

25. For a recent and forceful critique of Hume's doctrine on the relationship between impressions and ideas, and why it is an empirically inadequate account of both mental representation and the activity of thinking, see Aune, *Knowledge of the External World*, 117–19 and 133–35.

26. Christine Ladd-Franklin's apparently unintended, but conclusive, refutation of Russell's early endorsement of solipsism also comes to mind, although this example is more problematic. In her letter to Russell, she claimed that she was so thoroughly convinced by Russell's argument that she too was a solipsist. Russell noted with amusement that there must be something very wrong with his argument that somebody else could conclude to the view that they also were solipsists. However, Russell apparently did not see this as a refutation of solipsism rather than a refutation of the view that one can have a good argument for solipsism. And philosophers will be quick to note, that if Russell's argument were sound, he should not have admitted even receiving a letter from anybody; so it was not Christine Ladd-Franklin's answer that refuted the thesis, it would have been refuted even if she had disagreed with the argument, as long as Russell agreed that somebody wrote a letter. At any rate, given that there could be no good argument to the effect that I alone exist, because if anybody else accepted the argument, the argument would become unsound (we can imagine conditions in which the conclusion would not follow from the premises—namely, when anybody other than the author of the argument accepted the argument). To say that an argument is sound implies, presumably, that the conclusion holds for everybody and cannot be undermined by somebody actually accepting that conclusion. Doubtless, when Russell offered the argument it did not occur to him that the fact of somebody agreeing with his argument would be sufficient to refute the

position quite conclusively. So, to the question "Might I be the only person in the world?" the good answer is "No." And as providing an answer to the question "Why is Solipsism false?" the explanation offered here is correct, although when Russell first wrote his argument he had no explicit idea of what would refute his thesis. The empirical fact that Christine Ladd-Franklin agreed with the argument refuted it, but it would also have been conclusively refuted if she had disagreed with it, and Russell could not help but accept the view that he had received a letter from somebody. The fact that Russell did not see it as a conclusive refutation is a bit problematic although, presumably, the rest of us now do. For other reasons, one might well suggest that nobody in philosophy can coherently argue that solipsism is true, and that the thesis is a sufficiently well refuted philosophical position to warrant inclusion on a list of questions philosopher have correctly answered. As it is, the important point is that no philosophers really take solipsism seriously for a number of good reasons. See Bertrand Russell, *Human Knowledge*.

27. As Hilary Putnam has noted, scientific realism is the only theory that does not make a miracle out of scientific success (see *Reason, Truth and History*, 89). I have argued at length a variant of this thesis in the fourth chapter of *Blind Realism*.

28. As a matter of fact, it may be the case that philosophical theses need not have positive instances that support them but become acceptable when their denials are conclusively refuted empirically. If so, that would be another feature distinguishing scientific explanations, which must be testable in terms of positive instances implied by the hypothesis, and philosophical explanations which, while empirically refutable, would not need positive instances. But I am not certain about this claim.

29. See McGinn, *The Problem of Consciousness*, Chapter 1.

30. It is unclear whether Parfit regards his argument as an empirical refutation of belief in the existence of Cartesian Egos, or whether he simply regards it as a thesis that has not been empirically established and has not been empirically refuted.

31. See the last two chapters (entitled respectively "Scientific Progress and Peircean Utopian Realism," and "Blind Utopian Realism") of my *Blind Realism*.

32. For a sustained defense of this thesis see, for example, Rescher's *The Strife of Systems*.

33. See Ryle, "Ludwig Wittgenstein," as reprinted in *Essays in Philosophy*, 426ff.

Bibliography

Almeder, Robert. "Defeasibility and Skepticism." *Australasian Journal of Philosophy* 51 (December 1973): 238–44.

———. "Peirce on Meaning." *Synthese* 41 (1979): 1–26.

———. *The Philosophy of Charles Peirce: A Critical Introduction*. Oxford, England: Basil Blackwell, 1980.

———. "Basic Knowledge and Justification." *Canadian Journal of Philosophy* 13, no. 1 (March 1981): 115–27.

———. "A Definition of Pragmatism." *The History of Philosophy Quarterly* (January 1986): 79–89. Reprinted in *Pragmatik: Handbuch Pragmatischen Denkens*, vol. 2. Edited by H. Stachowiak. Hamburg: Felix Meiner, Verlag, 1987.

———. "Scientific Realism and Explanation." *American Philosophical Quarterly* (October 1989): 173–87.

———. "On Naturalizing Epistemology." *American Philosophical Quarterly* (October 1990): 263–81. Revised and reprinted in *Foundations of Philosophy of Science: Contemporary Developments*. Edited by James Fetzer. New York: Paragon Press, 1992.

———. "Vacuous Truth." *Synthese* 85 (December 1990): 1–19.

———. *Blind Realism: An Essay on Human Knowledge and Natural Science*. Lanham, MD: Rowman and Littlefield, 1991.

———. *Death and Personal Survival: The Evidence for Life After Death*. Lanham, MD: Rowman and Littlefield, 1992.

———. "Defining Justification and Naturalizing Epistemology." *Philosophy and Phenomenological Research* (October 1994).

———. "Dretske's Dreadful Question." *Philosophia* 24, nos. 3-4 (October 1996).

———. "Externalism and Justification." *Philosophia* 24, nos. 3-4 (October 1996).

Alston, William. *Knowledge, Perception, and Memory*. Dordrecht, Holland: D. Reidel, 1975.

———. "What's Wrong with Immediate Knowledge." *Synthese* 55 (April 1983): 73–96.

————. "Internalism and Externalism in Epistemology." *Philosophical Topics* 14, no. 1 (1986).

————. "Perceiving God." *Journal of Philosophy* 48 (October 1986): 655–66.

————. "An Internalist Externalism." *Synthese* 74 (1988): 265–83.

————. *Epistemic Justification*. Ithaca, NY: Cornell University Press, 1989.

Annis, David. "A Contextualist Theory of Justification." *American Philosophical Quarterly* 15 (October 1978): 213–19.

Aristotle. *Metaphysics*. Edited by Richard McKeon. New York: Random House, 1941. Book One, Chapter 1.

————. *De Anima*. Edited by Richard McKeon. New York: Random House, 1941. Book Three, Chapters 9–11.

————. *Nichomachean Ethics*. Edited by Richard McKeon. New York: Random House, 1941. Book Six, Chapter 12.

Armstrong, D.M. *Belief, Truth, and Knowledge*. London: Cambridge University Press, 1973.

Aune, Bruce. *Knowledge of the External World*. London: Routledge and Kegan Paul, 1991.

Baker, Lynn Rudder. *Saving Belief: A Critique of Physicalism*. Princeton, NJ: Princeton University Press, 1987.

Barker, John. "What You Don't Know Won't Hurt You." *American Philosophical Quarterly* 13 (1976): 1–3.

Barrett, Robert and Roger Gibson, eds. *Perspectives on Quine*. Oxford: Basil Blackwell, 1990.

Bartley, W.W., III. "Philosophy of Biology versus Philosophy of Physics." In *Evolutionary Epistemology, Theory of Rationality and the Sociology of Knowledge*. Edited by G. Radnitzky and W.W. Bartley III. La Salle, IL: Open Court, 1987.

Bechtel, William. "Toward Making Evolutionary Epistemology into a Truly Naturalized Epistemology." In *Evolution, Cognition, and Realism*. Edited by Nicholas Rescher. Washington, D.C.: University Press of America, 1990.

———— and Adel Abrahamson. "Beyond the Exclusively Propositional Era." *Synthese* 82 (September 1990).

Bonjour, Laurence. "Externalist Theories of Empirical Knowledge." Pp. 53–73 in *Midwest Studies in Philosophy*, vol. 5. Edited by Peter French, Theodore E. Uehling, and Howard Wettstein. Minneapolis: University of Minnesota Press, 1980.

————. *The Structure of Empirical Knowledge*. Cambridge, MA: Harvard University Press, 1980.

————. "Against Naturalized Epistemology." *Midwest Studies in Philosophy* 19 (October 1994): 22–23.

Boyd, Richard et al., eds. *The Philosophy of Science*. Cambridge, MA: MIT Press, 1991.

Bradie, Michael. "Evolutionary Epistemology and Naturalized Epistemology." *Epistemologia* (Spring 1998).

Butts, Robert. "Science and Pseudoscience." In *Pittsburgh Studies in the Philosophy of Science*. Lanham, MD: Rowman and Littlefield, 1994.

Chisholm, Roderick. *The Problem of the Criterion*. Milwaukee: Marquette University Press, 1973.

————. *The Theory of Knowledge*. 3d Edition. Englewood, NJ: Prentice Hall, 1980.

Churchland, Patricia. "Is Determinism Self-refuting?" *Mind* 90 (1981).

————. *Neurophilosophy*. Cambridge: MIT Press, 1986.

————. "Epistemology in the Age of Neuroscience." *Journal of Philosophy* 84, no. 10 (October 1987): 544–53.

Churchland, Paul. *Scientific Realism and the Plasticity of Mind*. Cambridge, England: Cambridge University Press, 1979.

————. "Eliminative Materialism and Propositional Attitudes." *Journal of Philosophy* 78, no. 2 (June 1981).

————. *Matter and Consciousness*. Cambridge, MA: Bradford Books, 1984.

————. "Some Reductive Strategies in Cognitive Neurobiology." *Mind* 95 (June 1986).

Clarke, Murray. "Reliability and Two Kinds of Epistemic Justification. Pp. 159–69 in *Naturalism and Rationality*. Edited by Newton Garver and Peter Hare. Buffalo, NY: Prometheus, 1986.

Clay, Marjorie and Keith Lehrer, eds. *Knowledge and Skepticism*. Boulder, CO: Westview Press, 1989.

Cohen, Stuart. "Justification and Truth." *Philosophical Studies* 46 (1984): 279–95.

Dennett, Daniel. *Brainstorms*. Sussex: Hassocks, 1979.

Devitt, Michael. *Coming to Our Senses*. Cambridge, England: Cambridge University Press, 1996.

Dretske, Fred. "Conclusive Reasons." *Australasian Journal of Philosophy* 49 (April 1971): 1–22.

————. *Knowledge and the Flow of Information*. Cambridge, MA: MIT Press, 1982.

————. "Precis of *Knowledge and the Flow of Information*." In *Naturalizing Epistemology*. Edited by Hilary Kornblith. Cambridge, MA: MIT Press,

1985.

———. "The Need to Know." Pp. 90–100 in *Knowledge and Skepticism*. Edited by Marjorie Clay and Keith Lehrer. Boulder, CO: Westview Press, 1989.

Dretske, Fred and Berent Enc. "Causal Theories of Knowledge." Pp. 517–27 in *Midwest Studies in Philosophy*, vol. 9. Edited by Peter French, Theodore E. Uehling, and Howard Wettstein. Minneapolis: University of Minnesota Press, 1985.

Earman, John, ed. *Testing Scientific Theories*. Minnesota Studies in the Philosophy of Science, vol. 10. Minneapolis: University of Minnesota Press, 1983.

———. *Bayes or Bust?* Cambridge, MA: MIT Press, 1992.

Feldman, Richard. "Goldman on Epistemology and Cognitive Science." *Philosophia* 19, nos. 2-3 (October 1989): 197–208.

Fetzer, James, ed. *Foundations of the Philosophy of Science: Contemporary Developments*. New York: Paragon Press, 1992.

Firth, Roderick. "Are Epistemic Concepts Reducible to Ethical Ones?" Pp. 215–29 in *Values and Morals*. Edited by Alvin Goldman and Jagwon Kim. Dordrecht, Holland: D. Reidel, 1978.

Foley, Richard. "Epistemic Luck and the Purely Epistemic." *The American Philosophical Quarterly* 21 (April 1984).

———. "What's Wrong with Reliabilism?" *The Monist* 68 (April 1985): 175–87.

French, Peter, et al., eds. *Midwest Studies v. Studies in Epistemology*. Minneapolis: University of Minnesota Press, 1980.

Friedman, Michael. "Philosophical Naturalism." *Proceedings of the American Philosophical Association* 71, no. 2 (November 1997).

Garver, Newton and Peter Hare. *Naturalism and Rationality*. Buffalo, NY: Prometheus, 1986.

Gettier, Edmund. "Is Justified True Belief Knowledge?" *Analysis* 23, no. 6 (April 1963): 121–23.

Gibson, Roger. "Quine on Naturalized Epistemology." *Erkenntnis* (1987).

Giere, Ron. *Explaining Science: A Cognitive Approach*. Chicago, IL: University of Chicago Press, 1988.

Ginet, Carl. *Knowledge, Perception, and Memory*. Norwell, MA: Kluwer Academic, 1975.

———. "Contra Reliabilism." *The Monist* 68 (April 1985): 175–87.

Glymour, Clark. *Theory and Evidence*. Princeton, NJ: Princeton University Press, 1980.

Goldman, Alvin. "A Causal Theory of Knowing." *Journal of Philosophy* 64, no. 12 (1967): 355–72.

———. "Discrimination and Perceptual Knowledge." *Journal of Philosophy* 73, no. 20 (September 1976): 771–91. Reprinted in *Essays on Knowledge and Justification*. Edited by George Pappas and Marshall Swain. Ithaca, NY: Cornell University Press, 1978.

——— and Jagwon Kim. *Values and Morals*. Dordrecht, Holland: D. Reidel, 1978.

———. "What Is Justified Belief?" Pp. 1–23 in *Justification and Knowledge*. Edited by George Pappas. Dordrecht, Holland: D. Reidel, 1979.

———. *Epistemology and Cognition*. Cambridge: Harvard University Press, 1985.

———. "The Relation Between Epistemology and Psychology." *Synthese* 64 (July 1985): 29–42.

———. "Strong and Weak Justification." *Philosophical Perspectives* 2 (June 1988).

———. "Reply to Almeder and Hogg." *Philosophia* 19, nos. 2-3 (October 1989): 309–311.

Goodman, Nelson. *Fact, Fiction, and Forecast*. 2d edition. Indianapolis: Bobbs-Merrill, 1965.

Guttenplan, Samuel, ed. *Mind and Language*. Oxford, England: Clarendon Press, 1975.

Haack, Susan. "Rebuilding the Ship While Sailing on the Water." In *Perspectives on Quine*. Edited by Robert Barrett and Roger Gibson. Oxford, England: Basil Blackwell, 1990.

———. "Recent Obituaries of Epistemology." *The American Philosophical Quarterly* 27, no. 3 (July 1990).

———. "Two Faces of Quine's Naturalism." *Synthese* (1991).

Hempel, Carl. *Introduction to the Philosophy of Natural Science*. Englewood Cliffs, NJ: Prentice Hall, 1966.

———. "Provisoes: A Problem Concerning the Inferential Function of Scientific Theories." *Erkenntnis* 28 (1988): 146–64. Reprinted in James Fetzer, ed. *Foundations of Philosophy of Science: Contemporary Developments*. New York: Paragon Press, 1992.

Horgan, Terry and Paul Woodard. "Folk Psychology Is Here to Stay." *Philosophical Review* 94 (July 1985).

Horowitz, Tamara. "A Priori Truth." *Journal of Philosophy* 82, no. 5 (May 1985): 225–39.

Horwich, Paul. "Explanations of Irrelevance." Pp. 55–65 in *Testing*

Scientific Theories. Minnesota Studies in the Philosophy of Science, vol. 10. Edited by John Earman. Minneapolis: University of Minnesota Press, 1983.

Hume, David. *Enquiry Concerning Human Understanding*. Pp. 19–22 in *Hume's Enquiries*. Edited by L.A. Selby-Bigge. Oxford: Clarendon Press, 1902. Section IX, Section II.

——. *Abstract of a Treatise of Human Nature*, as quoted in pp. 10–27, *Essays in Philosophy*. Edited by Houston Peterson. New York: Simon and Schuster, 1974.

——. *A Treatise of Human Nature*. Edited by L.A. Selby-Bigge. Oxford: Clarendon Press, 1978.

Humphreys, Paul. *Chances of Explanation*. Princeton, NJ: Princeton University Press, 1986.

Jacob, Pierre. "Review of Daniel Dennett's *Mental Content*." *Journal of Philosophy* 28, no. 12 (December 1991): 723ff.

Kaplan, Mark. "Epistemology on a Holiday." *Journal of Philosophy* 88, no. 3 (March 1991).

Kasher, Asa. "Justification of Speech, Acts, and Speech Acts." Pp. 281–303 in *New Directions in Semantics*. Edited by Ernest LePore. New York: Academic Press, 1987.

Ketchum, Richard. "The Paradox of Epistemology: A Defense of Naturalism." *Philosophical Studies* (October 1990).

Kim, Jagwon. "What is 'Naturalized Epistemology'?" *Philosophical Perspectives* 2 (1988): 381–405.

Kornblith, Hilary. "Beyond Foundationalism and the Coherence Theory." *Journal of Philosophy* 77 (1980): 597–610.

——, ed. *Naturalizing Epistemology*. Cambridge, MA: MIT Press, 1985.

Laudan, Larry. "The Demise of the Demarcation Problem" In *Physics, Philosophy, and Psychoanalysis: Essays in Honor of Adolf Grünbaum*. Edited by Robert Cohen and Carl G. Hempel. Dordrecht, Holland: D. Kluwer, 1983.

——. "Normative Naturalism." *Philosophy of Science* (1989).

Lehrer, Keith. "A Fourth Condition of Knowledge: A Defense." *Review of Metaphysics* (September 1970).

——. "How Reasons Give Us Knowledge, or the Case of the Gypsy Lawyer." *Journal of Philosophy* 68 (1971): 311–13.

—— and Stuart Cohen. "Justification, Truth, and Coherence." *Synthese* 55 (1983): 191–207.

LePore, Ernest and Brian McLaughlin, eds. *Language and Reality: Perspec-*

tives on the Philosophy of Donald Davidson. Oxford, England: Oxford University Press, 1986.

Luper-Foy, Steven. "The Reliabilist Theory of Rational Belief." *The Monist* 68 (1985): 203–25.

Lycan, William. *Judgement and Justification*. Cambridge, England: Cambridge University Press, 1988.

Maffie, James. "Recent Work on Naturalized Epistemology." *The American Philosophical Quarterly* (October 1990): 281ff.

McCauley, Robert. "Epistemology in an Age of Cognitive Science." *Philosophical Psychology* 1, no. 2 (1988): 147–49.

McGinn, Colin. *The Problem of Consciousness*. Oxford, England: Basil Blackwell, 1995.

Mitchell, Sam. "Toward a Defensible Bootstrapping." *Philosophy of Science* 62 (1995): 241–60.

Moser, Paul. "Reliabilism and Relevant Worlds." *Philosophia* 19, nos. 2-3 (October 1989): 155–64.

———. "Recent Work in Epistemology." *Philosophical Papers* (1991).

Munz, Peter. *Our Knowledge of the Growth of Knowledge: Popper or Wittgenstein?* London: Routledge and Kegan Paul, 1987.

Nelson, Leonard. *Socratic Method and Critical Philosophy*. Translated by Thomas K. Brown III. New York, 1965.

Nielsen, Kai. "Farewell to the Tradition." *Philosophia* (July 1991).

Nisbett, Richard and Timothy Wilson. "Telling More than We Can Know: Verbal Reports on Mental Processes." *Psychological Review* 84, no. 3 (1977): 231–59.

Papineau, David. "Is Epistemology Dead?" *Proceedings of the Aristotelian Society* 82 (April 1982): 129–42.

Pappas, George. "Lost Justification." In *Midwest Studies in Philosophy*, vol. 5. Minneapolis: University of Minnesota Press, 1986.

——— and Marshall Swain, eds. *Essays on Knowledge and Justification*. Ithaca, NY: Cornell University Press, 1978.

Parfit, Derek. *Reasons and Persons*. Oxford, England: Oxford University Press, 1981.

Pera, Marcello. *The Ambiguous Frog: The Galvani-Volta Controversy on Animal Electricity*. Translated by Jonathen Mandelbaum. Princeton, NJ: Princeton University Press, 1992.

Peterson, Houston, ed. *Essays in Philosophy*. New York: Washington Square Press, 1974.

Pollock, John. "Reliability and Justified Belief." *Canadian Journal of*

Philosophy 14 (March 1984): 103–114.

Putnam, Hilary. *Reason, Truth, and History*. Cambridge, England: Cambridge University Press, 1981.

———. "The Corroboration of a Theory." In *The Philosophy of Karl Popper*. Edited by Paul A. Schilp. La Salle, IL: Open Court, 1974. Reprinted in Richard Boyd et al., eds. *The Philosophy of Science*. Cambridge, MA: MIT Press, 1991.

Quine, Willard Van Orman. *Ontological Relativity and Other Essays*. New York: Columbia University Press, 1969.

———. "Epistemology Naturalized." In Willard Quine, *Ontological Relativity and Other Essays*. New York: Columbia University Press, 1969.

———. *The Roots of Reference*. La Salle, IL: Open Court, 1975.

———. "Reply to Stroud." In *Midwest Studies in Philosophy*, vol. 6. Edited by Peter French, Theodore E. Uehling, and Howard Wettstein. Minneapolis: University of Minnesota Press, 1981.

———. "Comments on Haack." In *Perspectives on Quine*. Edited by Robert Barrett and Roger Gibson. Oxford: Basil Blackwell, 1990.

Rescher, Nicholas. *Methodological Pragmatism*. Oxford, England: Basil Blackwell, 1977.

———. *The Strife of Systems*. Pittsburgh: University of Pittsburgh, Press, 1988.

———. "The Editor's Page." *American Philosophical Quarterly* 29, no. 3 (July 1992): 301–302.

Rorty, Richard. "Metaphilosophical Problems in Linguistic Philosophy." *The Linguistic Turn*. Princeton, NJ: Princeton University Press, 1968.

Rosenberg, Alexander. "A Field Guide to Recent Species of Naturalism." *British Journal for the Philosophy of Science* 47 (1996).

Ruse, Michael. *Taking Darwin Seriously: A Naturalistic Approach to Philosophy*. Oxford, England: Basil Blackwell, 1986.

Russell, Bertrand. *The Problems of Philosophy*. London: Oxford University Press, 1912.

———. *Human Knowledge: Its Scope and Limits*. New York: Simon and Schuster, 1962.

Ryle, Gilbert. "Ludwig Wittgenstein." *Analysis* 12 (1951). Reprinted in *Essays in Philosophy*. Edited by Houston Peterson. New York: Washington Square Press, 1974.

Sagal, Paul. "Naturalized Epistemology and the Harakiri of Philosophy." In *Naturalistic Epistemology: A Symposium of Two Decades*. Edited by A.

Shimony and G. Nails. Dordrecht, Holland: D. Reidel, 1987.

Salmon, Wesley. "Review of *The Ambiguous Frog: The Galvani-Volta Controversy on Animal Electricity.*" *Philosophy of Science* (March 1995): 164–65.

Sartwell, Crispin. "Why Knowledge Is Merely True Belief." *Journal of Philosophy* 89, no. 4 (April 1992): 167ff.

Schmitt, Frederick. "Reliability, Objectivity, and the Background of Justification." *Australasian Journal of Philosophy* 62 (March 1984): 1–15.

Shimony, Abner and Gail Nails. *Naturalistic Epistemology.* Dordrecht, Holland: D. Reidel, 1987.

Shope, Robert. "Knowledge and Falsity." *Philosophical Studies* 40 (November 1979): 128–36.

———. "Justification, Reliability, and Knowledge." *Philosophia* 19, nos. 2-3 (October 1989): 133–54.

Siegel, Harvey. "Justification, Discovery, and the Naturalization of Epistemology." *Philosophy of Science* 47 (1980): 297–321.

———. "Empirical Psychology, Naturalized Epistemology, and First Philosophy." *Philosophy of Science* 51 (1984): 657ff.

———. "What Is the Question Concerning the Rationality of Science?" *Philosophy of Science* 52 (1984): 517–37.

———. "Philosophy of Science Naturalized? Some Problems with Giere's Naturalism." *Studies in the History and Philosophy of Science* 20 (1989): 365–75.

———. "Naturalism, Instrumental Rationality, and the Normativity of Epistemology." Unpublished manuscript.

Skagestadt, Peter. "Hypothetical Realism." In *Scientific Inquiry and the Social Sciences: A Volume in Honor of Donald T. Campbell.* Edited by Brewer and Collins. San Francisco: Jossey-Bass, 1981.

Sosa, Ernest. "Nature Unmirrored: Epistemology Naturalized." *Synthese* 55 (1983).

———. "The Virtue of Coherence and the Coherence of Virtue." *Synthese* 64 (July 1985).

———. "A 'Circular' Coherence and 'Absurd' Foundations." In *Language and Reality: Perspectives on the Philosophy of Donald Davidson.* Edited by Ernest LePore and Brian McLaughlin. Oxford, England: Oxford University Press, 1986.

Stich, Stephen. *From Folk Psychology to Cognitive Science: The Case Against Belief.* Cambridge, MA: Bradford Books, 1983.

Swain, Marshall. "An Analysis of Knowledge." *Synthese* 23 (March 1972): 429–30.

———. "Justification and Reliable Belief." *Philosophical Studies* 40 (1981): 389–407.

———. *Reasons and Knowledge*. Ithaca, NY: Cornell University Press, 1981.

———. "Justification, Reasons, and Reliability." *Synthese* 64 (July 1985).

———. "Internalistic Externalism." *Philosophical Perspectives* 2, Epistemology (1988).

Thagaard, Paul. "Goldman's Psychologism." (Review of Goldman's Book *Epistemology and Cognition*. *Erkenntnis* 34, no. 1 (1991): 117ff.

Van Cleve, James. "Foundationalism, Epistemic Principles, and the Cartesian Circle." *The Philosophical Review* 88 (January 1979): 55–91.

Wilson, Timothy. "Strangers to Ourselves: The Origin and Accuracy of Beliefs about One's Own Mental States." Pp. 1–35 in *Attribution: Basic Issues and Applications*. Edited by H. Harvey and G. Weary. Orlando, 1985.

Winblad, Douglas. "Skepticism and Naturalized Epistemology." *Philosophia* 19 (October 1989): 99–114.

Winograd, Terrence. "What Does It Mean to Understand a Language?" Pp. 248–49 in *Perspectives on Cognitive Science*. Edited by Frank Norman. Norwood, 1981.

Woolridge, D.E. *The Machinery of the Brain*. New York, 1963.

Index